PAINTING

from Public Collections in Washington, D.C.

MILTON W. BROWN

with the assistance of Judith H. Lanius

Smithsonian Institution Press
Washington, D.C.
1983

*Dimensions are in inches and centimeters,
height preceding width and depth.*

Library of Congress Cataloging in Publication Data

Brown, Milton Wolf, 1911–
 One hundred masterpieces of American painting from
public collections in Washington, D.C.

 Includes index.
 1. Painting, American. 2. Painting—Washington (D.C.)
3. Art museums—Washington (D.C.) 4. Artists—United
States—Biography. I. Lanius, Judith H. II. Title
ND235.W3B7 1983 759.13'074'0153 83-600104
ISBN 0-87474-292-7
ISBN 0-87474-291-9 (pbk.)

Cover: Detail of *The Sierra Nevada in Cali-
fornia*, 1868, by Albert Bierstadt. National
Museum of American Art, Smithsonian
Institution; Bequest of Helen Huntington
Hull.

One Hundred Masterpieces of

AMERICAN

CONTENTS

PREFACE

Books, like people, are conditioned by their history. This book began life as the catalogue of an exhibition, a large and important one.

During the state visit in 1979 of President José López Portillo of Mexico and his wife, Carmen Romano de López Portillo, President Jimmy Carter, at the request of Mrs. López Portillo, promised to send to Mexico an exhibition of American art as a gesture of good will and to foster cultural relations between Mexico and the United States. It was decided for diplomatic and logistic reasons to select works from Washington public collections. The exhibition that emerged was, perhaps unexpectedly, so interesting that all involved in its preparation hoped it might be shown in Washington and elsewhere. The prospect of seeing so many familiar great American paintings from various Washington collections hung together in a new context was intriguing. Unfortunately, such an exhibition could not be arranged. The hope remained, however, that an English version of the catalogue, which had been printed in Spanish, could be published in the United States. This book is the fulfillment of that hope.

The exhibition was designed to present a historical panorama of American painting. To achieve the widest possible coverage, artists were represented by a single work. Emphasis was not on didacticism or historical completeness but on quality. Even the most important artists would be included only if a first-rate example of his or her work were available. American painting would be presented through its masterpieces. This remains the guiding principle for the organization of this book.

The exhibition, shown in 1981 at the Museo del Palacio de Bellas Artes in Mexico City, consisted of ninety paintings covering a period of some two hundred years of American art history. To make a neater and more comprehensive package, ten paintings have been added to make a total of one hundred.

The character of the Mexico City exhibition was determined to some extent, as are all exhibitions, by a variety of restrictions. Even with all the good will in the world and cooperation of everyone concerned, some works could not be lent because of legal restrictions by statute or bequest, others because they were too important to be removed even temporarily, but the most serious restriction was that the physical condition of some did not permit travel.

The opportunity has been taken to further enhance the selection by including paintings that could not be loaned for the exhibition. Even so, some major artists are not represented simply because their work is not included in Washington collections or is represented by inferior examples. In addition, it should be noted that the Freer Gallery of Art could not participate in the exhibition because none of its collections can be lent. The Freer does have an interesting group of American paintings focused largely on Whistler and his ambience, including the famous Peacock Room, but given the limitations of selection, representations from the Freer collection could not be

included in this book. Considering these facts and the need to keep each collection fairly evenly represented, this is my selection. Under different circumstances the selection might be different, and I am sure that one hundred different paintings of similar quality could be selected, although I would argue that some at least are irreplaceable in such a collection of masterpieces.

These, then, are my choices, and taken together they could hardly be bettered by American painting in any other city in the country. It is intended that this book will serve as an introduction to American painting, as an instigation to further exploration of the various Washington collections, and as a souvenir of an experience with art in the nation's capital.

MILTON W. BROWN
City University of New York
Graduate School and University Center

ACKNOWLEDGMENTS

In the preparation of the exhibition, catalogue, and book, I have had the assistance of Judith H. Lanius who deserves credit for handling much of the detail involved in all three projects.

I would also like to thank the staffs of the various collections for their cooperation. I am most beholden to the curators and their assistants with whom I worked in selecting the paintings for the book: Linda L. Ayres, E. A. Carmean, Clement E. Conger, Inez Garson, the late James McLaughlin, Betty C. Monkman, Edward J. Nygren, Harry Z. Rand, William H. Truettner, and John Wilmerding. They were all invariably helpful, cooperative, and gracious. It was a pleasure to work with them.

Information about the collections and paintings is based to a large extent on material supplied by the various museums. I am thankful for the assistance offered by Margery Byers, Carolyn Campbell, Martha Carey, Pamela Driscoll, John Gernand, Laura Lester, Barbara Murek, Mary Jane Pagan, Carol Parsons, Elizabeth Punsalan, Linda Simmons, and Judith Zilczer.

Equally important were the color transparencies supplied by the museums, and I am equally thankful to the following for their help: Rachel Allen, Ira Bartfield, Janet Dorman, Eleanor Fink, Michael Fischer, John Gillig, Lisa Gordinier, Michael Green, Lynn Kahler, Rebecca Tiger, and Francie Woltz.

In the preparation of the captions and biographies, Judith H. Lanius and I had the devoted assistance of a group of graduate students. My sincere gratitude to Craig Bailey, Margaret Betz, Ilene Fort, Gail Gelburd, Susan Ginsburg, Dominic Madormo, April Paul, Sarah Peters, Margaret Denton Smith, Leila Van Hook, Marcia Wallace, and Mina Wright. Craig Bailey was especially helpful in the preparation of the post-World War II section of the essay. I have edited the material and am finally responsible for all of it.

Last, although not least, my thanks to those in the United States Information Agency who supported the original exhibition.

M.W.B.

THE COLLECTIONS

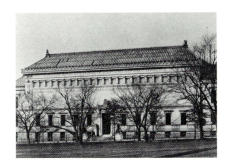

The Corcoran Gallery of Art

Seventeenth Street and New York Avenue, NW
Washington, D.C. 20006

Michael Botwinick, Director

William Wilson Corcoran was distinguished among his contemporaries by his dedication and commitment to American art and artists. Although he developed his connoisseurship by acquiring European art, it was to American art that he devoted himself during his maturity as a collector. By the 1850s he had assembled substantial holdings that were to serve as the core collection for an art museum, which was opened to the public in 1874. Construction of the Corcoran Gallery, designed by architect James Renwick in the Second Empire style, was begun in 1859, but the Civil War delayed its completion and occupancy.

What had begun as a collection of American nineteenth-century painting and sculpture has been increased by purchases and gifts. By 1897 the gallery collections were moved to a larger building designed by Ernest Flagg in the style of Beaux-Arts Classicism. The original building that had housed the first Corcoran Gallery is now the Renwick Gallery, a department of the Smithsonian's National Museum of American Art, and is devoted to the presentation of American crafts and design.

Conceived by Corcoran for "the encouragement of American genius," the gallery continues the founder's intentions through its acquisition and exhibition programs. Since 1907, when the first Corcoran biennial was held, the museum has continued to focus attention on recent developments in American art. Photography is also regularly shown in the gallery. The Corcoran is the one museum in the capital city that actively exhibits the work of Washington-area artists.

In addition to presenting a historical survey of American art, the Corcoran also displays a significant collection of European art. In 1925 a bequest by the William Andrews Clark family provided the gallery with a major group of Dutch, English, Flemish, and French painting, sculpture, and decorative art as well as funds for the construction of a wing to house the bequest. The European collection was further augmented in 1937 by a gift of French Impressionist paintings from the Walker collection.

As a patron and benefactor of American artists, Mr. Corcoran foresaw the need for a school of art that could benefit from its proximity to the museum. In 1890, shortly after Corcoran's death, with funds provided by his will, the Corcoran School of Art was opened. It is the only school of art in Washington and is located within the museum building.

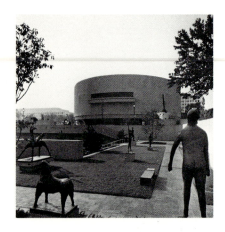

Hirshhorn Museum and Sculpture Garden

Smithsonian Institution
Independence Avenue at Eighth Street, SW
Washington, D.C. 20560

Abram Lerner, Director

Opened in 1974, the Hirshhorn Museum and Sculpture Garden, a collection of some twelve thousand paintings, sculptures, and drawings, is the result of the long and continuous interest in modern art by Joseph H. Hirshhorn, who immigrated to the United States from Latvia in 1905 and began collecting art during the 1930s. The entire collection was given to the people of the United States by Mr. Hirshhorn, who continually augmented the collection until his death in 1981.

The collections of the Hirshhorn Museum are located in and around the cylindrical-shaped building designed by Gordon Bunshaft of the architectural firm of Skidmore, Owings and Merrill. The museum building is a poured-concrete structure supported by four pylons with an open core. More than seventy-five pieces of sculpture are exhibited on the plaza and in the adjacent sculpture garden. The museum interior was designed specifically for the display of sculpture in an inner circle of galleries illuminated by natural light. Paintings and drawings are exhibited in enclosed galleries on the perimeter.

The holdings of the museum are divided between two equally important collections of modern painting and sculpture. The painting collection spans the development of modernism in the United States from its beginnings during the late nineteenth century to the present. Selections from the permanent collection are rotated frequently and are complemented by a number of temporary exhibitions that explore the variety of modern and contemporary painting and sculpture. A selection of work by European and Latin American artists is also represented in the collection.

Whereas the focus of the painting collection is on American artists, the sculpture collection includes works by numerous European modern masters and contains the largest public holding in America of sculpture by the English artist Henry Moore. The Hirshhorn collection represents a history of modern sculpture, with bronzes by Daumier, Degas, Matisse, Picasso, and Rodin; mobiles by Calder; boxes by Cornell; as well as large-scale sculptures by David Smith and Mark Di Suvero.

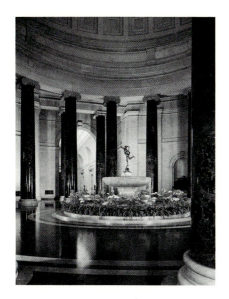

National Gallery of Art

Constitution Avenue at Sixth Street, NW
Washington, D.C. 20565

J. Carter Brown, Director

The collection of Andrew W. Mellon and a joint resolution of Congress provided in 1937 for the establishment and construction of the National Gallery of Art. Mr. Mellon's collection of European and American painting and sculpture from the thirteenth to the nineteenth centuries formed the character of the gallery, which has been further enhanced and augmented by the donation of outstanding collections and individual works of art. The original gift of 152 masterpieces included paintings by Botticelli, Raphael, Rembrandt, and van Eyck and a group of paintings formerly in the collection of the Hermitage in Leningrad.

The National Gallery opened to the public in 1941 in a Neoclassical building constructed with funds from Mr. Mellon and designed by John Russell Pope, architect of the Jefferson Memorial. Technically a bureau of the Smithsonian Institution, the National Gallery of Art is an autonomous and separately administered organization governed by a board of trustees, headed by the chief justice of the United States and including the secretaries of the departments of State and Treasury and five private citizens.

Following the lead of Mr. Mellon, Samuel H. Kress gave to the gallery his collection of Italian painting and sculpture. With his brother, Rush H. Kress, he augmented the original gift with Dutch and Flemish painting and French painting and sculpture. A collection of European painting, sculpture, and decorative art, including fourteen paintings by Rembrandt, was donated to the gallery by Joseph E. Widener and his father, P. A. B. Widener. Chester Dale's collection provided the basis for the creation of the gallery's major collection of nineteenth- and twentieth-century French painting, which has been enhanced by gifts from Ailsa Mellon Bruce and Paul Mellon. The donation of Lessing J. Rosenwald's extensive print collection has made the gallery a major center for graphic art, with holdings numbering more than fifty thousand prints.

The National Gallery also has a major collection of American art, which has been created by gifts from a variety of sources, including the Edgar William and Bernice Chrysler Collection of eighteenth- and nineteenth-century naïve painting, the Chester Dale Collection of Ashcan school painting, and the Paul Mellon collection of twentieth-century American painting.

In 1978 the gallery completed construction of a major new building, the East Wing, on a trapezoidal site adjacent to the original building, now called the West Wing. The land was set aside at the time of Andrew Mellon's original bequest for the future expansion of the museum's activities and collections. The dramatic asymmetrical design based on two interlocking triangles was conceived by the American architect I. M. Pei. The East Wing, faced with the same Tennessee pink marble used on the facade of the original building, is linked to it by an underground walkway and aboveground plaza. The new building accommodates the gallery's increased holdings, large-scale exhibitions, and Center for Advanced Study in the Visual Arts, with a major library and photographic reference archive for use by the curatorial staff and visiting scholars.

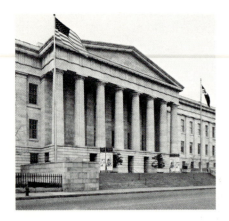

National Museum of American Art

Smithsonian Institution
Eighth and G Streets, NW
Washington, D.C. 20560

Charles C. Eldredge, Director

By its permanent collections, exhibition and publication programs, and research activities, the National Museum of American Art—formerly the National Collection of Fine Arts—seeks to develop and expand an awareness and understanding of American art. Opened to the public in 1968, in its first permanent home in the newly renovated, historic Patent Office Building, the National Museum of American Art has been the recipient of numerous collections of American art: the William T. Evans collection of American painting, the S. C. Johnson & Son collection of recent twentieth-century art, and the John Gellatly collection of some sixteen hundred objects, including American painting and examples of fine and decorative art from Europe, Asia, and the ancient world.

To complement its holdings of American art, the museum maintains an active exhibition schedule. The museum also comprises the collection and studio house of Alice Pike Barney, an artist and patron; and the Renwick Gallery, in which is exhibited American crafts and design.

The National Museum has had a curious history. Its origins can be traced to the nineteenth century with the collection of John Varden, who in the interest of forming a permanent museum in the nation's capital, opened part of his house to the public in 1836, calling it the Washington Museum. Varden's typically nineteenth-century collection of paintings, specimens of nature, and historical objects was acquired in 1841 by the National Institute and relocated in the Patent Office Building designed in the Greek Revival style by William Parker Eliot. The Smithsonian Institution, founded in 1846 as a museum and research center, absorbed the National Institute in 1862. The institute's collections were on view in the Smithsonian Building, the Castle, but only until 1865, when a fire in the building forced the removal of the painting collection to the Corcoran Gallery of Art. With the paintings on loan to the Corcoran, the issue of what the Smithsonian would do with the collection remained unresolved until 1906, when President James Buchanan's niece, Harriet Lane Johnston, gave her collection to the nation with the stipulation that it go to a "national museum." The restriction resulted in amalgamation of her bequest, composed primarily of European painting, with the existing Smithsonian painting collection to form the National Gallery of Art.

In 1937 a unique event occurred that was to produce two national collections. Andrew Mellon gave his collection of old-master paintings to the nation and funds for the construction of a gallery modeled on the National Gallery in London. The Mellon collection became the National Gallery of Art, and, in turn, the name National Collection of Fine Arts was assumed by the Smithsonian's collection. The National Collection was housed in the Smithsonian's Natural History Building until it was moved permanently to the Old Patent Office Building, its early home. To emphasize the collection's focus on American art, the name of the museum was changed in 1980 to National Museum of American Art.

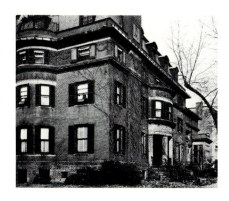

The Phillips Collection

1600 Twenty-first Street, NW
Washington, D.C. 20009

Laughlin Phillips, Director

The Phillips Memorial Gallery opened to the public in 1921 for three afternoons a week in a few rooms of the family home, with a small collection of French and American nineteenth- and twentieth-century paintings. The Phillips Collection represents a highly personal selection and remains a record of Duncan Phillips's development as a connoisseur, nurtured and conditioned by Impressionism. Duncan Phillips believed in an understanding of art through education and in making art accessible to people through the intimate atmosphere of his home.

The collection, which today includes works by contemporary artists, had by the 1930s assumed its basic character as a conservative collection of modern art, including paintings by the major Impressionists, Postimpressionists, Fauves, and Cubists as well as works by American artists influenced by modernism. The collection is not presented chronologically; the arrangement is intended rather to establish a series of sympathetic and thoughtful interrelationships among diverse works of art. And for this purpose, Duncan Phillips, with his belief in the sources of modernism, collected paintings by Chardin, Constable, Delacroix, El Greco, and Goya among others. The great majority of the collection was selected by Duncan Phillips and his artist wife, Marjorie Phillips, and since his death in 1966, additions have been made annually. Of the two thousand works in the collection, less than 250 are exhibited at one time, with the result that the selection on view is frequently changed and the gallery lends generously to other museums. The gallery also maintains an active exhibition program.

The Phillips Collection remains an enduring interest of the Phillips family, and, unlike so many early collections of modern art, it has not been absorbed into a larger museum. Duncan Phillips's son, following his mother, continues today as director of the gallery.

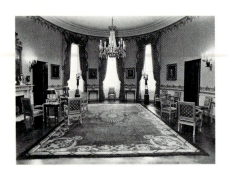

The White House

1600 Pennsylvania Avenue, NW
Washington, D.C. 20500

Clement E. Conger, Curator

The American painting collection of the White House is distributed throughout the public and private rooms of the president's residence. This small but distinguished collection originally consisted entirely of portraits of the presidents and their wives, but since 1961, when the White House Historical Association and Curator's Office were established, it has been consistently and considerably enlarged to include American landscape, genre, and still-life painting. The collection, depicting scenes of American life, numbers more than 250 paintings and has been assembled primarily through the generosity of American citizens. The collection contains many fine examples of eighteenth- and nineteenth-century paintings illustrating the diversity of the American landscape. Represented in the collection are works by outstanding American artists, including Albert Bierstadt, George Caleb Bingham, John Kensett, William Harnett, and Gilbert Stuart.

Although the collection is devoted to American art, it also includes eight Cézannes bequeathed in 1952 by Charles A. Loeser and a Monet landscape given in memory of President John Fitzgerald Kennedy by his family. The collection also contains prints, drawings, early maps, and other source material relating the history of the White House.

AMERICAN PAINTING: A SURVEY

American art in its beginnings during the seventeenth century was essentially a provincial transplantation of European traditions, overwhelmingly English with isolated pockets of Spanish influence in Florida, the Southwest, and California; French influence along the Saint Lawrence River, the Great Lakes, and the Mississippi River down to New Orleans; and some admixture of Dutch in New York and New Jersey, Swedish in Delaware, and German in Pennsylvania. These earliest settlers brought with them the memories and habits of a rich European heritage, which they proceeded to reproduce as fully and faithfully as conditions of nature, economy, and technology permitted. It was only natural during these first years of struggle and hardship in a harsh environment that the earliest artistic efforts were limited to the more utilitarian forms of architecture and crafts rather than to the luxury arts of painting and sculpture.

Thus during most of the colonial period, painting and sculpture were limited but not only for economic reasons. Religious attitudes in the Protestant areas prohibited idolatrous imagery, and moral precepts concerning vanity and ostentation in the secular fields severely restricted the production of painting and sculpture. As a result, there was almost no religious painting and, in the realm of secular art, painting was confined to the occasional bit of wall or overmantel interior decoration and portraits, which remained a dominant form until well into the nineteenth century.

During the seventeenth century there were no professional, academically trained portrait painters in the colonies. Likenesses were created by anonymous, often itinerant artisans with no formal training, in most cases probably sign painters who did occasional portraits when the demand arose. The naïve character of the work of such so-called limners has led to their mistaken identification as primitive or folk artists, though they patently reflect more sophisticated European sources. Authentic examples of this period are extremely rare. A few from New England are naïvely charming, strongly patterned, linear, and flat, with an almost Mannerist flavor. Several from New Amsterdam are just as endearingly childlike in character, though more firmly modeled in the Dutch tradition. It is sometimes even difficult to decide whether or not some were actually done in Europe.

In the eighteenth century the growing population, wealth, and stability of the colonies along the Atlantic seaboard led to the expansion of urban life and fostered the rise of a class of merchants in the North and of plantation owners in the South interested in more gracious living and capable of supporting a higher level of luxury production in the arts. An increasing professional competence was apparent in architecture as well as crafts, and changing European fashions were assiduously copied. For the first time European painters of at least limited training came from various countries and settled in the colonies. They differed in native ability and level of competence, but what distinguished them from the previous generation of limners was a common background of academic training. However mediocre and provincial, they were the carriers of a conscious studio tradition of portraiture, and since they were mostly

English, they imitated the formal elegance, aristocratic pretensions, and artificiality of the court painters of England from Anthony van Dyck through Peter Lely to Godfrey Kneller.

Among the first to arrive from England were John Smibert, unquestionably the most competent, and the engraver Peter Pelham, both of whom settled in Boston. The German painter Justus Engelhart Kühn and the Swede Gustavus Hesselius were active in Pennsylvania, Maryland, and Virginia. Records indicate that Charles Bridges out of London painted portraits of the southern gentry for a short time, and Jeremiah Theüs, a Swiss immigrant, settled and worked in South Carolina.

Before long the first American-born painters appeared on the scene, almost all un-inspired imitators of European mannerisms that they had learned from émigré artists or from prints. Among them, Robert Feke was the first of any quality, and among such mediocrity he sparkles like a rare jewel. Feke's portraits exhibit the new artistic fashion coming from England in the persons of William Williams, Joseph Blackburn, and John Wollaston and reflecting a change in English taste. This less aristocratic and more informal style was exemplified on an infinitely higher level in England by William Hogarth, Joseph Highmore, and Thomas Hudson, and it was this influence that helped form the next generation of colonial painters. With that generation, colonial culture came full circle, feeding its sons back into the mainstream of European culture to study and in some cases to remain.

John Singleton Copley was America's first artistic genius. From his earliest works it is apparent that he was dependent upon the current fashion in Boston and that he borrowed unblushingly from whatever prints and paintings were available. He soon outstripped his sources, however, and created a personal style, vigorously realistic and psychologically penetrating, in which he immortalized the colonial era, leaving a gallery of memorable portraits of artisans, merchants, political leaders, fashionable ladies, and fascinating old women. Before he left for Europe in 1774, never to return, he had raised the standards of portraiture to a respectable level and created for the first time not only a recognizable native style in painting but a realist image that has continued to assert itself in American history.

Although Benjamin West, an absolute contemporary of Copley, was born in the colonies, he left for Europe as a very young man, received his training abroad, and remained in England for the rest of his life. He played an interesting and critical role in European as well as English art, first as an early proponent of Neoclassicism, then as the first to introduce contemporary events and costumes in history painting, and finally as a precursor of Romanticism. West always considered himself an American and during his many years in England was teacher and protector to several generations of American artists who came abroad to study, the most notable among them being Charles Willson Peale and Gilbert Stuart.

Peale, in his forthright realism, proved to be much more a disciple of Copley than of West, and between Copley's departure and Stuart's return, he was the outstanding painter in the United States. A fascinating and versatile personality, he eventually gave up painting for a variety of other pursuits, mainly scientific, but not before he had taught painting to his brother James and various of his progeny, among them his sons Raphaelle and Rembrandt. Copley's realistic style was also carried on by lesser painters such as the provincial and largely self-taught Ralph Earl and many other local, itinerant, and often anonymous portraitists who continued the basically realistic manner into the nineteenth century.

Independence did not immediately transform American culture and art. Many old ways and attitudes and the dependence on European models continued, but there was a new self-consciousness and search for national identity. Political optimism was strengthened by economic growth, by increased immigration fostered by European political unrest, and by westward expansion spurred by the Louisiana Purchase of 1803. Cultural nationalism reflected a new sense of American destiny based on a social doctrine of liberty, equality, and opportunity.

Although architecture found an immediate role in housing the new nation, the pictorial arts remained a luxury still largely confined to portraiture. Some younger artists dreamed of enshrining the heroic events of the Revolution in history painting, but the new nation was apparently not prepared for a *grand* style, and the efforts of John Trumbull, John Vanderlyn, Washington Allston, and Samuel F. B. Morse were aborted. The general secularization and democratization of society, however, afforded new possibilities for landscape, genre, and still-life painting and collecting.

Gilbert Stuart had become a successful portrait painter in London, but after the establishment of the new republic, he returned with the hope of doing a portrait of its first president, George Washington. He settled first in Philadelphia, where he had a brilliant though erratic career, and introduced a newer fashion of bright, fluent, impressionistic painting in the English style of George Romney and Henry Raeburn. Just as Copley had captured the solid, forthright materialism of the colonial age, Stuart embodied the newer elegance, wealth, and pretension of the Federal period, sometimes superficially and sometimes with penetrating visual and psychological acuity. Stuart's bravura style, but without his virtuosity, was carried on into the nineteenth century by a host of lesser men like Thomas Sully, John Wesley Jarvis, and others in an increasingly bourgeois manner, until the advent of the camera displaced the painter as the maker of likenesses.

With the increasing stability and wealth of the larger eastern cities during the nineteenth century came an expansion of taste in the arts. Academies and other institutions were established to exhibit and sell works of art in Philadelphia, New York, and Boston and later in other cities like Baltimore, Hartford, Albany, and New Haven. By the middle of the century the first commercial art galleries were opened, and the enterprising though short-lived American Art-Union, a lottery-financed organization that exhibited, bought, and distributed works by American artists, helped spread the arts to a wider audience. People were becoming interested in collecting as a mark of cultural refinement, and as a result landscape, still-life, and genre pictures were added to the repertory of painting in the United States.

For the general public with no pretensions to culture the popular print satisfied a variety of needs, partly artistic, partly literary, and largely journalistic. Hand-colored engraved and lithographed sheets, mass-produced and cheaply marketed by firms such as Currier & Ives, became common household decorations throughout the nation. They offered the public a variety of subjects from news events, battle scenes, and disasters to nostalgic remembrances of rural life and heroic images of adventure.

There was also a marked growth in sophistication among artists; most went abroad to study, to London at first and then to Paris and Rome, where they absorbed cultural attitudes and standards hardly appreciated at home. The first generation of post-Revolutionary artists like Allston, Trumbull, Vanderlyn, and Morse were no longer satisfied with painting portraits but wanted to explore the larger European tradition of historical, allegorical, and literary themes. These artists reflected the then current

European mode of Romanticism expressed in landscapes or scenes of dramatic action, from the theatricalism of Trumbull's battle pictures to Allston's scenes of "Gothik" terror. The American public, unfortunately, was not yet ready for this kind of art, and Trumbull's historical epics and Allston's biblical subjects and classical landscapes found little acceptance. Vanderlyn sank into oblivion, and Morse turned his energies from art to science, to the invention of the telegraph and the introduction of photography in the United States.

Romanticism eventually had its efflorescence in the Hudson River school, a group of loosely associated landscape painters who were the counterpart of the nature poets of the period. They worked along the Hudson River and in the neighboring Catskill mountains, though their locale was not actually so restricted. In typical Romantic fashion their concern was with both the sublime and the idyllic in nature, with the wild and the peaceful, with grandeur as well as intimacy. And the unspoiled New World landscape was a natural subject for them. The "noble redman" of James Fenimore Cooper found a place in the primordial forests of Thomas Cole, and the lyrical appreciation of nature by the poet William Cullen Bryant had its reflection in the more intimate idyllicism of Asher B. Durand. Except for the apocalyptic visions of Cole, the early group of Hudson River school painters, which included Durand and Morse as well as Thomas Doughty, Alvan Fisher, and Henry Inman, avoided the *terribilità* of nature and concentrated rather on its grandeur and magnificence, its limitless vistas in which the divine spirit was felt to reside.

The more lyrical and intimate aspects of nature were first explored by Durand and led to an art that was much closer to the French Barbizon school than to the Italian and German Romantic landscapists. Among the second generation of Hudson River school painters carrying on this tradition were John Kensett, Worthington Whittredge, Jasper Cropsey, Sanford Gifford, John Casilear, Frederic Church, and Albert Bierstadt.

Casilear and Cropsey remained most loyal to Durand, but even they became more realistic and domesticated. It was Kensett and Whittredge who transformed the poetic intimacy of Durand into a more immediate almost anti-Romantic naturalism, with a new interest in light rather than picturesque form, which eventually evolved into Luminism. Also included among the Luminists are Sanford Gifford; Robert Salmon and Fitz Hugh Lane, seascape painters who derive from a totally different tradition; Martin Heade, who stands somewhat apart yet shares many features with the Luminists; and Church and Bierstadt in some early works.

But Church and Bierstadt are better known for their epic landscapes, exploiting the newly discovered natural wonders of the West as well as of Central and South America and transforming the transcendentalism of Cole into grandiloquence. They reflected not only a Romantic concern with nature but a national pride in the immensity and richness of the continent, which, translated into political terms, became "manifest destiny." They arrived at a style popular in appeal and lofty in intention, grand in scale and meticulous in execution. These records of a new kind of spectacular scenery seemed to satisfy the yearning for the ideal as well as the concern with the literal, fulfilling the dream of an indigenous American art.

A much more mundane concern with everyday life was reflected in the popular art of the Jacksonian era. In prints as well as in paintings and sculptures, genre subjects were treated with humor and sentiment. Among the first of these early genre painters, whose works were often reproduced in prints, was William Sidney Mount, a native of Long Island, New York. His anecdotal scenes of rural life were very popular, and,

though his subjects are at times naïve, he was capable of sensitive observation and sincere feeling. Much more monumental in conception and less sentimental are the paintings of George Caleb Bingham, known as the "Mount of the West," whose works were also extensively reproduced. Whereas Mount looked for inspiration to Netherlandish genre paintings, Bingham turned to the more classic tradition of Poussin and the Italian Renaissance. Bingham was the outstanding artistic expression of the Jacksonian era. He captured firsthand in the life along the rivers of the Midwest the dream of western expansion and grass-roots democracy.

The opening of the West had all the ingredients of a Romantic saga—primeval nature, an exotic aboriginal population, the drama of an adventure into the unknown, and the promise of empire. Even at the time there was an awareness of the epic dimensions and historic import of the experience as well as an understanding and sense of urgency that the wave of civilization would inevitably destroy what had remained untouched for millennia. John James Audubon felt that way about his birds and animals, George Catlin about his Indians, just as Bingham did about the frontier life he knew so well— all of which was soon to disappear. A group of intrepid artists, in some cases only through necessity, compiled an invaluable record of a now vanished world. The most notable after Catlin were the U.S. Army officer Seth Eastman, the Swiss artist Karl Bodmer, Alfred Jacob Miller, John Mix Stanley, and Charles Wimar. On a popular level, the adventurous and anecdotal aspects of the western experience, rendered by Charles Deas, William Ranney, and Arthur Fitzwilliam Tait, were reproduced in engravings and lithographs.

Although the more important realist painters like Mount and Bingham and later Winslow Homer and Thomas Eakins worked away from the story picture toward a straightforward depiction of contemporary life, most nineteenth-century genre painting in the United States was dominated by anecdotal or moral intent. Of unusual interest are the eccentric satirical paintings of David Gilmour Blythe and the imaginative illustrations of John Quidor. The tradition of anecdotal genre painting continued and remained popular through the century in the work of Richard Caton Woodville, John George Brown, Thomas Waterman Wood, Edward Lamson Henry, and Thomas Hovenden, for all of whom the sentimental appeal of subject outweighed artistic considerations. At the same time, art for the people was being spread by the publication of magazines, books, and prints, and many artists were made more famous through reproduction. The nostalgic country idylls of George Henry Durrie were probably the most popular of all.

Perhaps because art was so democratically oriented during the Jacksonian era, the more exalted realm of history painting was largely ignored. Governmental commissions were extremely limited, and there was little popular support or patronage for the "higher" art forms. Only William Page, an authentic poetic Romantic with a rich painterly style, whose works have suffered technical deterioration and are now very rare, is worthy of consideration. Among others, then famous, were Daniel Huntington and Henry Peters Gray, hopelessly retardataire academic painters who combined a search for ideal beauty, the old-master look, and sentimental piety into a successful package; and Emanuel Leutze, the leading exponent of the Düsseldorf manner in the United States, who achieved much renown with his iconic *Washington Crossing the Delaware*.

The Civil War marked the emergence of the United States as a modern industrial nation. In 1860 it still relied on a largely agricultural economy, but in the next decade industrial production had doubled, and by 1900 the United States had become the leading industrial country in the world. Twelve new states had been added to the

Union, and the population had increased to seventy-six million, of whom fifteen million were immigrants. The land mass had been consolidated, the frontier had disappeared, and unprecedented natural resources were waiting for development.

Physical expansion had its less positive side, however, for the country now faced the complex problems of a burgeoning capitalist society. The earlier altruistic idealism of an intellectual elite that conceived of a national destiny based on moral principles and individual responsibility was replaced by a narrow materialism, a concern for personal advantage, and a belief in social Darwinism or survival of the fittest. The concentration of wealth grew apace and class antagonisms heightened. At the same time cultural nationalism declined as the old dream of American destiny faded into an individualistic, competitive drive for wealth and power. The nouveau riche industrial and financial tycoons were less tasteful than extravagant and less knowledgeable than acquisitive. The shortest and surest road to social and cultural standing was the assumption of European aristocratic trappings. During the Gilded Age, American millionaires began to emulate both the manner and scale of princely existence, building fake palaces, chateaux, and castles and forming old-master collections.

American artists no longer found patronage simply because they were American. Even the most untutored of robber barons was aware that European art carried greater social cachet. If he could not afford authentic old masters, he bought second-rate examples, copies, fakes, or contemporary European academic works. In addition the portrait trade had finally been undermined by photography. The distinction between fine and popular art became sharper as class interests and tastes diverged. Popular art became increasingly anecdotal and sentimental, and the fine arts took on the guise of gentility.

Once again some American artists found their environment unsympathetic. A new sophistication about aesthetic standards led some into expatriation, and a new seriousness toward creative integrity led others to work at home against the grain of current taste. But much art of the time was a false facade behind which the realities of life were hidden.

After a long period of nationalist isolation, the arts turned again to Europe. Artists went abroad to study at an earlier age, when they were more susceptible to influence. The day of Düsseldorf was over, and Paris and Munich became the new magnets. Not all had the insight or opportunity to study for any length of time or make meaningful connections. The majority collected a bag of tricks, assumed the artist's habit, and returned to a culture that had suddenly become unreceptive. Others reacted to the more vital aspects of contemporary European art. George Inness had discovered Corot, Rousseau, and the Barbizon school. William Morris Hunt, and after him Robert Loftin Newman, found the atelier of Couture in Paris, though Hunt later transferred his allegiance to Millet. John La Farge spent a short time with Couture, and James McNeill Whistler was also influenced by his work. Whistler met Courbet and Manet and became one of the dissidents later called Impressionists. Mary Cassatt met Degas, who introduced her to the same circle. John Singer Sargent studied with Carolus-Duran and was influenced by Manet.

Whistler, Cassatt, and Sargent remained abroad as expatriates, and American art without them is immeasurably poorer. None ever renounced his American origins, yet all three worked within the context of European rather than American art. Sargent was not even born in the United States; Whistler and Cassatt settled in Europe early in their careers. What is American in their art is difficult to define, but there is no

question that they had an impact on younger American artists, and that Whistler's status and notoriety, Cassatt's connection with the Impressionists, and Sargent's international reputation reflected glory on American art. The fact that they chose to live in Europe rather than the United States is at least in part a reflection of the cultural limitations of the American environment. It should be noted that of those artists who remained in their native land, Eakins, Ryder, and Blakelock were tragically neglected.

After the Civil War and continuing into the first decade of the twentieth century, painting in the United States became increasingly eclectic, responding to various and successive winds of European influence. One can, however, isolate two main currents, Realism and Romanticism, which seem to have coexisted symbiotically for the remainder of the century.

Realism in the United States must be seen in relationship not only to its native sources but also to the development of Realism in Europe from Courbet and Manet to the Impressionists. In this context one can better understand the avant-garde role Whistler played in the emergence of visual realism as well as the historic importance of his break from it, the adherence of Cassatt to Impressionism, and Sargent's parallel relationship to Manet through Carolus-Duran and Spanish painting but perhaps more importantly through the collateral English line of visual realism from van Dyck to Lawrence.

Winslow Homer was exceptional in his lack of connection with the historical sources of visual realism, though his development paralleled that of Manet and early Impressionism. Homer, who had begun as a journalistic illustrator, went on to achieve a sparkling and clear-eyed realism in which the anecdote was largely submerged. From his early studies of children and rural life to the later, more dramatic hunting and sea scenes in both oil and watercolor, he produced an art that comes fairly close to Impressionism without the color theory or practice. Like Homer, Eakins was a thoroughgoing realist but, unlike Homer, had received academic training abroad, was scientifically oriented, and was never involved with illustration or anecdotal genre. He has left a collection of profound portraits and a series of brilliant sporting pictures that are at the peak of the realist tradition in the United States. Eastman Johnson developed from an anecdotal, rather meticulous genre style a broader, more daring treatment of figures in landscape. This loosening of style reflects a general shift among young artists from the tightness and polish of the Düsseldorf school, which had attracted the earlier genre painters, to the broader, more spontaneous and virtuoso handling of paint that characterized the Munich school as exemplified by Frank Duveneck and William Merritt Chase.

In connection with Realism, mention should be made of the phenomenal efflorescence at the end of the nineteenth century of trompe l'oeil painting as a popular form. Still-life painting had been almost entirely dominated in the early part of the century by three generations of Charles Willson Peale's descendants. It continued as a viable decorative form, though it did not appeal to the sophisticated taste for the sublime, the grandiose, or the aesthetic. Trompe l'oeil painters produced a very popular genre of anecdotal still-life painting that exploited fidelity of detail without a loss of compositional largeness, especially in the cases of William Harnett and Frederick Peto. Harnett was quite successful in his day, but the rest were forgotten and only have been rediscovered recently.

A new American Romanticism emerged after the Civil War in the work of George Inness, William Morris Hunt, and John La Farge, who brought back with them from

abroad the aesthetic doctrine that art was not the imitation of nature but the expression of emotion. Though connected in some respects with the older tradition of Allston and Page, the new Romantics sought poetic sentiment in the commonplace rather than in the sublime and the picturesque, and they pointed toward a new galaxy of exemplars—Constable, Turner, Delacroix, Géricault, Corot, Millet, and the Barbizon school of landscape painters. Hunt, who had lived and worked with Millet, spread the new Barbizon gospel in the United States even before it found currency in France. His influence is to be seen among such figure painters as John La Farge, Robert Loftin Newman, George Fuller, and finally, in a more genteel and domesticated form, Thomas Dewing.

At the same time a group of landscape painters, George Inness, Alexander Wyant, and Homer Martin among others, achieved a new poetic lyricism through a broader and more fluent handling of paint. Led by George Inness, who had broken from the Hudson River school tradition under the influence of the Barbizon school, they sought a more personal and even mystical connection with nature. Though tangentially related to Impressionism, Inness's work revealed a remarkable affinity with the silvery wood-land idylls of Corot and the tonal nocturnes of Whistler. The subjective response to nature found more emotional expression in the moonlit landscapes of Ralph Blakelock and, most notably, in the mystic seascapes and allegorical and literary subjects, which Albert Ryder rendered with such dramatic intensity and formal power.

Luminists like Kensett, Whittredge, and Heade and, in their outdoor paintings, Eakins, Eastman Johnson, and especially Homer had independently come within an eye blink of Impressionism. Sargent in his watercolors and Chase in his later Long Island landscapes had not only shown an awareness of Impressionism but had adapted much of its vocabulary. But it was a new generation of American painters in France during the 1880s who finally reacted directly to Impressionism, which had been exhibited in the United States as early as 1886, found collectors at a fairly early date, and public acceptance almost immediately. By the turn of the century it had become a dominant mode. The Ten, the most prestigious group of painters working in the United States, were Impressionists, among them the leading exponents of the style, Theodore Robinson, John Twachtman, J. Alden Weir, and Childe Hassam. Though they owed much to French Impressionism, they are distinguishable in their concern with the reality of substance and the poetry of sentiment, characteristics common to much of late-nineteenth-century painting in the United States.

The beginning of the twentieth century saw the emergence of the United States as a major world power, poised to assume leadership in a radically changing world that within less than a century would be transformed by the electric light, the motion picture, the telephone, the automobile, the airplane, radio, television, computers, nuclear energy, and interplanetary travel. It is also the century of global wars, revolutions, genocide, the holocaust, the atomic and nuclear bombs, intercontinental and interplanetary missiles. The reactions in culture and art have been tentative and troubled.

At the beginning of the century American painting was dominated by an academic eclecticism in which almost any recognizable traditional manner from Neoclassicism to Impressionism was acceptable. But the genteel complacency of the academic art world was rudely disturbed by a group of young Philadelphia newspaper artists, turned painters under the inspiration and direction of Robert Henri who had just returned from Paris. They surfaced as a force in American art only after they had all migrated to New York and become known as the New York Realists, later dubbed the Ashcan school. They were painters of urban genre, treating subjects made common

by such Impressionist painters as Manet and Degas and later Toulouse-Lautrec. They dealt with the leisure activities of the urban population in streets, cafés, theaters, and parks. The Ashcan painters dealt also with the life of people in the slums, reflecting the demographic changes that had occurred through mass immigration in the major industrial cities of the United States. Overcrowding, poverty, and filth were recognized as serious social problems, and social reformers fought for an amelioration of such conditions, while so-called muckrakers were exposing corruption in business and politics.

The work of the New York Realists, along with that of Jerome Myers, Eugene Higgins, and George Bellows, a young student of Henri, had become visible enough to be identified with social reformism, muckraking, and radicalism, and they were denounced as a "revolutionary black gang." But they were far from revolutionary; only by implication and sympathy could they even be called reformist. This new realist tendency dealing with life in the raw attracted a generation of young painters, beginning with Bellows and including Gifford Beal, Rockwell Kent, and Leon Kroll, all of whom exhibited a brash muscularity and optimism that was identified as American and became very popular. Much closer to the core of the Ashcan tradition, however, were Edward Hopper, Guy Pène du Bois, Stuart Davis, and Glenn O. Coleman.

In 1908 the New York Realists were joined by Arthur B. Davies, a romantic, symbolist painter of poetic idylls; Ernest Lawson, an Impressionist; and Maurice Prendergast, the only Postimpressionist in the United States, in an historic exhibition of the Eight. They were not a homogeneous group and they never exhibited together again, but perhaps because of their combined prestige, they became the power base in the struggle against the academy. The exhibition had served as a demonstration of the vitality and quality of American art, as propaganda for it, and as proof of the validity of the nonjuried exhibition system.

While these independent artists were launching a frontal attack on the citadel of academicism, it was being undermined from another angle by the introduction of European and then American modernism by the photographer Alfred Stieglitz at his Photo-Secession Gallery, better known as 291. Opened in 1905 to support the struggle of photographers against the academic establishment, it branched out in the role of defender of everything new and exciting in the arts. In 1908 Stieglitz exhibited for the first time in the United States drawings by Rodin and Matisse. He subsequently showed the work of Toulouse-Lautrec, Henri Rousseau, Cézanne, and Picasso and of such innovative Americans as Alfred Maurer, John Marin, Marsden Hartley, Arthur Dove, Arthur Carles, Max Weber, and Abraham Walkowitz. 291 was the only gallery in the United States consistently to present the controversial and revolutionary aspects of modern art. The magazine *Camera Work*, published by the gallery, was an open forum for modernist opinion. The gallery served as a meeting place for kindred radical spirits, and Stieglitz's purse aided many a struggling artist. Although Stieglitz was doubtless the most important single figure in the dissemination of modernism in the United States, it was the artists who created the revolution.

Most of the young painters who were later to turn to modernism were in the first decade of the twentieth century already studying abroad where they were exposed to the new movements. The salon of Gertrude and Leo Stein served to introduce many to avant-garde art as well as to such leaders as Matisse and Picasso. Maurer came under Matisse's influence, Weber and Patrick Henry Bruce were members of Matisse's class, and Weber met Le Douanier Rousseau and the Cubist entourage of Picasso. Samuel Halpert was close to Delaunay and the Orphists as was Bruce, and

Morgan Russell and Stanton Macdonald-Wright were experimenting with color theory and devising their own movement, Synchromism. Yet, little was done by Americans before the Armory Show that would have appeared avant-garde by Paris standards.

The Armory Show of 1913 catapulted all this preparation into the public consciousness and opened a new era in American art. *The International Exhibition of Modern Art* held in New York at the Sixty-ninth Infantry Regiment Armory was organized by the Association of American Painters and Sculptors, twenty-five independent and progressive artists including the Eight. Its original intention was to foster American art, but it was later expanded to include "the best examples procurable of contemporary art." About thirteen hundred works were shown, of which about five hundred were European; the exhibition, though reduced in scale, traveled also to Chicago and Boston; in all some three hundred thousand people saw it; some two hundred and fifty works, including prints, were sold, of which two hundred were European, and almost all of the most avant-garde were among them. The very structure of the art market was transformed. New galleries appeared to exhibit European as well as American modern art. A new group of collectors, directly or indirectly influenced by the show, emerged to help change taste in the United States: John Quinn, Lillie Bliss, Walter Arensberg, Arthur Jerome Eddy, and Albert E. Gallatin. For the artists themselves the aftermath was unexpected and profound. Academicism was in effect no longer an issue, but the realists, who had been so active in arranging the show and so hopeful of its results, found themselves suddenly passé. For the earlier American modernists, the show was a vindication and an incentive. For a whole younger generation it was a revelation. The floodgates had been opened, and American art was never the same again.

The evolution of modernism in the United States does not follow a clearly definable pattern, in part because the history of European modernism came telescoped. American artists were recipients of, rather than participants in, avant-garde movements. They were thus essentially derivative and eclectic, though they produced original variations and personal styles. It is impossible and not very valid to describe individual artists as Fauves, Cubists, or Futurists, but it is possible to trace the influences of various European tendencies on American painters. The years immediately following the Armory Show were among the most experimental and radical in the artistic history of the United States, and isolated as artists were until the 1920s because of the war, those years were also among the most original.

Fauvism had little impact in the United States, perhaps because it presupposed a certain aesthetic sophistication to accept its irrationality, "wildness," and simplification; and German Expressionism came in only after the war. Maurer and Weber were the most obviously derivative from Fauvism, especially Matisse. Although Marin showed strong affinities with Fauvism in compositional tensions, in the closeness between feeling and facture, and in programmatic simplification, he was essentially a lyrical artist and always susceptible to Cubist intrusions. Walt Kuhn exhibited strong Fauve leanings in his early work and was later close to Derain, but he was too conservative an artist to be labeled a Fauve. Only Conrad Kramer, who had come from Germany, and Marsden Hartley, who had met Kandinsky and the Blaue Reiter group in Munich, had any connection with German Expressionism, which surfaced in the United States only during the twenties.

Cubism was the most influential of modernist styles and the only one that was widespread. It may have appealed because of its apparent rationalism in contrast to the emotional and intuitive aspects of Fauvism. An ingrained optimism may also explain the failure of American artists to respond to the nihilism of Dada or the social violence of Futurism. The period of the greatest Cubist influence was from the Armory

Show through World War I, when many artists were experimenting. The general pattern was toward a progressive assimilation or eventual rejection of Cubist elements rather than toward a logical investigation of further possibilities. The presence of Marcel Duchamp and Francis Picabia in New York had a marked effect on a whole circle of artists—Man Ray, Morton Schamberg, Charles Demuth, Charles Sheeler, but they were themselves then already committed to a form of mechanism and to Dada rather than orthodox Cubism.

The most important manifestation of Cubism in the United States was its domestication in the form of Precisionism during the twenties. But of those independently responsive to Cubist influence Max Weber was the most clearly committed to the Cubist vocabulary, and John Marin, intuitively a Fauve, referred continually to Cubist forms. Marsden Hartley had a short Cubist phase after his return from Germany, and Alfred Maurer did a series of still-life abstractions in the Synthetic Cubist mode during the late twenties. Stuart Davis was perhaps the most original and inventive of Americans working in the Cubist idiom, finally achieving an authentic variation on its basic formulas. Although Arthur Dove owed something to Cubism in his collages, his art existed outside its framework. Maintaining a very personal vision in his search for abstraction, he remained always poetic and evocative of nature in color and form, avoiding total nonobjectivity.

The most radical contribution made to modern art by American artists of this generation was Synchromism, developed in Paris in 1913 by two young American painters, Morgan Russell and Stanton Macdonald-Wright. Although they knew Robert Delaunay and the Orphist entourage, it is possible that they evolved independently along parallel lines toward color abstraction from a study of Neoimpressionist color theory and late Cézanne watercolors. Working in a similar vein in Paris were Patrick Henry Bruce and Arthur Frost, Jr. The Synchromists were first shown in the United States in 1914, and their influence, though short lived, can be seen for a time in the paintings of Arthur B. Davies, Joseph Stella, Andrew Dasburg, Morton Schamberg, Thomas Hart Benton, and James Daugherty.

After the brief interlude of World War I, the United States entered a period of economic prosperity and political conservatism. Radical reformism and Wilsonian internationalism gave way to political repression and isolationism. During the 1920s business became the symbol of the American way of life, but it was also a period of disillusionment and of the "lost generation." The social idealism of the earlier muckrakers was replaced by the critical cynicism of the debunkers. But if intellectuals and artists as a whole did not subscribe to the new American dream, they also could not and did not do much to obstruct it.

Art had gone through a radical phase after the Armory Show and modernism had become the ascendant mode, but individual artists with few exceptions had turned from experimentation to consolidation. They were also responding to a pervasive and growing nationalism, perhaps as a reaction to the dominance of European modernism in the art world and market. Although the sense of identity with native tradition and native genius that characterized progressive artists before the war was still operative, the tolerance of internationalism was beginning to weaken. There was also a growing consciousness of the American environment and subject as something unique.

Precisionism, the one coherent and recognizable style to emerge after the Armory Show, came out of a combination of mechanism and adaptation of Cubism. The Precisionists never exhibited together, articulated a shared aesthetic, or even recognized themselves as a group. Iconographically their emphasis was on the industrial

landscape and the machine, though some were also interested in organic form. The Precisionist simplification and rationalization of forms served as a metaphor for machine production and mechanical precision. Most Precisionists, having gone through a Cubist phase, turned toward a simplification of reality and in some cases during the late twenties toward a photographic realism.

Precisionism had mechanistic antecedents in Futurism and shared a parallel interest in the machine with English Vorticism, Léger, and Russian Constructivism and a stylistic affinity with French Purism, but its immediate inspiration seems to stem from the influence of Duchamp and Picabia. Morton Schamberg's machine images were the first classic icons of modern American technology, representing mechanical forms with an idealized purity without either the pessimism or mechano-sexual aspects of Dada. Unfortunately, Schamberg died suddenly and prematurely in 1918 and it was Charles Demuth who first moved from a Cubist to a Precisionist view of the industrial environment, soon to be followed by Charles Sheeler, Joseph Stella, Louis Lozowick, Preston Dickinson, Niles Spenser, and Georgia O'Keeffe among others. Precisionism was a conscious search for American subjects, most obviously in the modern industrial landscape (skyscrapers, bridges, and machines) but no less significantly in the country barns of Sheeler, the Georgian architecture of Demuth, the rural landscapes of Peter Blume, or the adobe Indian dwellings of O'Keeffe. Precisionism became in the end a glorification of the American theme.

Postwar isolationism had its positive aspects in a reevaluation of American history and a probing for the American ethos. There was a new and expanding interest in native art and culture. The American wing of the Metropolitan Museum of Art was opened in 1924, the Museum of Modern Art in 1930, and the Whitney Museum of American Art in 1931. Within this climate the reemergence of a native realism that had been submerged by the first wave of modernism seemed only natural. In fact, many of the Ashcan painters were still alive and active, though most had moved out of the range of social commentary. By the mid-twenties some tried to recapture the past. Sloan and Bellows attempted to update their memories; Coleman simply reworked older drawings. Only Pène du Bois, having continued to work in the vein, moved with the times and managed to capture an urbane vision of café society that matched the cold sparkle of the Gin Age.

The simultaneous appearance in the early twenties of Charles Burchfield and Edward Hopper was the harbinger of a new dimension and new direction in American realism. The American subject was now expanded beyond the urban to the rural, but the vision had also changed, becoming more introspective, searching, and critical. Instead of innocence, tradition, and stability, artists found in the small towns of the United States, as did writers like Sinclair Lewis, Maxwell Anderson, and Edgar Lee Masters, poverty and a meanness of existence. Both Burchfield and Hopper described the provincial lineaments of American life and landscape, revealing its untended and shabbier aspects, the railroad cuts, jerry-built shanties, abandoned farms and houses, and they had the unmistakable authenticity of time and place. Behind it all was a deep attachment to the provincial—based not simply on a sentimental longing for an agrarian past—as native and symbolic of the American present. Hopper's horizon was wide enough to encompass the city as well, but the bleakness of his vision may have been reinforced by his conception of provincial America. He found no warmth in its streets or its houses. And its people in his paintings are strangers, lonely, anonymous, temporary inhabitants of inhospitable environments.

Although the so-called Regionalists—Thomas Hart Benton, Grant Wood, and John Steuart Curry—did not peak until the early thirties, they had come to represent a

recognizable tendency during the twenties. Benton had already begun in the early twenties a projected epic series on American history, but he was a polemical artist and not a realist in the sense that the American Scene painters were. Though they had in common a focus on the hinterlands of the United States, the Regionalists were clearly midwestern and agricultural rather than provincial and small town as were the American Scene painters. Actually, the attitudes of neither the American Scene nor the Regionalist were monolithic. Hopper was only partly committed to the provincial, and some of the early Regionalist work, especially Wood's, was intended or can be read, as critical of provincial modes and customs. Benton's paintings of the late twenties and his mural series of the early thirties dealt equally critically with urban and rural life in the United States. On the whole, the growth of Americanism and the revival of the American subject during the twenties gather up many threads of American painting, of the avant-garde as well as various aspects of realism.

The Wall Street crash in late 1929 signaled the beginning of the Great Depression in the United States. It also opened a decade of worldwide crises culminating in World War II. For Americans it meant the end of an unprecedented era of growth and prosperity. The depression produced a unique social and cultural configuration in the United States quite different from contemporary European manifestations, an inevitable drawing back from international affairs and the heightening political tensions in Europe and Asia and a concentration of internal problems of survival. The United States was thus for a time even more isolated than previously, though the echoes of international political convulsions were heard, and, as they intensified, the nation was drawn into the maelstrom.

Nationalism in art had been on the increase during the twenties. Now the national cultural consciousness was fostered inadvertently and on an unprecedented scale by emergency governmental support of the arts under a series of agencies as part of the Roosevelt administration's efforts to cope with unemployment and economic stagnation. Never in the history of the United States had so many artists of all kinds been gainfully employed in the democratic process of bringing art to the people. Not only was art kept alive, but artists of all political and aesthetic persuasions were given an opportunity to work consistently and relatively unhampered as professionals. The "Projects" became a mass-training ground for a generation of artists, raised the level of professional competence, and fostered a consciousness of art as a function of society.

Under such circumstances, American art veered away from the reigning modes of European modernism on a more independent course, reacting much more directly to the exigencies of social and economic pressures. American artists were in a sense being forced both economically and ideologically into social responsibility. By accepting public funds, they were impelled either ideologically or bureaucratically to respond to public sentiment and taste. Faced by an unprecedented social crisis, they were led to reconsider the social role of art.

Painting in the 1930s was predominantly representational (though not necessarily naturalistic), communicative, and popular. It dealt with contemporary life in the United States and, especially in the mural projects, American history. Within this parameter existed a broad range of social and political attitudes and artistic variations from patriotic nationalism to revolutionary propaganda, from Realism to Surrealism.

As a preeminently public art, mural painting emerged as a new and logical form, and all kinds of government and public buildings were decorated. Benton's early interest in an American epic had led him to monumental mural art during the late twenties, but it was probably the presence of the great Mexican muralists Rivera, Orozco, and

Siqueiros, who had lost governmental support with the change in political climate in Mexico and were working in the United States during the late twenties and early thirties, which was crucial for the growing popularity of mural painting. Rivera was active on the Ford murals at the Detroit Institute of Arts and then worked at Rockefeller Center, where his unfinished mural was destroyed (though not without great public objection) for its revolutionary content. As a reprisal Rivera painted a series of panels on the history of the United States for the headquarters of a Communist Party splinter group, in which he was assisted by Ben Shahn. Orozco executed murals first at Pomona College in Claremont, California, and then at the New School for Social Research in New York, and in 1934 the *Epic of American Civilization* at Dartmouth College in Hanover, New Hampshire. Benton, as the native counterpart of Orozco, was also commissioned to do a mural series for the New School in 1930 and two years later a comparable series for the new Whitney Museum of American Art. Siqueiros executed some exterior murals that have disappeared, but his studio in New York attracted American artists, and Jackson Pollock at least has admitted the influence that Siqueiros had on his development. The Mexican muralists had produced a public, socially oriented, representational, popular art of international stature, which acted as a counterfoil to the attraction of European modernism, and those who were interested could follow their example. It is a matter of record that George Biddle in proposing the establishment of a governmental art project to President Roosevelt in 1932 specifically cited the Mexican experience as a model.

In any case, the confluence of events helped create a new artistic climate. Many artists, involved until then in what was small scale, private, and personal in expression, turned eagerly to the new and demanding discipline of a monumental, public, communicative art, though not always with the happiest of results. Without experience or training in mural painting, many fell back on the formal and ideological banalities of an outworn academic tradition. The walls of untold buildings were covered with genre scenes overblown to heroic proportions or charades of textbook history. Bureaucratic supervision and ideological and aesthetic restrictions did much to stultify creativity and resulted in a recognizable "Project Realism."

But for many the mural-project experience was crucial. They found an excitement in the investigation of media and techniques, a challenge in the problem of scale, a sense of importance in moving out of the isolation of the studio into the larger world of public activity. The mural renaissance may have died with the projects, but its influence was felt in the art of the next decades. Many murals can be seen in Washington in the government buildings for which they were commissioned.

If the growth of representational art was a response to the social imperatives of the depression, it was still not monolithic, either ideologically or aesthetically. Beside Project Realism, there were three more or less distinct and sometimes antagonistic representational camps: Urban Realism, Social Realism, and Regionalism. Urban Realism was essentially a continuation rather than a revival of the earlier Ashcan tradition. Most artists who worked in this manner—Kenneth Hayes Miller, Reginald Marsh, the Soyer brothers, and Isabel Bishop—lived or had studios in the vicinity of Union Square and painted the colorful and crowded life of the lower-class commercial area adjoining the bohemia of Greenwich Village. The interest of these artists was in the life of the city and its streets, in the lower classes, in the everyday activities of the common people, all seen with unpretentious realism in the Ashcan manner as life rather than art.

Social Realism had much in common with Urban Realism, except that the social comment was conscious and pointed and the formal expression often moved beyond

the confines of naturalism into a wider range, including Symbolism, Expressionism, and even Surrealism. For political as well as artistic reasons the Social Realists were the most directly influenced by the Mexican school of social artists. Although Social Realism did not dominate the art of the thirties, it was for a time at least the eye of a storm of controversy. It polarized artistic attitudes by postulating the premises of social relevance and communication as requisites for art and calling on all artists to commit themselves to the class struggle. Of course many artists did not accept either the political convictions or the philosophical arguments of the Social Realists, and many who did refused to equate art with propaganda. The Social Realists attacked the Regionalists for what they considered reactionary social attitudes, wrote off many artists for their political obtuseness or lack of commitment at a time of world crisis, and denounced abstraction and the avant-garde in general as social and cultural obfuscation. The polemics, however, were not one sided. The Regionalists reviled the Social Realists and modernists as equally un-American, effete, and subversive of native traditions. And the modernists dismissed representationalism in art as irrelevant and, more specifically, Regionalism as illustration and Social Realism as propaganda. The heat of the arguments was symptomatic of the social and political climate in the face of the rising threat of war and fascism and of communism as an economic-political alternative. But it was also the crucible in which ideological and aesthetic doctrines were being tested for the future.

For a time historical circumstances appeared to be vindicating the political and, by inference, artistic position of left-wing artists, and Social Realism began to attract to its ranks artists who previously had not been given to social comment—Max Weber, Peter Blume, and Philip Guston. The work of many of the Urban Realists also became more pointed. Among the major artists identified with Social Realism were Ben Shahn, Philip Evergood, Jack Levine, Jacob Lawrence, William Gropper, Robert Gwathmey, and Joseph Hirsch. There were, of course, a great many others, and as the movement spread westward it weaned some of the younger artists from Regionalism. Social Realism as a force did not last beyond World War II, though individual artists remained loyal to its precepts in the face of an increasingly hostile artistic ambience and the atmosphere of the Cold War.

Somewhere between Realism and Surrealism was an ill-defined and rather minor movement called Magic Realism that emerged toward the end of the decade and had much in common with German Neue Sachlichkeit and French Neoromanticism. It was unmistakably American in subject matter, native, and popular, prefiguring Pop Art in its fascination with iconic trivia. A compulsive concern with tromp l'oeil distinguishes it from European parallels though it shared with them a pervasive nostalgia. Magic Realism was really a phenomenon rather than a movement. It was an eccentric realism that found the unexpected in the expected, fantasy in the commonplace, the undecipherable in the apparent. It caused changes in subject painting by inverting accepted notions of significance and offered representational painters, dissatisfied with the limitations of Regionalism, Urban Realism, or Social Realism and unwilling to make the leap to Surrealism, the possibility of philosophical or psychological meaning beyond the explicit. Significant among the Magic Realists were Peter Blume, O. Louis Guglielmi, and Andrew Wyeth.

Regionalism reached its climax in the early thirties, when it emerged as a characteristically "American" style, both nationalistic and nostalgic in intention. Thomas Hart Benton's fame as a muralist, the popular appeal of Grant Wood and John Steuart Curry, and the public championing of the cause by the critic Thomas Craven gave them unusual recognition and acceptance, as compared with the Social Realists tainted with alien politics and the modernists with alien aesthetics. They programmatically

turned their backs on the decadence of the cities and the modern world and returned to the rural heartland of the nation in their search for harmony and moral virtue. But though some of the younger Regionalists like Joe Jones and Alexandre Hogue found rural life transformed by technology and racked by the depression, Benton, Curry, and Wood abandoned earlier critical and satirical intentions for an idealized image of a mythical past of peace and plenty. As the decade advanced they seemed more reactionary and less important. They remained popular, however, and spawned a host of imitators.

The art world in the United States expanded phenomenally in spite of the economic crisis. The number of galleries exhibiting modern and American art increased, museums assumed more liberal policies toward the exhibition and purchase of contemporary art, and the Works Progress Administration (WPA), as part of the federal relief program, established art centers throughout the country. In the course of the thirties, the artistic power structure began to tip in the direction of modernism: the Museum of Modern Art assumed the role of national tastemaker, and the status of avant-garde art was further strengthened by the addition of the Gallery of Living Art (the Albert E. Gallatin collection) at New York University, the Museum of Non-Objective Painting (the Guggenheim collection), and a growing number of important commercial galleries exhibiting European modern art. The increased impact of modernism had its effect on the character of the Whitney Museum annuals, even on so conservative an institution as the Metropolitan Museum of Art, and was eventually felt throughout the country. Never before had European contemporary art been shown with such consistency, coherence, and immediacy. As for American art, prestige in the art market, museums, and exhibitions still remained with the older established artists, especially the first generation of modernists who had managed to convert the influences of Fauvism and Cubism into something recognizably American, if more conservative, and enjoyed a growing esteem as native modern masters. It was their eminence that obscured for a time the rise of a new generation of avant-garde artists.

The younger American modernists found the older ones rather pale in comparison with the richness and variety of experimentation abroad and instead of following already charted native lines began to pick up the threads of new European modes. Only Stuart Davis, with his freewheeling adaptation of Cubism, seemed able to bridge the gap between the old and the new.

Beginning with the arrival in the United States of George Grosz and Hans Hofmann in the early thirties, the migration of major European artists mounted steadily, especially after Hitler came to power in Germany and the threat of war increased. Their presence in the United States increased the influence of European art and at the same time gave Americans an unexpected independence from the fabled European mentors, who in the flesh and outside their native habitat seemed less formidable. The dissolution of the Bauhaus brought to America Walter Gropius, Marcel Breuer, László Moholy-Nagy, Gyorgy Kepes, Josef Albers, Lyonel Feininger. Through the thirties individual artists arrived as visitors or refugees—Fernand Léger, Salvador Dali, Joan Miró, Matta, Marc Chagall, Piet Mondrian, Amédée Ozenfant, Jean Hélion, Eugène Berman, Pavel Tchelitchew. With the outbreak of war the Surrealists came en masse—André Breton, Max Ernst, André Masson, Yves Tanguy, Kurt Seligmann. Many Europeans became teachers at academic institutions and art schools, and Hofmann and Albers trained a generation of painters, most of whom reached maturity after the war.

A small group of young artists were working their way through the post-Cubist abstraction of Purism, Constructivism, and Neoplasticism. They found some en-

couragement in the 1935 exhibition at the Whitney Museum *Abstract Painting in America*, though it was largely confined to the older generation of modernists, and the 1936 exhibition at the Museum of Modern Art *Cubism and Abstract Art*, to which they took exception because Americans were ignored. With the return from Europe of expatriates like Alexander Calder, Carl Holty, and John Ferren, who had belonged to the Cercle et Carré and Abstraction-Création groups in Paris, and the addition of the émigrés Albers and Fritz Glarner, the geometric or hard-edge abstractionists attained a more noticeable presence. The Abstract American Artists, founded in 1936, included along with some of the above, Burgoyne Diller, Harry Holtzman, and Ilya Bolotowsky, the first of the Mondrian disciples; I. Rice Pereira, Balcomb Greene, and Ad Reinhardt; as well as the sculptors Ibram Lassaw and David Smith. This group spearheaded the attack on realism in American art and began to pressure museums to recognize American avant-garde artists.

Classical or veristic Surrealism had some limited influence among American painters, including Federico Castellón, Kay Sage, and Dorothy Tanner. Others, such as Morris Graves, Stephen Green, or Edwin Dickinson, responded to it very personally and idiosyncratically. The alternatives presented by Surrealism, however, triggered a chain reaction that proved revolutionary. It had an obvious though superficial effect on Magic Realism and a more profound one on such socially oriented artists as Walter Quirt and David Smith, who attempted to adapt Surrealist assumptions to their own intentions. But its major impact was to offer the younger abstractionists an avenue of escape from the tight intellectual prescriptions of "purism." The abstract Surrealists—Miró, Masson, Arp, Matta, and to a certain extent Ernst—offered a kind of liberation by extending the range of abstraction to encompass psychic automatism; biomorphic and amorphic form; symbolism, often sexual, seen as an expression of a universal subconscious or, in Jungian terms, the collective unconscious; the dialectic of the creative process; and the relevance of accident. In a sense it was a return to the radical early work of Kandinsky, the original "abstract expressionist." Like their socially oriented colleagues, the younger abstractionists, raised under the WPA and indoctrinated by the ideological battles of the time, could no longer see art as the making of objects or commodities but as the deepest kind of personal, philosophic, or social commitment.

The postwar period saw a remarkable flowering of painting in the United States. A large community of avant-garde artists, reacting to what they saw as the decline of the School of Paris, made significant innovations in the nature of painting that led to the dominance of American art in the western world. This community was known variously as the New York School, Action Painters, or Abstract Expressionists. All three terms only loosely describe the group: most lived, for a while at least, in New York; many applied paint with an energetic fluidity; and most, even when they included figurative elements, relied on formal, sensuous elements to carry an instinctual, intuitive message.

The combination of a depressed economy and a brutal war, with its cold-war aftermath had served to embitter and alienate artists, as it had in Europe following World War I. The ultimate failure of social programs to resolve worldwide problems of poverty, oppression, and strife promoted a wave of almost psychoanalytic self-consciousness that stimulated the Abstract Expressionist search for universal meaning in the intuitive actions of the individual.

For the Abstract Expressionists, the Surrealist influx during the 1940s was decisive. During the forties, after assiduous study of Picasso, Miró, and Matta, Arshile Gorky developed a vocabulary of images abstracted from nature into signs of sexuality and

aggression, joy and despair. His union of lush painterliness and ambiguous Surrealistic images characterized much Abstract Expressionist painting during the decade. William Baziotes propagated highly allusive, biomorphic forms bathed in an atmospheric coloration, and Theordore Stamos searched through earthy vestiges for the essence of nature. Humanoid figures by Picasso, Miró, Ernst, and Masson and North American Indian totems found frequent echoes during the early forties in the paintings of Clyfford Still, Mark Rothko, Adolph Gottlieb, and Richard Pousette-Dart.

The most portentous adaptation of Surrealism was made by Jackson Pollock. During the thirties and early forties, he learned much from Picasso (whose *Guernica* impressed many of these young artists), Orozco, Siqueiros, and Masson among others. During the period Pollock wedded suggestions of totemic figures with his own raw, boisterious energy to create symbols of sexual tension or mythic, chthonian power. Like Hans Hofmann, he began pouring streams of paint for surface inflection around 1943; in paintings from 1947 on, this method was given its full expressive range. In these poured paintings, webs of pigment—dominated by black, white, and aluminum—were dripped onto unprimed canvas; the incidence of accidental and controlled painting "events" was carried evenly throughout the picture. Mark Tobey, in his "white-writing" paintings, had already developed such an overall, nonhierarchical composition but on a much more intimate, refined scale. Pollock had left Surrealist imagery for Action Painting, identifying with American Indian sand painters who created magic through ritual. He transformed gestural violence and expressionist catharsis into an open-ended rhythmic process, now seen as the precursor of Color-Field Painting.

Though Pollock was recognized as a generative force by many of his peers, Willem de Kooning probably exercised more influence over the avant-garde of the late forties and fifties. During the thirties, de Kooning shared with Gorky an interest in Picasso and Miró. Unlike Pollock, he remained loyal to the brush, postulating painting as a dramatic existentialist act of daring and commitment, full of unresolved contradictions, driven by angst, generating an art that is necessarily restless, complex, infinitely dense, ambiguous, and above all fluid. He combined intensity and finesse, muscular brushwork and refined calligraphy, tortured forms and delicate, even pretty, color.

The convoluted energy and coloristic grace of de Kooning's charged brushwork found scores of emulators; artists like Robert Motherwell, Franz Kline, Philip Guston, James Brooks, and Jack Tworkov have made distinctive, personal statements from such an approach, in which line, color, and form become directly associated with human gesture.

Like de Kooning, Motherwell has employed little Surrealist vocabulary but has looked to automatism as an aid to formal invention. The characteristic black lattice structure of Franz Kline's paintings of the early fifties have been seen as abstract equivalents of urban energy. His later works became broader and bolder and were the most readily identifiable as direct expressions of bodily and gestural action.

The works of Still, Rothko, and Newman and the later works of Gottlieb present an elaboration of Pollock's overall composition toward a unified color field. By the end of the forties, the figuration in their earlier paintings had been dissolved, coalesced, or attenuated beyond recognition. The burden of meaning was then placed entirely on the chromatic shift from one large color plane to the next, modulated by a translucent or flickering edge, textured or thin pigment, an intermittent stripe or burst. Acting quite individually, these artists were really opposed to Action Painting in their search for transcendental truths rather than existential values, expressing themselves

in fields of intense color and optical ambiguity. Newman moved from myth to abstraction and ultimately to a single color field, almost subliminal in nuance. Gottlieb evolved more obviously from a personal pictographic language to the symbolic polar opposition of his bursts. Rothko grew out of a turgid Surrealist automatism of symbolically charged forms to the serenity of luminous equilibrium of color and shape hinting at infinity. Still, from similar sources, found the universal and the sublime in the infinite variation of complex screens of color.

The first generation of Abstract Expressionist painters also includes Hans Hofmann—the most influential teacher of the period who attempted to combine Cubist structure with Expressionist color and brushwork: Bradley Walker Tomlin, John Ferren, George McNeil, Esteban Vicente, Lee Krasner, and Conrad Marca-Relli. Scores of younger artists, many of them students of Hofmann, adopted a gestural style: Milton Resnick, Joan Mitchell, Robert Goodnough, Michael Goldberg, and Alfred Leslie. Clyfford Still's teaching sojourn in San Francisco, 1946–50, had a considerable impact on western painters.

Though gestural abstraction dominated the 1950s, realism did not disappear. The abstractionists' sense of alienation was shared by many vanguard artists with realist aspirations, who attempted to shape their more patent humanism with the empathetic power of Action Painting brushwork. This style of figuration—one or two loosely worked figures in an ill-defined atmosphere—became as widespread as its parent and included Larry Rivers, Lester Johnson, Jan Muller, Grace Hartigan, Nicholas Marsicano in New York; Richard Diebenkorn, Nathan Oliveira, Rico Lebrun, David Park, Elmer Bischoff in California; and Leon Golub in Chicago. Diebenkorn created a series of Matissean abstract landscapes as well as more figurative work, and during the fifties Rivers used both a detailed figurative style and a gestural treatment of stereotyped, kitsch subject matter; this latter style, in its imagery and flip irony, gave strong impetus to the evolution of Pop Art.

Several artists continued to work untouched by Abstract Expressionism: Andrew Wyeth, who maintained an old-fashioned loyalty to American realism; the mysterious, evocative Edwin Dickinson; and Fairfield Porter, in the tradition of Hopper. The most provocative figurative painters of the fifties were Robert Rauschenberg and Jasper Johns. In his painted collages of urban detritus, Rauschenberg explored the aesthetic possibilities of the ordinary, attempting to fill the gap between art and life implicit in Abstract Expressionism. Both artists borrowed, and sometimes mocked, Abstract Expressionist painterliness; but the blatant "uselessness" of abstract painting was matched by the similar uselessness of Rauschenberg's refuse and Johns's clichés—flags, targets, and numerals. Despite their taste for Abstract Expressionist cuisine, painting became for them a more openly intellectual activity. Their art questioned the availability of visual meaning. The presence of identifiable words and images seems to intimate a larger, coherent meaning, but the viewer's desire for such meaning is frustrated by contradiction, misdirection, or deliberate abstruseness. The startling juxtapositions and dislocations of their imagery assumes a Duchampian irony and wit and insinuates a sense of allegory, which became fundamental to much art of the sixties.

By the end of the fifties, the impulse to integrate art and life had borne several offspring: junk sculpture, theatrical Happenings, Pop Art.

Pop Art's most brazen apostacy was to deny the unchallenged canons of modern western painting from Cézanne to Abstract Expressionism and propose an alternate tradition that was both popular and, most characteristically, American. Pop Art was

an appreciation of popular, mass-produced culture, reflecting the visual impact of various commercial media: news, movies, television (commercials in particular). Taking cues from Rivers, Johns, and the sinister apparitions of Richard Lindner, the Pop painters appropriated and subverted both the commercial and familiar imagery of comic strips and ads and the inherently bold, flat simplifications of commercial methods: photoreproduction, serigraphy, Benday halftone dots. Banal imagery rated banal techniques.

Pop Art went public in the early 1960s with exhibitions by Roy Lichtenstein, Andy Warhol, James Rosenquist, Tom Wesselmann, Robert Indiana, and Claes Oldenburg. Lichtenstein's caricatures of preexisting images first concentrated on comic strips. Their subsequent extension to art-world subjects questioned the seriousness of any and all subject matter—abstract or figurative—and focused a detached attention on the formal values of his art. At the outset at least, Pop Art also questioned, in the equivocal manner of the sixties, the myths, shibboleths, and premises of American (or was it bourgeois?) certitude. It was perhaps a failure of nerve that led to the abandonment of its original political, social, and cultural intentions. The steadfast triteness of Warhol's iconic subjects and their intrinsic replicability cast suspicion on the Abstract Expressionist emphasis on individual genius and stylistic uniqueness. The works of Wesselmann and Indiana share many of the formal concerns of contemporary abstract art; but Indiana has added a sometimes puzzling overlay of words and images, and Wesselmann an erotic parody. Rosenquist's collagelike confluence of disparate, figurative fragments has furnished a striking, often enigmatic plenitude. Jim Dine, who bridged Happenings and Pop Art, has forced the painted surface/real object combination of Rauschenberg and Johns into aggressive/sentimental dichotomies more clearcut than the poetic hermeticism of the others. The impact of Pop Art was explosive, and it immediately stamped its imprint on a generation of American painters, too numerous to mention.

This burst of interest in figurative painting was accompanied by a less ostentatious renewal of portrait and figure painting. Alex Katz and Howard Kanovitz resorted to the flat, reductive means of Pop Art to revitalize portraiture. Philip Pearlstein and Alfred Leslie, both second-generation Abstract Expressionists, shifted their attention to large-scale, "Baroque," carefully rendered figure studies. The result was a new monumental, "heroic" realism, consciously avoiding social contexts, as their obsessive involvement with the nude would indicate. This detached attitude toward the figure, along with close rendering abetted by strong design, also characterizes the work of many younger figure painters and is equally apparent in Neorealist landscape and still-life painting.

The new realism of the sixties was accompanied by new forms of abstraction. These modes were marked by an open, restrained hedonism on the one hand and an intellectualism on the other; both abjured the profoundly held feelings sought in the forties and fifties, and gestural, heavily textured brushwork was considered a mannerism of the previous decade. The sensuous mode of this "postpainterly" abstraction grew out of the work of Pollock and the chromatic abstractions of Still, Rothko, and Newman as developed in the work of the younger avant-garde, particularly Helen Frankenthaler, Friedel Dzubas, and Sam Francis. The clean, geometric shapes of Ad Reinhardt and the grid paintings of Alfred Jensen also presaged a change in the sixties—a return to less spontaneous, more sharply defined picture-making. Frankenthaler combined the airiness of Pollock's poured paintings with Rothko's large-scale, saturated veils of color. Her incorporation and transformation of Abstract Expressionism informed the paintings of Paul Feeley and the Washington artists Morris Louis and Kenneth Noland, who turned pouring and staining techniques to the production of vibrantly beautiful,

though radically simplified imagery. Their optically vivid, symmetrical veils, fans, and rivulets of high-key color became, around 1960, less graduated in tone and more geometrical: columns, circles, quadrifoils, vees, and stripes. This combination of brilliant color and large, reductive geometry affected an entire group of Washington painters.

During the sixties, Jules Olitski, Ray Parker, and Dan Christensen typified the lyrical, spontaneous aspect of field painting in which painted elements became inflections of a continuous space rather than discrete objects. In the seventies, Walter Darby Bannard and Stanley Boxer have extended the range of this kind of luscious chromatic abstraction.

A hard-edge, geometric shape-making has occupied most abstraction of the past two decades. During the fifties, Ellsworth Kelly, Leon Polk Smith, and Alexander Liberman, running contrary to the prevailing aesthetic, followed Reinhardt and Newman in abutting one large, sharply defined plane against another.

Abstract Expressionism had raised numerous questions about creative and perceptual processes. This probing of art's limits became a preoccupation of the sixties and seventies. Paradoxical illusions and after-images generated by certain basic patterns and color combinations had occasionally emerged in Abstract Expressionist painting and more consciously in the work of Albers. His series Homage to the Square experimented with the affective qualities of three or four apparently superimposed squares of color. The generation of visual paradox became the raison d'être for Op Art, a short-lived development in Hard-Edge Painting that never took root in the United States, except for the work of Richard Anuszkiewicz, a student of Albers, who has examined the effects of concentric squares or rectangles of complementary colors. Though visual illusion appears in the paintings of Larry Poons, Al Held, Ron Davis, and other Hard-Edge artists, paradoxical optical illusion had remained coincidental to their work.

The conceptual planning of Albers and Reinhardt was further explored by Frank Stella during the late fifties and sixties. In a series of monochromatic, shaped paintings, Stella carefully and severely limited his choices prior to making the works (in fact, many of his paintings have been designed by him but executed by his assistants). During the past two decades, Stella's works have grown visually more complex—emboldened by flashy colors and unexpected shapes; but they are still formulated with the sang froid of an engineer.

The desire for a system, within which to follow certain options, has found expression in the works of Agnes Martin, Robert Mangold, Robert Ryman, Bruce Boice, Jennifer Bartlett and the pattern paintings of Miriam Schapiro, Joyce Kozloff, and Kim MacConnell; it has been pursued vigorously by several artists who are painters only on occasion: Sol Lewitt, Dorothea Rockburne, and Mel Bochner.

The desire to increase the capacity of painting to engender meaning has led artists to investigate surface, support, color, process, and primitive marking and image-making. During the seventies, the presumptions surrounding these aspects of painting have been investigated by Brice Marden, Alan Shields, Ralph Humphrey, Ryman, Joan Snyder, Bartlett, Ron Gorchov, and Gary Stephen.

Figurative painting began the 1970s with a photographic obsession. As Pop Art had drawn inspiration from commercial media, the Photorealist art of the early seventies drew from photography. In the late sixties, Chuck Close had, with almost fanatical

attention to detail, transformed closeup photographs of himself and friends into enormous paintings. Close's technical proficiency and absorption with the photograph as both source and effect proved a bellwether for subsequent painters. Richard Estes, Wayne Thiebaud, Malcolm Morley, Robert Cottingham, John Salt, Robert Bechtle, Don Eddy, Ralph Goings, Ben Schonzeit, and Audrey Flack have employed similar techniques in their treatment of Pop-related subjects: transportation, entertainment, consumer goods, the urban environment encrusted with signs.

During the seventies, American painting faced a critical and often harsh reappraisal by a new generation of artists. It may be too pat to tie their disillusionment to the Vietnam war, proliferating world crises, and the shifting status of the United States within the global community, but there is no doubt that many basic assumptions in art are being questioned. Perhaps, the sudden and phenomenal recognition and financial success of the new American masters, even in their own lifetime, has evoked a serious reassessment of the value of art. One response has been to turn away from the concept of art as a commodity and the art market as a bourse. Others have been to question art as personal expression, art for museums, art for collectors, art as show business, art as investment, or art for art's sake. One answer has been to make art that cannot be sold, collected, or displaced, art that has a social and/or environmental function. This is in a sense a search for new ways or for reviving old ways of making art meaningful, a turning away from the traditional, discrete forms of art to the making of art objects in forms that can have an impact on the human condition. Thus, Conceptual Art cuts across the established and traditional boundaries, avoids the production of marketable objects, even attempts the ultimate in the negation of art as a specific category. Ironically, Conceptual Art, in spite of itself, is being converted by an art market that manages to convert everything into negotiable currency. All roads seem to lead away from painting, although one may doubt that it has been rendered permanently obsolescent. There may be a road back or to a new region of the imagination.

THE PAINTINGS

JOHN SINGLETON COPLEY
1738–1815

The Copley Family

1776–77
oil on canvas
72½ × 90⅜ in (188.4 × 229.7 cm)
National Gallery of Art
Andrew W. Mellon Fund 1961

Copley painted this portrait of his family in 1776–77, soon after they joined him in England. Fresh from study in Europe, Copley shows renewed confidence by attempting his first large figure composition. He chose the style of the fashionable English conversation piece, a lively group portrait with overtones of genre painting. Copley has depicted himself in the upper left of the composition, turning away from some sketches to greet the viewer. His father-in-law, Richard Clarke, who left the colonies because of Loyalist sympathies, is seated next to him and is holding Copley's youngest child, Suzanna, who was less than a year old when the portrait was painted. The oldest child, Elizabeth, called Betsy, stands in the center. Copley's wife is turned toward her four-year-old son, John Singleton Copely, Jr., who grew up to be lord chancellor of London. Mary, a year younger, is on the couch, snuggling up to her mother. Copley's joy in being reunited with his family is evident. The painting also provided him the opportunity to prove himself adept at handling the grand manner of British portraiture. The gentle undulating curves, linking the two pyramidal parts of the composition, and the transition from lavish interior to romantic landscape would have appealed to prospective English patrons. Vestiges of his early, realistic American style remain, however, as in the wrinkled features of the father-in-law and the carefully drawn doll in the corner. Copley exhibited this portrait at the Royal Academy in 1777; it remained in the family for many years, hung over the fireplace in their home.

BORN 1738 in Boston; father died, 1748; mother remarried. Trained by stepfather, English portrait painter and engraver Peter Pelham. Inherited Pelham's studio, 1751. Influenced by Joseph Blackburn, who was in Boston, 1755–62. Exhibited at Society of Artists, 1765, London. Became successful portraitist, Boston. Traveled to France and Italy to study old-master paintings, 1774–75. Settled in England. Elected member, Royal Academy, 1783. Never returned to United States. Died 1815 in London.

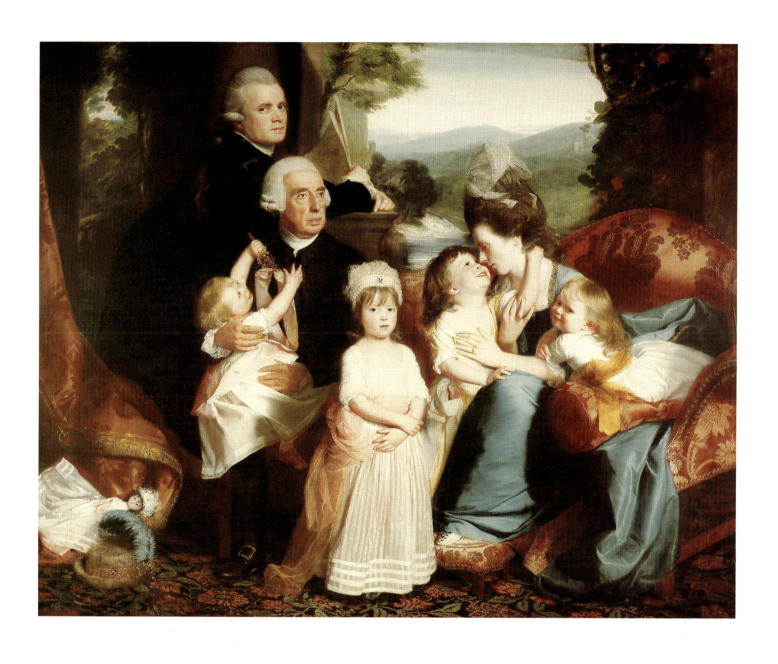

BENJAMIN WEST
1738–1820

Cupid and Psyche

1808
oil on canvas
54½ × 56¼ in (137.8 × 142.5 cm)
The Corcoran Gallery of Art
Museum purchase, 1910

The first native-born artist to travel abroad, Benjamin West left America to escape the routine of portrait painting and to study art in Italy. In London by 1763, West catapulted himself into a position of prominence with his crisp renditions of classical history and literature, which not only satisfied the late-eighteenth-century craze for the antique (fostered in part by the recent discoveries at Herculaneum and Pompeii) but also the belief in a hierarchy of pictorial values, which placed utmost importance on history and religious painting. As a highly paid history painter to George III, West experimented in his sketches of cataclysmic biblical episodes with a painterly, emotional style based on an academic aesthetic codification of the sublime. During the first decade of the nineteenth century, West began infusing remnants of his early Neoclassicism with subjective content and expressive technique. *Cupid and Psyche*, painted when the artist was seventy, displays this hybrid Classical-Romanticism. The mythological subject matter and sculpturesque treatment of nude forms, centrally placed and uniformly lit, are distinctly Neoclassical, while the ambiguous, cloud-filled background, lush Venetian coloring, and androgynous character of the protagonists reflect the burgeoning of Romanticism. Psyche, a mortal, has just returned from the last of her divinely imposed tasks before accepting Cupid, a god, as her lover; a vial of water from the Styx, the turbulent river of the Dead, lies at her feet.

BORN 1738 near Springfield, Pennsylvania. Self-taught artist. Worked as portraitist, sign painter, by 1756; eager to paint classical scenes of history, scripture. Said to have been first American to study in Italy, where he maintained studio, 1760–63. Moved to London, 1763. Gained fame for history paintings; became close friend of Sir Joshua Reynolds. George III was patron, 1772–c. 1804. Founding member, teacher, second president, Royal Academy, London. Refused knighthood because of Quaker principles. A role model and instructor in London for three generations of American artists who traveled to England to study with him. Never returned to United States. Died 1820 in London.

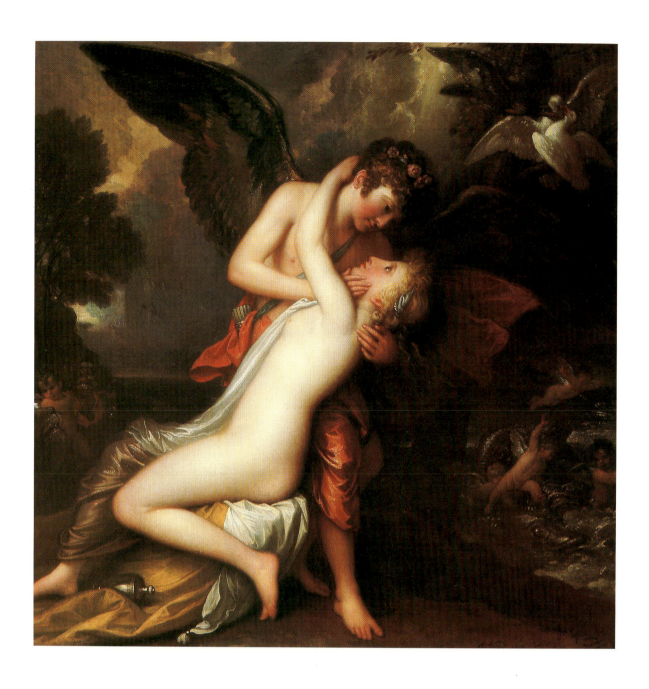

JOHN TRUMBULL
1756–1843

The Sortie Made by the Garrison of Gibraltar

1787
oil on canvas
15⅛ × 22⅛ in (38.4 × 56.2 cm)
The Corcoran Gallery of Art
Museum purchase, 1966

Trumbull's life ambition was to be the painter of the American Revolution. As a son of the Revolutionary governor of Connecticut, he had entrée to the highest levels of American politics and society, he knew Adams and Jefferson, was an aide to Washington and Gates, studied with Benjamin West, and was befriended by the great French painter Jacques-Louis David. Yet he never achieved the apogée of his ambition: to record what he considered the greatest historic event of his time. Perhaps, it was because of his personal character, the limits of his talent, or the immaturity of American culture that the heroic project was never completed. In London, in 1784, Trumbull was encouraged by both West and John Singleton Copley to pursue the project; he was even assisted by Adams and Jefferson in the selection of subjects. Realizing that a subscription to a series of engravings on American history would not be very popular at that time, he decided to paint a subject from British history. In *The Sortie* he selected the climax of a successful surprise attack by the British garrison at Gibraltar on the Spanish lines on November 26–27, 1781. The scene, interestingly enough, depicts the death of Don José Barboza, the commander of the enemy vanguard troops, rather than the British victory. Trumbull made several sketches and painted three versions of the event, this oil sketch being the first. The painting is based on West's Romantic historical style, and the composition recalls his famous *Death of Wolfe* (1770). The oil sketch reveals Trumbull's individuality, a light and painterly touch, and a delicate vivacity that are usually lost in his larger, more labored finished works.

BORN 1756 in Lebanon, Connecticut. Graduated from Harvard College, Cambridge, Massachusetts, 1773. Served briefly as aide to General Washington. Resigned commission; traveled to England; studied with Benjamin West, 1780. Imprisoned as suspected spy for eight months. Released and deported back to United States. Lived in London, 1784–89, studied with West; worked on studies for series of paintings on American Revolution. Spent several years in United States as secretary to John Jay. Returned with Jay to London, 1794; commissioner of the Jay Treaty, London, 1794–1804. Continued work on projected paintings of the Revolution. Lived in New York, 1804–8; London, 1808–16. Director, American Academy of the Fine Arts, 1817. Commissioned to paint four large works for Capitol Rotunda, Washington, D.C., 1817. Gave collection of paintings to Yale University, New Haven, Connecticut, in exchange for pension. Published autobiography, 1841. Died 1843 in New York.

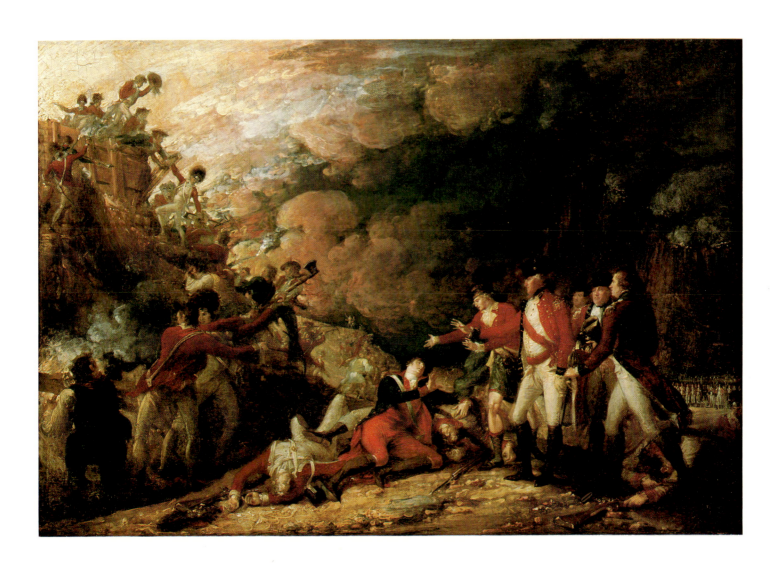

GILBERT STUART
1755–1828

Mrs. Richard Yates

1793/94
oil on canvas
30¼ × 25 in (77.0 × 63.0 cm)
National Gallery of Art
Andrew W. Mellon Collection 1940

This portrait of Mrs. Richard Yates is one of Stuart's most accomplished works. It was painted in 1793/94 when the sitter was about fifty-eight years old. Her husband operated an importing firm in New York with his brother Lawrence. They were among Stuart's first patrons after he returned to America. Dressed in heavy silk and seated in an elegant scoop-backed chair, Mrs. Yates is clearly the wife of a successful merchant. This portrait, however, has been seen as expressing many of the qualities of the new republic. Though her dress is of fine material, Mrs. Yates is dressed simply and wears the popular mobcap, a symbol of democracy worn by women during the French Revolution. Stuart has shown her to be a shrewd and industrious individual, occupied in a simple activity, greeting the viewer as if interrupted in her sewing. Stuart's technique contributed to this feeling of immediacy. In the manner of the contemporary British portraitists Sir Henry Raeburn and Sir George Romney he applied paint directly onto the canvas in broad, rapid strokes. He created lifelike skin tones and suggested the facial structure by brilliant highlights. A final translucent glaze completed the process of making the subject seem vibrant and animated. The portrait of Mrs. Yates is one of his most successful achievements. Her alertness and severe, angular features are brought to life through Stuart's mastery of subdued color and restless line. The result is a fascinating character study of both the sitter and the time in which she lived.

BORN Gilbert Stewart 1755 in North Kingstown, Rhode Island; grew up in nearby Newport. Trained by itinerant Scottish painter Cosmo Alexander. Accompanied Alexander to Edinburgh, 1771. Moved to London, 1775. Studied with Benjamin West, 1777–82. Exhibited *The Skater* (portrait of William Grant), Royal Academy, London, 1782, establishing his reputation. Opened studio in London; became fashionable portraitist. Moved to Dublin, 1787. Returned to United States, 1793. Lived briefly in New York. Painted Washington portrait, 1795. Lived in Philadelphia, 1795–1803. Moved to Washington, D.C., 1803. Painted leading political figures of the new republic. Settled in Boston, 1805, where he died in 1828.

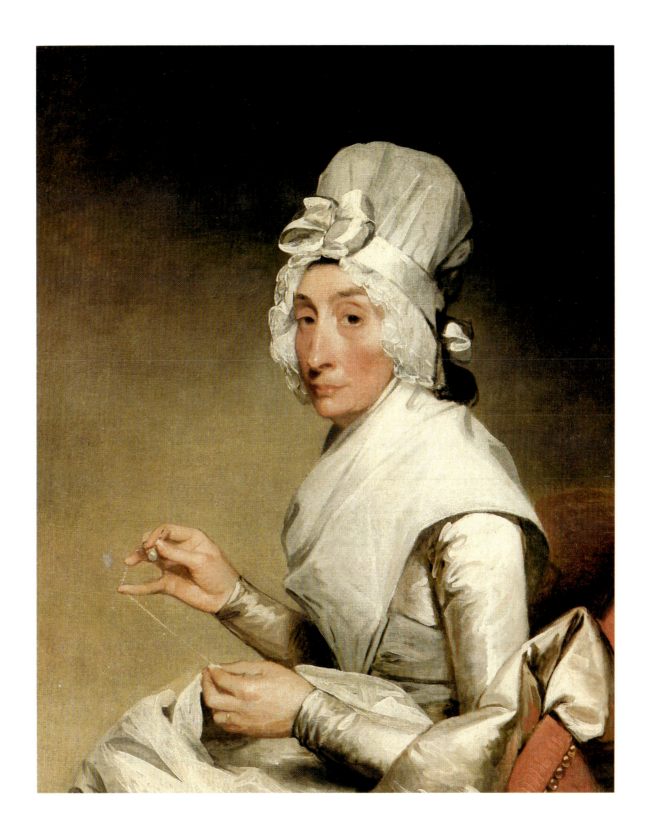

SAMUEL FINLEY BREESE MORSE
1791–1872

The Old House of Representatives

1822
oil on canvas
86½ × 130¾ in (219.7 × 337.3 cm)
The Corcoran Gallery of Art
Museum purchase, 1911

93¼

G

Upon his return to America from London in 1815, finances forced Samuel F.B. Morse to become a portraitist. As a result of his studies with Benjamin West and Washington Allston, he was a devout proponent of the Grand Manner and preferred to devote himself to history painting. *The Old House of Representatives* was his means of elevating group portraiture to a higher artistic realm while simultaneously creating history painting of national value. He chose to depict the enormous National Hall of the Capitol with all its furnishings illuminated at night while Congress was in session. More than eighty figures, all based on living personages, and painted from life, except for one, were realistically disposed throughout the room. Morse was not so much concerned with the faithfulness of the portraits, however, for he intended the architecture itself, not the people, to demonstrate the nobility of the democratic system of government. The painting was sent on tour with the hope that the public would pay to see it. The public, unfortunately, could not understand a painting without an obvious narrative and criticized the diminutive size and large number of figures. Because of its financial failure, Morse became even more discouraged with the artistic situation in the United States and turned to scientific pursuits, which resulted in his invention of the telegraph.

BORN 1791 in Charlestown, Massachusetts. Studied at Phillips Academy, Andover, Massachusetts; Yale University, New Haven, Connecticut. Painted miniatures. Traveled to London, with Washington Allston, 1811. Returned to United States, 1815. Worked as itinerant portrait painter, Massachusetts, New Hampshire, 1815; Charleston, South Carolina, 1818; Washington, D.C., 1821. Settled in New York; painted portrait of Lafayette for New York City Hall, 1825–26. Founding member, National Academy of Design, 1826; president, 1826–45, 1861–62. Traveled to Europe to paint commissioned landscape views and copies of old-master paintings, 1829–32. Returned to United States, 1839. Founding member, Metropolitan Museum of Art, New York, 1870. Died 1872 in New York.

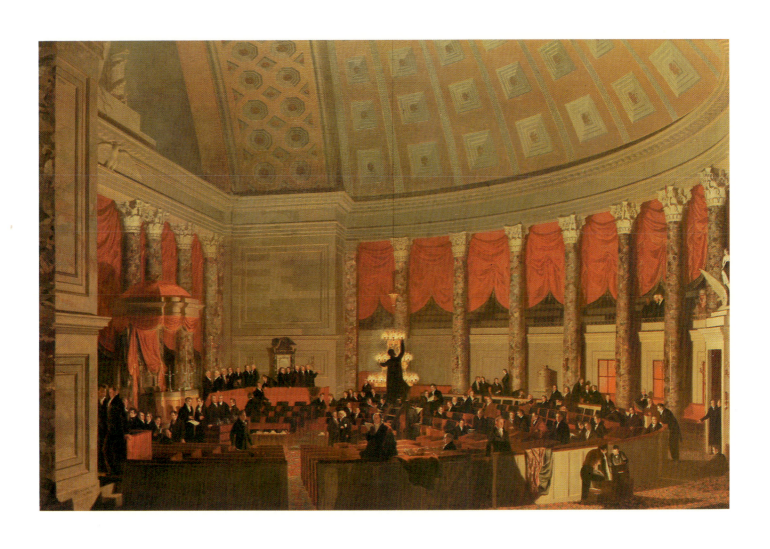

GEORGE CATLIN
1796–1872

Old Bear, A Medicine Man

1832
oil on canvas
29 × 24 in (73.7 × 60.9 cm)
National Museum of American Art
Smithsonian Institution
Gift of Mrs. Joseph Harrison, Jr.

Catlin had been captivated by the sight of a group of Indians in full regalia on an official visit to Philadelphia, and he wrote years later that he had then decided to dedicate his life to being the historian of the Indian. He began his travels in 1830 and spent almost eight years among the Indians. He was the first artist to penetrate the Far West and amassed close to six hundred paintings of incomparable documentary value, which he organized into his traveling "Indian Gallery." It toured the United States and Europe to great acclaim. After the exhibition closed in 1852, Catlin tried unsuccessfully to sell the collection of paintings, paraphernalia, and artifacts to the U.S. Government, but it was not until after his death that it was acquired by the Smithsonian Institution in 1879. Catlin was not a well-trained artist and was forced to work under difficult conditions, but, despite his shortcomings, he did have an eye for the dramatic, for composition, pattern, and linear movement. His sketches of Indian life, often not more than shorthand notations, are full of vivacity, and, though they call for further elaboration, the basic elements are present. He completed some paintings later by adding detail to the original sketch. Among his most effective works are the portraits, such as *Old Bear, A Medicine Man*. Catlin wrote in his notes that Old Bear spent the entire forenoon painting and decorating his person and arrived with his entourage to pose for the picture. Catlin has captured in the simplest terms the native pride and common humanity of the Indian underneath his exotic trappings.

An extensive collection of paintings by Catlin can be seen at the National Gallery of Art.

BORN 1796 in Wilkes-Barre, Pennsylvania. Classically educated. Practiced law; self-taught artist. Painted portraits, miniatures, Philadelphia, 1823; Washington, D.C., 1824–29. Exhibited at American Academy of the Fine Arts, New York, 1828. Painted portraits of Indians in upstate New York, 1829–30. Moved to Saint Louis, 1830. With explorer William Clark, who was commissioned by U.S. Government to negotiate treaties with Indians, traveled throughout the West, painting Indian portraits, villages, landscapes, 1830s. Exhibited Indian Gallery of Portraits and Artifacts, New York, 1837–39. Began publishing accounts of his western travels, 1841. Traveled to South America to study Indians, 1850s. Died 1872 in Jersey City, New Jersey.

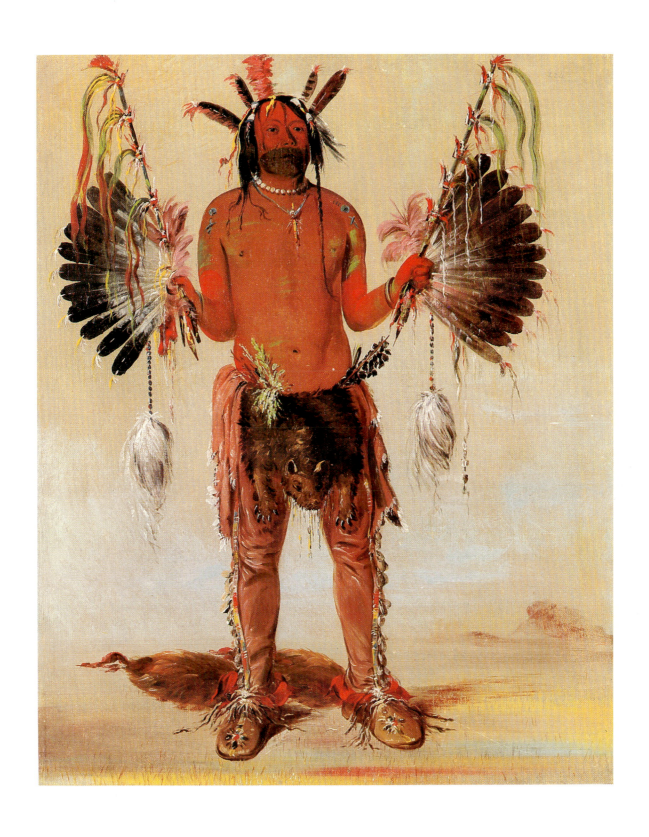

WILLIAM SIDNEY MOUNT
1807–1868

The Long Story

1837
oil on panel
17 × 22 in (43.2 × 55.9 cm)
The Corcoran Gallery of Art
Museum purchase, 1874

Although others had experimented with the form before him, William Sidney Mount is regarded, along with George Caleb Bingham, as the quintessential American genre painter of the early nineteenth century. By 1837 Mount had resettled permanently on Long Island where the manners and activities of the local rural populace absorbed his attention. Mount was strongly motivated by the contemporary desire for a readily identifiable American subject matter in art. Critics of the day were rapturous over the bucolic sentiment and anecdote of Mount's paintings but overlooked an important formal aspect of his creativity. Mount was an avid student of geometry, optics, and scientific theory. Making up for his lack of direct exposure to European art, he read extensively and based his finest genre pieces on his understanding of Venetian color and Renaissance composition and perspective. In its sparseness of setting and richness of incident, *The Long Story* encapsulates the salient qualities of Mount's aesthetic and social vision. Based on an encounter between a traveler, wrapped in a cloak, a yarn-spinning invalid/trickster, and a gullible looking storekeeper, it describes an anecdotal situation in a meticulous arrangement and style that reflects the artist's knowledge of Dutch and Flemish art. The incisive, humorous handling of gesture, pose, and dress, sharp lighting, and polished brushwork characterize each individual's type and class and invariably convey a good-natured, if ingenuous, optimism.

BORN 1807 in Setauket, Long Island, New York; moved with family to Stony Brook, New York, 1816. Apprenticed to brother, New York sign painter, 1824. Studied at National Academy of Design, 1826; elected academician, 1832; exhibited annually. Maintained studio in New York, 1829–36. Settled in Stony Brook, 1837. Published engravings of genre scenes. Invented hollow-back fiddle, portable studio, 1850s. Died 1868 in Setauket.

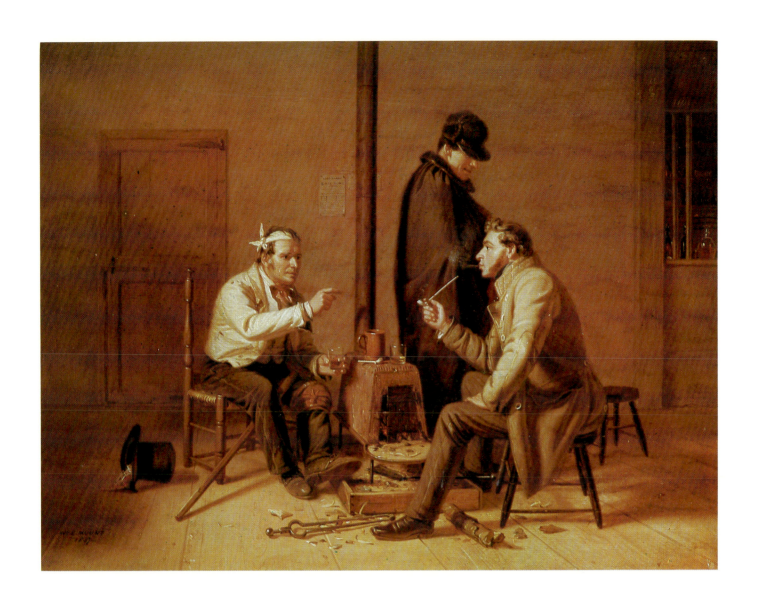

GEORGE CALEB BINGHAM
1811–1879

The Jolly Flatboatmen

1846
oil on canvas
38⅛ × 48½ in (96.9 × 123.2 cm)
The Pell Family Trust
Honorable Clairborne Pell, Trustee
On loan to the National Gallery of Art

In 1845, after working as an itinerant portraitist, George Caleb Bingham began painting genre scenes of life in the West. *The Jolly Flatboatmen* is the first of a series of paintings about the Missouri River boatmen, a popular subject in literature and ballads of the period. In this geometrically exact composition, reflecting his interest in Italian Renaissance art, several lounging figures listen to the ever-present fiddler and watch a man dancing. The dancer forms the apex and the two seated men the corners of a triangle, while the lines of the boat extend the triangle, so that the boat moves frontally out toward the viewer. In 1847 the American Art-Union bought the painting and distributed an engraving of it. It was through this print that Bingham's reputation as the western counterpart of William Sidney Mount was established throughout the country. In a later version, Bingham transformed the dancer into a spirited, satyrlike figure based on classical statuary and softened the original red tonality that had been criticized as too harsh. In still another version painted in 1857 while Bingham was in Düsseldorf, he brought the boatmen to shore so that he could combine the two worlds of the American West—the town and the river.

BORN 1811 near Charlottesville, Virginia; moved with family to Franklin, Missouri, 1819. Apprenticed to cabinetmaker, 1827. Worked as itinerant portraitist along Missouri River, 1833. Studied at Pennsylvania Academy of the Fine Arts, Philadelphia, 1838. First exhibited at National Academy of Design, New York, 1840. Painted portraits of politicians, Washington, D.C., 1840–43. Began involvement with Missouri politics, 1840s. Served in Missouri State Legislature, 1848. Made frequent trips to Philadelphia, New York, from 1850s, occasional trips to Washington, D.C. Studied in Düsseldorf, 1856–59. Served as Missouri State treasurer, 1862–65; adjutant-general, 1875–77. Taught at University of Missouri School of Art, Columbia, 1877. Died 1879, in Kansas City, Missouri.

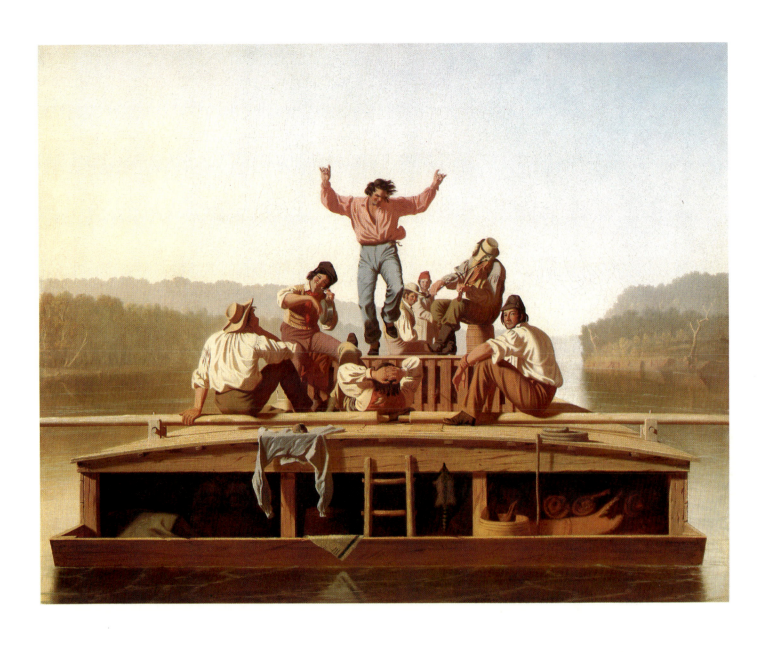

JOHN QUIDOR
1801–1881

The Return of Rip Van Winkle

1849
oil on canvas
39¾ × 49¾ in (101.0 × 126.5 cm)
National Gallery of Art
Andrew W. Mellon Collection 1942

John Quidor remains an enigmatic figure. The score of paintings he left were painted over a lifetime in which he had little recognition, eking out a living as a painter of signs, banners, fire buckets, and panels for coaches and fire engines. But he was not just an artisan. He had been apprenticed to the portraitist John Wesley Jarvis, had exhibited at the National Academy of Design, listed himself as a portrait painter in the New York directory, and had as a pupil Charles Loring Elliot, also a portrait painter. Aside from occasional religious pictures, however, Quidor's known works were illustrations based mainly on the stories of James Fenimore Cooper and Washington Irving, although they were never published as such. He seems to have preferred to select his themes from literary sources. Quidor transformed these picturesque folk tales into burlesques of "Gothik" terror, walking the narrow line between prank and nightmare, amusement and fear. In *The Return of Rip Van Winkle* Quidor selects from Irving's *Sketch Book* the moment when Rip, awakening after a twenty-year sleep, faces reality in confusion bordering on terror. Though unappreciated in his own day, Quidor was one of the most sophisticated painters of the period, carrying on the academic tradition of solid underpainting and subtle overglazing to create three-dimensional form in light and atmosphere, to which he added his own embellishment of lively brushwork and brilliant color. The earthy genre types and the transparent luminosity of his paint would indicate some firsthand contact with Dutch and Flemish genre painting.

BORN 1801 in Tappan, New York; moved with family to New York, 1811. Apprenticed to John Wesley Jarvis, New York, c. 1814–22. Lived and painted in New York, 1827–36. Lived in West, 1837–50 (?); New York, 1851–68; Jersey City Heights, New Jersey, 1868–81, where he died in 1881.

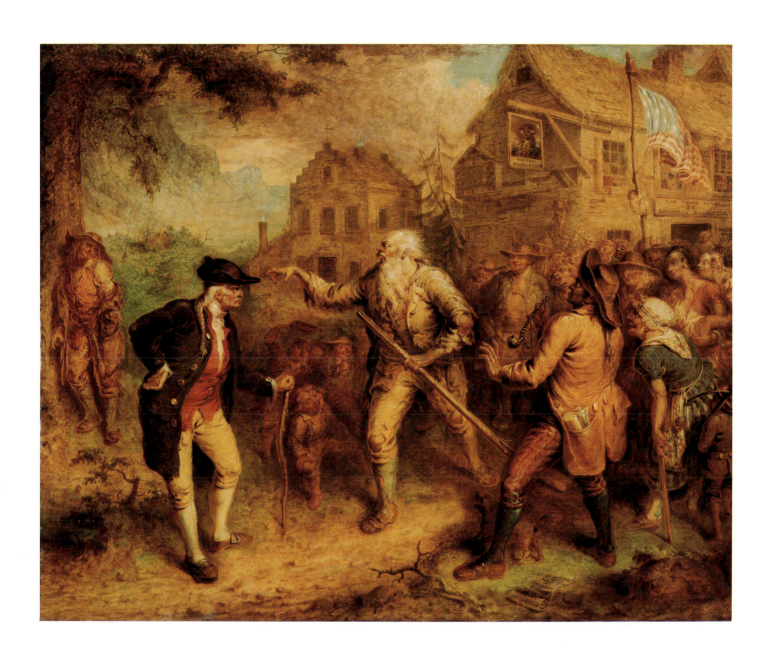

THOMAS COLE
1801–1848

Tornado

1835
oil on canvas
46⅜ × 64⅝ (117.8 × 164.2 cm)
The Corcoran Gallery of Art
Museum purchase, 1877

The foremost landscape artist of the 1830s and 1840s, Thomas Cole combined his admiration of the American wilderness with a desire to elevate the feelings of his audience. *Tornado*, in its grandness of scale, subject matter, and overall conception, exemplifies the first-generation Hudson River school view of untamed nature. A studio piece, it presents no specific aspect of the landscape but rather a generalized synthesis of immensity and sublimity conveyed by the very size of the canvas and the storm-lashed trees and sky. Cole's aim has been to inspire awe and terror in the beholder. In painting the aftereffects of a devastating storm, the power of divinity is expressed in a situation Americans could easily comprehend and, at the same time, be transported beyond their experience. The artist has reinforced his conception through pointed use of established Romantic formulae. The blasted tree trunks in the foreground are quotations from Salvator Rosa, the burnished sunset recalls Claude Lorrain. Cole's insistent interjection of philosophical notions into his scenes of nature, so characteristic of transcendentalism, was perhaps not always understood or appreciated by the public.

BORN 1801 in Bolton-le-Moor, Lancashire, England. Apprenticed to Liverpool textile designer and engraver, 1815. Immigrated with family to United States, 1818; learned wood engraving in Philadelphia. Traveled to West Indies, 1819; returned to Philadelphia, 1823. Moved to New York, 1825. Made sketching trips to Catskills and along banks of Hudson River. Founding member, National Academy of Design, 1826. Visited Niagara Falls, 1829; England, France, Italy, 1829–32; occupied Claude Lorrain's studio, Rome. Returned to New York, 1832. Opened studio in Catskill-on-the-Hudson, New York. Visited England and Italy, 1841–42. Died 1848 in Catskill, New York.

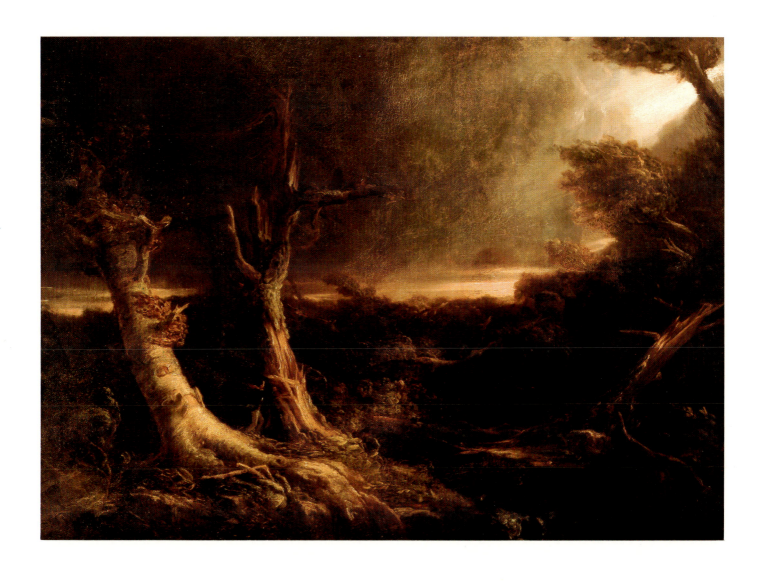

ASHER BROWN DURAND
1796–1886

Edge of the Forest

1871
oil on canvas
78½ × 64 in (199.4 × 162.5 cm)
The Corcoran Gallery of Art
Museum purchase, 1874

Shortly before 1850, Asher B. Durand, one of the first Hudson River painters, began to foresake the ideal Arcadian landscape formula on which his reputation was based for a more realistic view of nature based on direct observation. He moved closer into the landscape as in the paintings of forest glades, of which *Edge of the Forest* is an example, a late work done not long after Durand retired to New Jersey. It is also one of his largest paintings. Despite its size, the painting reveals a vigorous and broad handling similar to the brushwork in Durand's smaller nature studies painted out of doors. Such forest paintings enabled Durand to explore the quality of light by contrasting the darkness of the forest depths with the blazing sunlight over the distant mountains. For Durand nature was pervaded by the spiritual, and man's contemplation of it was communion with the divine. As Daniel Huntington, president of the National Academy of Design, noted in his 1887 memorial address for Durand, the solitude of this forest scene is "primeval in its grandeur and silence." Paintings such as this led to a more naturalistic treatment of landscape among second-generation Hudson River school painters.

BORN 1796 in Maplewood, New Jersey. Apprenticed to Peter Maverick, Newark engraver, 1812. Entered into partnership with Maverick, New York, 1817. Commissioned to engrave John Trumbull's *Declaration of Independence*; dissolved partnership with Maverick, 1820. Became foremost engraver in United States. Founding member, National Academy of Design, 1826; New York Sketch Club, 1827. Gave up engraving for oil painting on advise of patron Luman Reed, 1835. Began sketching trips, upstate New York, 1837. Traveled to Europe with John Kensett, John Casilear, Thomas Rossiter, 1840–41. Returned to United States; began sketching excursions through New York, New England, 1841. President, National Academy of Design, 1845–61. Wrote "Letters on Landscape Painting," *Crayon*, 1855. Retired to New Jersey, 1868, where he died in 1886.

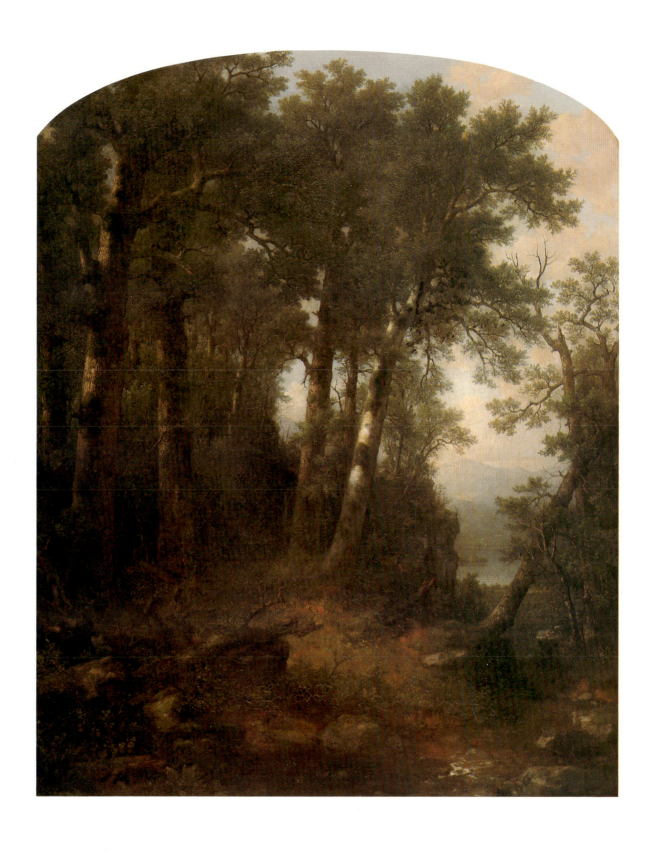

JOHN FREDERICK KENSETT
1816–1872

Beacon Rock, Newport Harbor

1857
oil on canvas
22½ × 36 in (57.2 × 91.4 cm)
National Gallery of Art
Gift of Frederick Sturges, Jr. 1953

In *Beacon Rock, Newport Harbor*, we are struck by Kensett's extraordinary ability to paint both sensitively and accurately, evocatively and yet with absolute precision, not only observed light but all the details of favored vistas around the northeastern region, where he was based throughout his career. Like other Hudson River school painters of the first and second generation, Kensett traveled far afield during the summer and autumn, making on-the-spot sketches to work up into finished oils during the winter, producing loving records of the coastline, the rivers, the mountains, and any number of other locales along familiar "pilgrimage routes" through the revered landscape of the United States. The environs of Newport were especially attractive to Kensett, and he painted them frequently; he traveled there for the first time in 1854, returning in 1855 and 1856. He did not visit Newport again until 1863 and 1864. This painting, produced in 1857 after his first trips, is an early example of the many works that resulted from his experience of the site. Yet is is typical of the group of Newport paintings in many respects, all characterized by a crisp, sharp juxtaposition of sky, rocks, and water in relatively simple and spare compositions. And here, Kensett's reductive and precise manner, as in all his works, still leaves us with a scene "instinct with feeling, all live with love."

BORN 1816 in Cheshire, Connecticut; son of immigrant English engraver; learned to draw and engrave in father's New Haven firm. Urged to paint by John Casilear. Exhibited at National Academy of Design, New York, 1838. Traveled and painted in Europe with Casilear, Asher B. Durand, Thomas Rossiter, 1840. Lived in Paris, London; returned to New York, 1847. Elected academician, National Academy of Design, 1849. Founding member, Metropolitan Museum of Art, New York, 1870. Worked in New York studio, winters; conducted sketching tours in Catskills, White Mountains, Adirondacks, summers. Traveled to Niagara Falls, 1851; Mississippi River, 1854; Colorado, 1870. Died 1872 in New York.

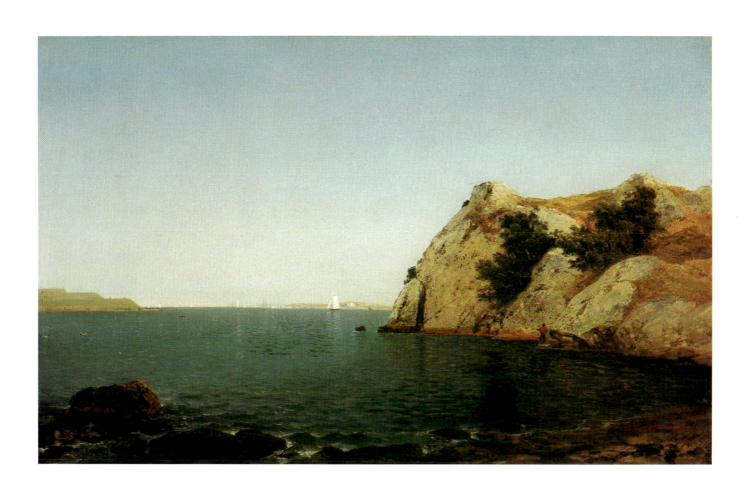

THOMAS WORTHINGTON WHITTREDGE
1820–1910

Trout Brook in the Catskills

1875
oil on canvas
35½ × 48⅜ in (90.2 × 122.9 cm)
The Corcoran Gallery of Art
Museum purchase, 1875

The subject of landscape in all its variety engaged Whittredge from his early days of depicting the countryside of his native Ohio, through his ten years in Europe, and subsequent painting trips in America to New England and the West. Perhaps because he was raised on a farm in the Midwest, Whittredge was not as closely tied to the landscape of the Catskill Mountains and the Hudson River as some of his contemporaries, though upon his return to the United States in 1859, after studying and painting in Germany and Italy, he was profoundly influenced by the paintings of the Hudson Valley region by Thomas Cole and Asher B. Durand. Together with John Kensett, Whittredge shared an admiration for the work of Durand, but his own painting stemmed from Durand's more intimate and lyrical phase. His handling of paint was also more fluid than that of either and his vision more informal and less romantic than Kensett's. His landscapes are broad, gentle, and pastoral, with an emphasis on the horizontal, on openness, and on quietude, and in that mood he belongs within the ambience of the Luminists. Ultimately, his rendering of woodland scenes with light filtering through the trees and dappling the forest interior, of which *Trout Brook in the Catskills* is an example, established his reputation as a second-generation Hudson River school painter and became the hallmark of his personal style.

BORN 1820 near Springfield, Ohio. Worked as house painter, daguerreotypist, portraitist, Cincinnati, Indianapolis, and West Virginia, 1840–49. Began landscape painting, 1843. Traveled to England, Belgium, France, Germany, 1849–51. Studied in Düsseldorf with Carl Lessing, 1851–54. Friend of Emanuel Leutze, Eastman Johnson, Albert Bierstadt. Lived in Rome, 1854–59. Elected member, National Academy of Design, 1861. Maintained studio in New York, 1859–80. Accompanied Major-General John Pope on expedition to Rocky Mountains, 1865–66. Limited his sketching trips mainly to New England, upstate New York, after 1867. Traveled west with John Kensett, Sanford Gifford, 1870. President, National Academy of Design, 1865, 1874–77. Moved to Summit, New Jersey, 1880. Traveled to Mexico, 1893. Wrote autobiography, 1905. Died 1910 in Summit.

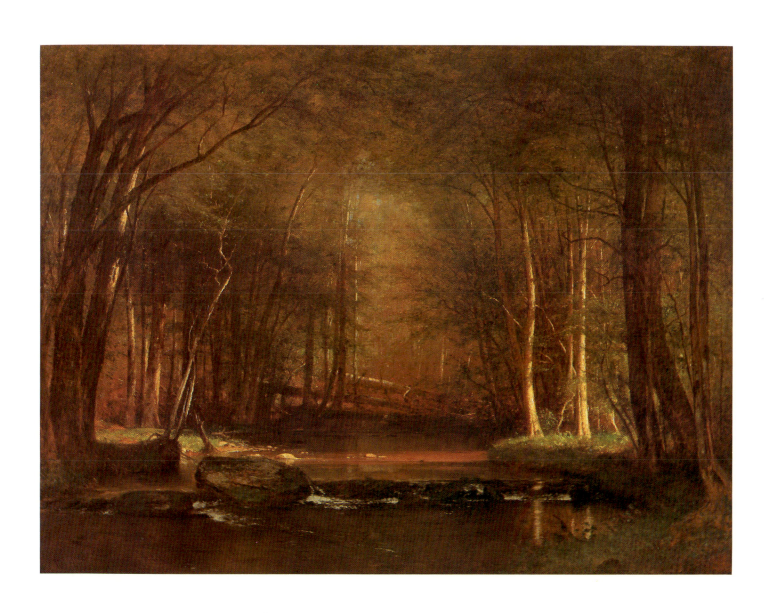

FITZ HUGH LANE
1804–1865

Lumber Schooners at Evening on Penobscot Bay

1860
oil on canvas
24⅝ × 38⅛ in (62.5 × 96.8 cm)
National Gallery of Art
Andrew W. Mellon Fund and
Gift of Mr. and Mrs. Francis
W. Hatch, Sr. 1980

Lumber Schooners is one of many views of harbors and shipping activities painted by Lane along the northeastern coastline from New York to Maine. Although he was crippled at an early age and spent most of his life in Gloucester, he did get about, even as far afield as Puerto Rico. But the New England coast, especially its harbors, most often Gloucester, Boston, and Salem constituted the major theme in his work. In 1848 he visited Maine for the first time and returned every summer to paint such seascapes as *Lumber Schooners*. Ships such as these carried lumber or granite from Maine to Boston. Lane was influenced early in his career by the English painter Robert Salmon, who painted calm and pristine harbor views during his residence in Boston from 1828 to 1840. Salmon worked for a time in William Pendleton's lithography shop where Lane, as an apprentice, received his only formal training. Lane is one of the major and perhaps the first of the Luminist painters who broke from the emotive Romanticism of the Hudson River school, and *Lumber Schooners* is a consummate example of his mature Luminist style. The open-ended horizontal format and recession into depth create an infinite space completely suffused by an even luminosity. A hushed stillness permeates the air, the mirror surface of the water is ruffled only in the foreground by a slight breeze, as the pink glow of dusk illumines the distant hills and schooner masts, evoking the typical Luminist mood of quiet contemplation and nostalgia at the passing of time. For Lane, as for other Luminists, landscape was an expression of the transcendentalist harmony of man with nature, the divinity of nature, and light as the epiphany of nature's intangible spirit.

BORN Nathaniel Rogers Lane 1804 in Gloucester, Massachusetts. Apprenticed to William Pendleton, Boston lithographer, 1832–37. Partner with John W. A. Scott, lithographer, 1845–47. Returned to Gloucester, 1849; produced lithographs ranging from tradecards, sheet-music covers, book illustrations to topographical views of New England coastal towns. Made annual cruises to Castine, Maine, 1848–55. Traveled to New York, Baltimore, Puerto Rico, 1850s. Died 1865 in Gloucester.

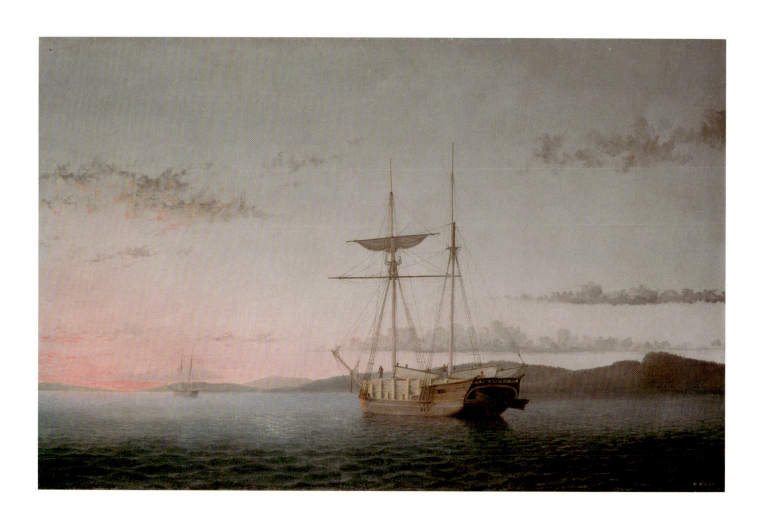

MARTIN JOHNSON HEADE

1819–1904

Cattleya Orchid and Three Brazilian Hummingbirds around Nest

1871
oil on panel
13¾ × 18 in (34.8 × 45.6 cm)
National Gallery of Art
The Morris and Gwendolyn Cafritz
Foundation 1982

Heade's artistic career was rather eccentric. After studying with the provincial and "primitive" painters, Edward and Thomas Hicks, he tried his hand at portrait painting. He visited Europe twice and traveled extensively in the Midwest as an itinerant portrait painter before settling in New York in 1859. His earliest essays in landscape painting in the early 1850s were in the manner of Kensett and Whittredge, but, around 1860, influenced by Luminism, his style underwent a transformation. His paintings of the seashore and salt marshes with haystacks along the eastern littoral were dramatic and foreboding rather than poetic and placid as were the landscapes of other Luminists. In 1863 he took the first of three trips to Brazil with an amateur naturalist, the Reverend J. C. Fletcher, to do studies for a projected, though never published, book on the hummingbirds of South America. As an outgrowth of that experience, Heade made a large number of paintings of birds and flowers in a jungle setting. The freshness of conception and brilliance in color lend credence to the belief that *Cattleya Orchid and Three Brazilian Hummingbirds* was the prototype of a subsequent series combining hummingbirds and orchids. It is also the only one of the series that has more than two birds. Aside from their interest as scientific studies, the hummingbird pictures have been admired for their meticulous and precise rendering of detail, their high-keyed, luminescent color, but perhaps most of all for their naïve, Victorian charm. Despite Heade's extensive travel and practice and original artistic vision and instinct, he remained always, in his early Luminist landscapes as well as later jungle paintings, something of an unsophisticated "primitive" painter.

BORN 1819 in Lumberville, Pennsylvania. Traveled to Italy, France, England, c. 1840–43. Opened studio in New York, 1843. Painted and exhibited in Brooklyn, Philadelphia, Trenton, 1845–47; Saint Louis, 1851–52; Chicago, 1853–54; Trenton, 1855–56; Providence, 1857–58; New York, 1859–60; Boston, 1861–63. Traveled to Brazil, Colombia, 1863–64; awarded Order of the Rose by Dom Pedro II, emperor of Brazil, 1864. Traveled to London, 1865; Nicaragua, 1866; Colombia, Panama, Jamaica, 1870; British Columbia, 1872. Painted in a variety of places in the United States, including Connecticut, Long Island, New Jersey, Vermont, Maine, California. Moved to Washington, D.C., 1881; Saint Augustine, Florida, 1885, where he died in 1904.

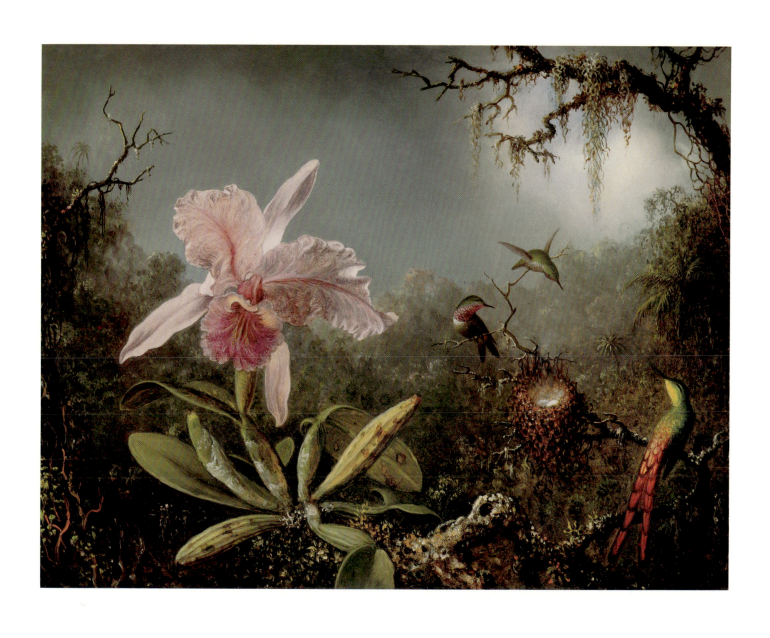

FREDERIC EDWIN CHURCH
1826–1900

Aurora Borealis

1865
oil on canvas
56⅛ × 83½ in (142.3 × 212.2 cm)
National Museum of American Art
Smithsonian Institution
Gift of Eleanor Blodgett

Profoundly influenced by the cosmological theories of the great German naturalist Alexander von Humbolt, Frederic Church attempted in his landscapes to combine scientific truth with the dramatic portrayal of natural phenomena. He consciously sought sublimity in unknown and unexplored regions, which he tried to render in their most characteristic form. Having already recorded the natural wonders of Latin America and the Caribbean and the legendary character of the Middle East, he turned to the mysteries of the Arctic north in which he had long been interested. *Aurora Borealis* is unique among Church's paintings in its imaginative reconstruction not only of a spectacular natural phenomenon but of a particular occurrence that he had not actually witnessed. Church had observed and recorded the Aurora Borealis on Mount Desert Island in Maine and had painted many studies of icebergs around Labrador, but the painting itself is based on a composite of verbal and written descriptions and sketches made by his friend and sometimes student, Arctic explorer Isaac T. Hayes, as well as Church's own experiences and imagination. It is much broader in handling and more visionary in conception than his typical epic views of nature. It is essentially a painting of light, in which a fantastic configuration of ice becomes the foil for the reality of illumination.

BORN 1826 in Hartford, Connecticut. Studied with Benjamin Coe, Alexander Emmons, Hartford, 1842–43; studied and lived with Thomas Cole, Catskill, New York, 1844–46. Exhibited at National Academy of Design, New York, 1845. Opened studio in New York, 1848. Elected associate, National Academy of Design, 1848; academician, 1849. Traveled, with Cyrus Field, to Ecuador and Colombia, 1853; Niagara Falls, 1856, 1858; second trip to South America, 1857; Newfoundland, Labrador, 1859; Jamaica, 1865; Europe, Palestine, 1867–69. Collaborated with architect Calvert Vaux on the building of villa, "Olana," on Hudson River, 1870–72. Right hand crippled by rheumatism, 1876–77. Tried to paint with left hand for remaining twenty-three years of his life but with only partial success. Wintered in Mexico, 1880–1900. Died 1900 in New York.

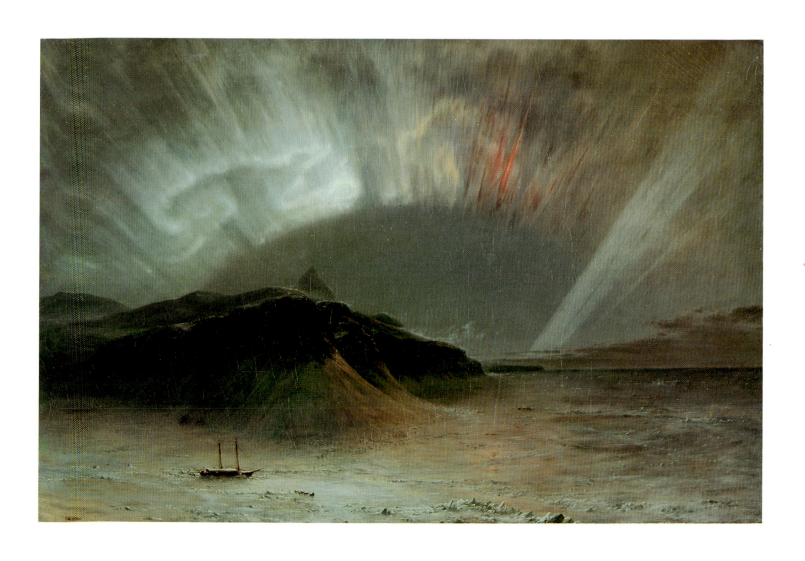

CECILIA BEAUX

1855–1942

Man with the Cat (Henry Sturgis Drinker)

1898
oil on canvas
48 × 34⅝ in (121.9 × 87.8 cm)
National Museum of American Art
Smithsonian Institution
Bequest of Henry Ward Ranger through
the National Academy of Design

As the leading female painter in the United States in her day, Cecilia Beaux was successful and greatly honored. She was born and raised in Philadelphia in a genteel and fairly cloistered milieu, and her art training as well as her education were largely private. She claimed to have been kept by her family from the Eakins circle at the Pennsylvania Academy of the Fine Arts, but her name appears on its rolls for 1877—79. She went abroad only after reaching maturity and achieving some recognition and in Paris studied with the usual academic masters of the time. She was rather disdainful of French contemporary art, although she must have known Mary Cassatt, but she was impressed by such old masters in the Louvre as Titian, Velázquez, Rubens, and Rembrandt. Curiously, however, she did adopt a modified Impressionism as did John Singer Sargent and William Merritt Chase, although there remain reminiscences of James McNeill Whistler in the composition, pattern, and flatness of her canvases and of Eakins in her psychological probity. Like Sargent, she was a virtuoso portraitist and like him painted slick and highly polished portraits of aristocratic sitters or at least endowed them with that air. Her best work has a serious, even contemplative, cast that raises it above the level of aesthetic flattery. Among her finest paintings is *Man with the Cat*, a portrait of her brother-in-law, Henry Sturgis Drinker, whose commanding patrician presence comes through in the elegance of his bearing and manner and her own painterly dexterity.

BORN 1855 in Philadelphia. Received first art instruction from Catherine Drinker. Studied with William Sartain. Executed fossil drawings for U.S. Geological Survey. Exhibited at Pennsylvania Academy of the Fine Arts, Philadelphia, 1879; Paris Salon, 1887. Studied at Académie Julian, Paris; copied works at Louvre, admired Velázquez, Rubens, Titian, 1888. Visited England and Italy, 1888–89. Returned to Philadelphia, 1889. Taught at Pennsylvania Academy, 1895–1915. Elected academician, National Academy of Design, 1903. Visited Spain, France, Italy, 1906. Broke hip in Paris, 1924, restricted her painting. Published autobiography, *Background with Figures*, 1930. Died 1942 in Green Alley, Pennsylvania.

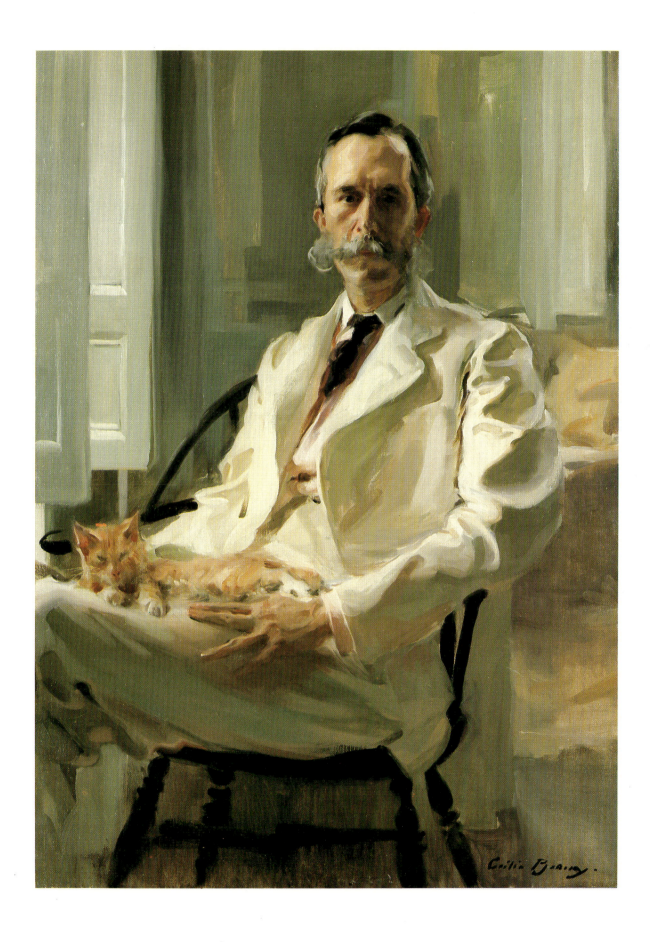

EASTMAN JOHNSON
1824–1906

The Brown Family

1869
oil on paper mounted on canvas
23⅝ × 28½ in (59.3 × 72.4 cm)
National Gallery of Art
Gift of David Edward Finley
and Margaret Eustis Finley 1978

The New York banker John Crosby Brown commissioned Eastman Johnson to paint a portrait of his parents and his son in 1869. *The Brown Family* reveals Johnson's abilities as a painter of portraits and scenes of everyday life. Johnson depicted the elder Browns in the comfortable parlor of their house, surrounded by their paintings and possessions, firmly seated at a uniform height, and dressed in black clothes, which contrast with the red draperies, green wallpaper, and white painted woodwork. The Browns embody a reasoned, genteel, and prosperous world. In composing *The Brown Family*, Johnson may have relied on a recently released lithograph entitled *The Four Seasons of Life: Old Age*. But Johnson went beyond borrowing a sentimental motif from a popular print. A photograph of the Browns, taken in their parlor, reveals Johnson's extraordinary faithfulness both to the objects that surrounded the family and to their individual appearances. Johnson has blended both to create a portrait of a family whose tender affection reflected the values of the age in which they lived.

BORN 1824 in Lowell, Maine. Apprenticed to J. H. Bufford, Boston lithographer, 1840–42. Worked as portraitist, Augusta, Maine, 1842; Washington, D.C., 1844–45; Cambridge, Massachusetts, 1846–49. Studied at Königlich Preussische Kunstakademie der Rheinprovinzen, 1849–51; with Emanuel Leutze, Düsseldorf, 1851. Lived in the Hague, 1851–55. Studied with Thomas Couture, Paris. Returned to Washington, D.C., 1855. Exhibited at National Academy of Design, New York, 1856–1900; elected associate, 1859; academician, 1860; taught there, 1868–69. Sketched scenes of homefront and battlefields during Civil War, 1861–65. Summered in Nantucket, Massachusetts, and occasionally in Maine, 1870s, 1880s. Traveled to Europe, 1885, 1891, 1897. Died 1906 in New York.

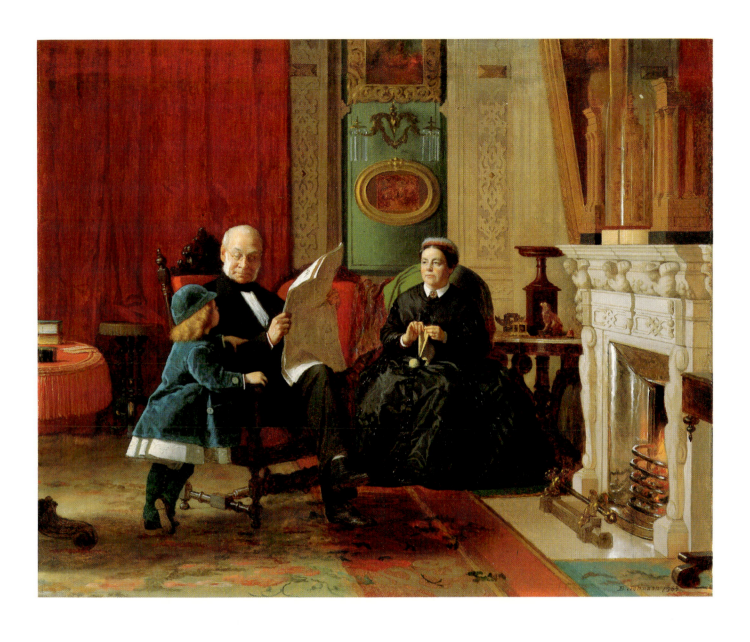

THOMAS EAKINS
1844–1916

Miss Van Buren

c. 1889–91
oil on canvas
45 × 32 in (114.3 × 81.3 cm)
The Phillips Collection

For Thomas Eakins, his central preoccupation remained the realistic portrayal of the human figure observed in repose or actively engaged in or out of doors in some contemporary activity. He spent his life in Philadelphia except for four years in Europe—three years studying at the Ecole des Beaux-Arts in Paris with Jean-Léon Gérôme and one year traveling in Germany, Spain, and Italy. One of America's greatest portrait painters, Eakins, unlike his contemporary John Singer Sargent, did not paint society portraits, rarely received commissions, and remained unrecognized during his lifetime. His perception of character has an intensity and directness that disturbed his contemporaries and prospective patrons. Eakins's arduous requirements of lengthy sittings restricted his portraits to willing friends, as in the case of Miss Amelia C. Van Buren, his student and a friend of his wife. In his portrait of her, pensive but alert, can be found the distinctive features of Eakins's mature portrait style: unaffected pose, dramatic lighting, deep feeling. One is keenly aware of the probing appraisal of Miss Van Buren's personality, her very psyche. The setting is stark but effective. In his solid factualism, Eakins invites comparison with the French and German academic realists; his insight into personality extends his alliance with European realism to Courbet and Manet. But it was the subdued, startling work of Velázquez, seen firsthand in the Prado, that exercised the decisive influence in his methods. Eakins did not aim to flatter his subjects and rarely sold a canvas.

A large collection of works by Eakins can be seen at the Hirshhorn Museum and Sculpture Garden.

BORN 1844 in Philadelphia. Studied at Pennsylvania Academy of the Fine Arts, 1861–65; anatomy at Jefferson Medical College of Philadelphia; Ecole des Beaux-Arts, Paris, with Jean-Leon Gérôme, 1866–69; in atelier of Léon Bonnat, Paris, 1869. Traveled to Italy, Germany, 1868; Spain, admired the work of Velázquez, Ribera, 1869–70. Returned to Philadelphia, 1870; resumed studies, Jefferson Medical College. Taught at Pennsylvania Academy, 1876–86; director, 1882–86; forced to resign because of his emphasis on study from nude models, 1886. Member, Society of American Artists, 1880–92. Worked with photographer Eadweard Muybridge, conducted studies in motion photography, University of Pennsylvania, Philadelphia, 1884–85. Director, Art Students League of Philadelphia, founded by former students, 1886–92. Only solo exhibition held during his lifetime in 1896, Earle Galleries, Philadelphia. Elected associate, academician, National Academy of Design, 1902. Died 1916 in Philadelphia.

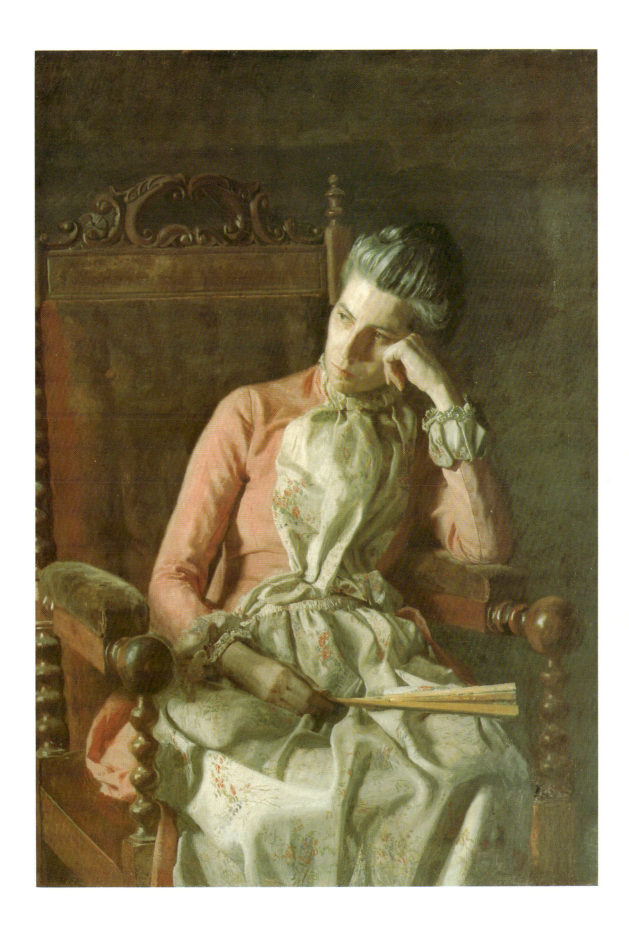

WINSLOW HOMER
1836–1910

Hound and Hunter

1892
oil on canvas
28¼ × 48⅛ in (71.8 × 122.3 cm)
National Gallery of Art
Gift of Stephen C. Clark 1947

Winslow Homer has been called the most American of American painters. It may be because of his subject matter, or his apparently unsophisticated style, or the freshness of his observation. Yet there is no doubt that he was influenced by Japanese prints and that his work of the 1860s has a remarkable affinity with Manet's of the same years. His early paintings, bright colored and full of sunlight, dealt with pleasant scenes of recreation and rural life, but he grew progressively more serious in outlook and somber in color; his theme became that of man against nature, and his manner dramatic and heroic. *Hound and Hunter* belongs to a series of adventure pictures begun in the 1880s (when he returned to watercolor and painted in Latin America, the Caribbean islands, Canada, and the Adirondacks), which served as metaphors of the struggle for survival. In this painting, Homer depicts an unusually barbarous form of hunting in which the deer is driven into the water by dogs and, while relatively helpless, drowned by forcing his head under. Whatever Homer's feelings about the cruelty of the act, he reports it simply as fact. As Henry James wrote of him, "He paints the life that he sees as he sees it, he never softens a line or modifies a feature, nor yields for a moment to any soft seduction of beauty." But he manages to convey the tenseness of the moment, the irony of death in the silence of the wilderness, and the poignancy of the sinking buck's head framed by the concentric white ripples against the autumnal darkness of the water. This oil painting was carefully reworked from a brilliant watercolor done from nature in the Adirondacks.

BORN 1836 in Boston. Apprenticed to J. H. Bufford, Boston lithographer, 1855. Contributed illustrations to *Ballou's Pictorial, Harper's Weekly*. Moved to New York 1859. Began painting, 1861. Studied drawing briefly in Brooklyn and at National Academy of Design, New York. Commissioned to make illustrations of Civil War scenes for *Harper's Weekly*. Elected associate, National Academy of Design, 1864; academician, 1865. Traveled to France, 1865–66. Returned to New York. Stopped illustrating, 1874; devoted himself to watercolor and oil painting. Traveled to England, 1881–82. Moved to Prout's Neck, Maine, 1882, where he lived for remainder of his life, except for brief trips to Adirondacks in summer and Caribbean in winter. Became a recluse. Died 1910 in Prout's Neck.

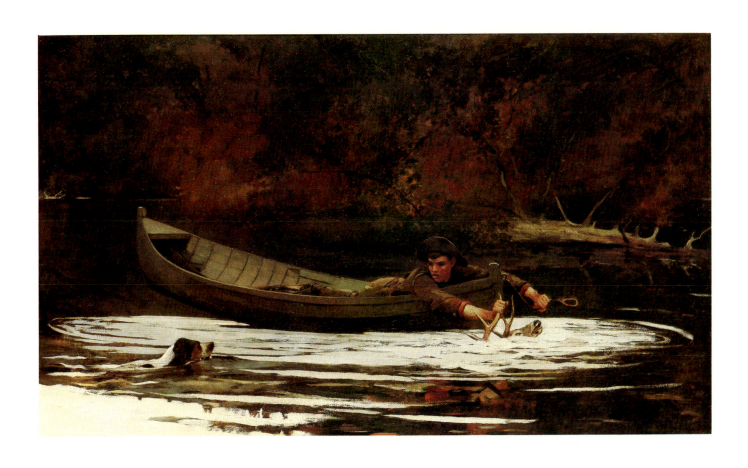

WILLIAM MICHAEL HARNETT
1848–1892

Cincinnati Enquirer

1888
oil on canvas
30 × 25⅛ in (76.2 × 63.8 cm)
The White House

Harnett was the most famous of the American trompe l'oeil painters. In 1886 he returned to the United States from Munich, where his work had evolved to an unaccustomed richness of subject matter within complex compositions. *Cincinnati Enquirer* manifests a return to the simpler forms and the American subject matter of his earlier style, a format he retained to his death. Rediscovered in Catoosa, Oklahoma, in 1948, the painting is a typical Harnett tabletop still life with the pipe, rectangular tobacco box, and hard round biscuits that he had used in earlier works. The Dutch jar, reminiscent of those used in sixteenth- and seventeenth-century Netherlandish still lifes, is one of the most characteristic of Harnett's models during the last years of his life. A curious and unprecedented feature of the *Cincinnati Enquirer* is that it is Harnett's only representation of a newspaper in which one can read the headlines and subheads. Research has shown that what Harnett depicted was actually printed in the paper for May 8, 1888; the artist, however, made several adjustments. As always, Harnett's deceptions are magical, and the viewer has an irresistible urge to reach out and right the tilting candlestick and snuff out the burning area of the newspaper.

BORN 1848 in Clonakilty, County Cork, Ireland; immigrated with family to Philadelphia, 1849. Trained as a silver engraver; studied at Pennsylvania Academy of the Fine Arts, Philadelphia, evenings, 1867. Moved to New York, 1869. Worked as engraver for several jewelry firms. Attended Cooper Union for the Advancement of Science and Art, nights. Began making still-life paintings, 1874. Exhibited at National Academy of Design, 1875. Lived in Philadelphia; Munich, 1880–86; New York, from 1886, where he died in 1892.

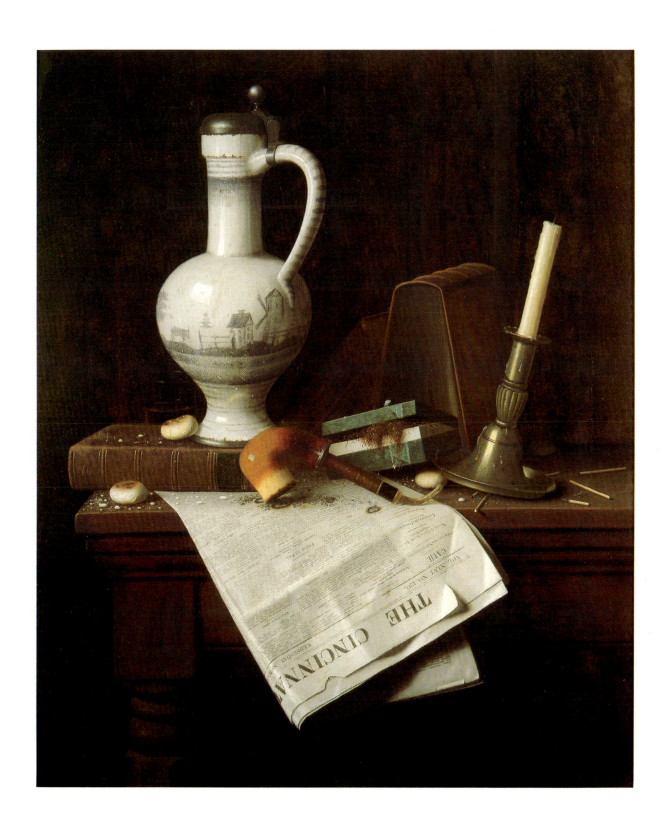

JOHN FREDERICK PETO
1854–1907

Old Reminiscences

1900
oil on canvas
30 × 25 in (76.1 × 63.5 cm)
The Phillips Collection

Peto shares a prestige equal to that of Harnett in American trompe l'oeil painting. *Old Reminiscences* represents a later example of Peto's series of rack paintings. Portrayed is a letter-rack grid comprised of a square of felt strips with a central X, inside which Peto has tucked several envelopes, a photograph, the well-known Mathew Brady picture of Abraham Lincoln, and cards. All are characteristic Peto models. Lincoln's assassination may account for the pessimistic mood of the artist's late works as epitomized in these final rack paintings. Mistakenly attributed to Harnett, the painting is posthumously dated, bearing in large numerals the legend "1900," eight years after Harnett's death. Since this could not be accounted for rationally, it was interpreted as Harnett's little surrealistic joke. From early in his career Peto was sensitive to the new Impressionist vision that had gradually crept into American painting at about this time, and, seen through diffused light, the work does not appear wholly trompe l'oeil. The muted radiance of color, the soft, powdery texture—which has caused critics to invoke the name of Vermeer—reflect the crucial distinctions between Peto and Harnett. In this work Peto's geometrical compartmentalization is evidence of his interest in formal relationships and makes the painting seem modern even today.

BORN 1854 in Philadelphia. Studied at Pennsylvania Academy of the Fine Arts, Philadelphia, 1878; exhibited there, 1879–81, 1885–87. Associated with, and influenced by, the still-life painter William Harnett, before 1880. Moved to Island Heights, New Jersey, 1889. Many paintings given the forged signature of Harnett and sold as Harnetts. Died 1907 in Island Heights. Virtually unknown until 1940s.

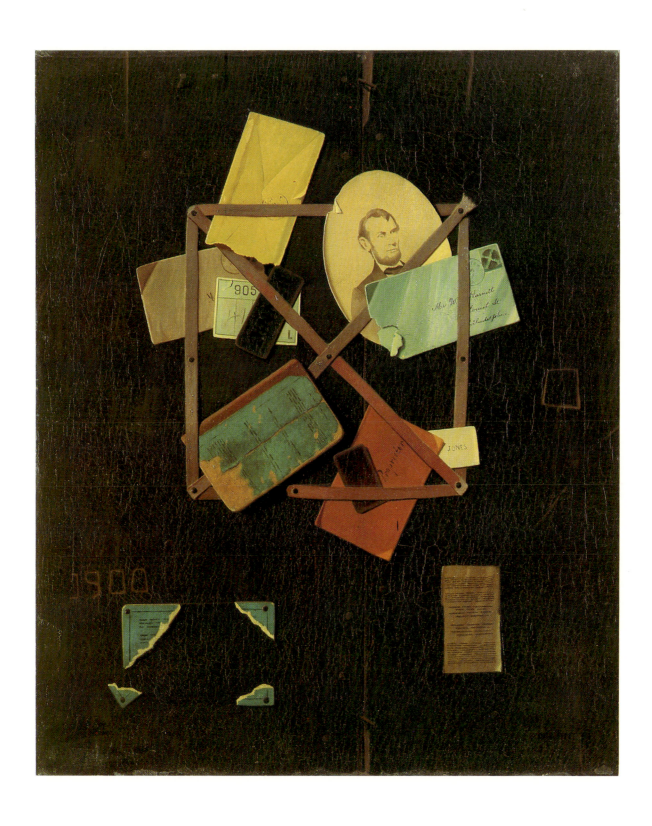

JOHN LA FARGE
1835–1910

Greek Love Token

1866
oil on canvas
24⅛ × 13⅛ in (61.1 × 33.1 cm)
National Museum of American Art
Smithsonian Institution
Gift of John Gellatly

By the time he was twenty-five, John La Farge was conversant with the most advanced techniques and aesthetic concepts of the day. A product of a classical education, he had studied briefly with Thomas Couture in Paris and discovered the Pre-Raphaelites on a visit to England. During his tutelage under William Morris Hunt in Newport, La Farge copied works by the Barbizon school and conducted experiments in advanced color theory. He was also one of the first Americans to collect and be influenced by Japanese prints. Though he claimed to paint from reality, La Farge's early preoccupation with form and color and his essentially subjective approach to subject matter, ranging from still lifes to figure studies, foreshadow a shift in the current of late-nineteenth-century American art toward intrinsic aesthetic matters. He was, however, deflected from realizing the full potential of his intuitive vision by a heavy involvement, later in his career, with monumental murals, illustration, stained glass, and travels to exotic lands. *Greek Love Token*, an early work, done before he became involved with large enterprises, subtly incorporates the artist's research in color, knowledge of the classical tradition, and personal expressiveness. The motif of the wreath of fresh flowers placed against a heavily textured wall refers to the Greek custom of marriage proposal. The inscription, "As summer was just beginning," elegiac in its connotations, may allude to the death of La Farge's son the year before the work was finished.

BORN 1835 in New York of French émigré parents. Received earliest training from grandfather, a miniaturist. Studied at Mount Saint Mary's College, Emmitsburg, Maryland, B.A., 1835, M.A., 1855; law, New York. Traveled to Europe, 1856–57. Visited England, 1857. Exhibited at National Academy of Design, New York, 1862; elected associate, 1863; academician, 1869. Made second trip to Europe, 1873. Began work in stained glass, 1874; invented opalescent glass, c. 1877; numerous commissions followed. Executed first mural commission: Trinity Church, Boston, 1876–78; followed by long career as designer of ecclesiastical, secular interiors. First solo exhibition held 1878, Pierce & Co., Boston. Traveled, with Henry Adams, to Japan, 1886, and South Seas, 1890–91; illustrated, wrote essays on these cultures. Lecturer and writer on art, after c. 1895. Died 1910 in Providence, Rhode Island.

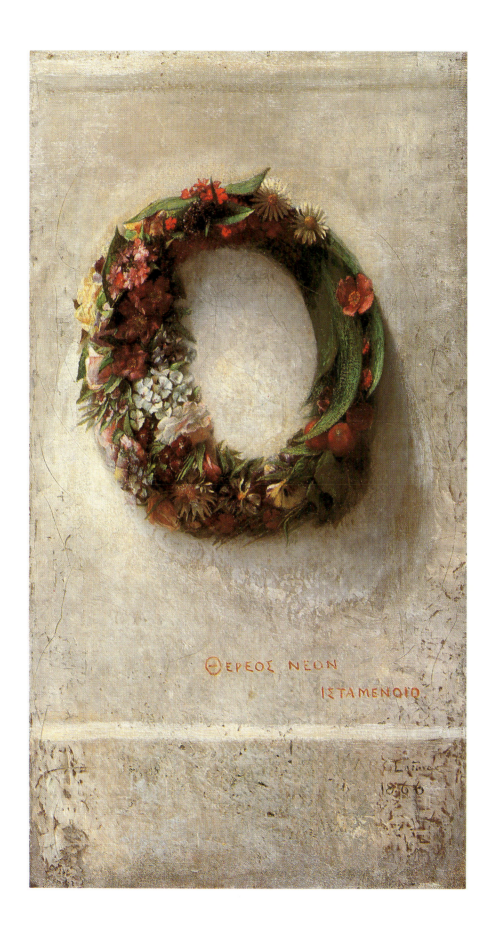

ALBERT PINKHAM RYDER
1847–1917

Moonlit Cove

c. 1890–1900
oil on canvas
14 × 17 in (35.5 × 43.2 cm)
The Phillips Collection

Ryder has often been described as being out of context with his time and an eccentric recluse. He was in fact part of the "new movement" that embraced all the novel currents brought back from Europe, culminating in the formation of the Society of American Artists in 1878, and he maintained friendships with many of his colleagues through the years. Ryder belongs to the group of tonal painters with a preference for the lower registers in color, crepuscular effects, and a brooding sadness, along with William Morris Hunt and his immediate circle—Robert Loftin Newman, George Fuller, the young John La Farge, Ralph Albert Blakelock—and among the pure landscapists, George Inness and some of his disciples. Tangential, though also relevant, are the nocturnes of James McNeill Whistler and the nocturnal figure pieces of Thomas Dewing. Ryder's earliest bucolic paintings are related to the Barbizon tradition, but the works of his maturity have a new and unique dramatic intensity inspired either by literary themes from Shakespeare, the Bible, and Wagnerian opera or by his memory of the sea by moonlight. *Moonlit Cove* is a signature example of his mature marine paintings—the silhouette of a cockleshell boat bobbing on the vast sea, glowing green out of blackness, cloud phantoms looming against the sky, the silver moonlight bathing the universe in phosphorescence—expressive of his spiritual response to beauty and the mystery of nature. The small magical canvases were created through years of patient and fanatical reworking in questionable materials that resulted in irreducible images, translucent surfaces, and gemlike color, but it also led to darkening and cracking of pigment and often irretrievable loss.

Other paintings by Ryder can be seen at the National Museum of American Art.

BORN 1847 in New Bedford, Massachusetts; moved with family to New York, c. 1870. Studied informally with portrait painter and engraver William Edgar Marshall, New York, c. 1870; at National Academy of Design, New York, 1870–72, 1874–75. Traveled to Europe, 1877, 1882. Founding member, Society of American Artists, 1878; exhibited there, 1878–87. Rarely exhibited after 1887. Made sea voyages, 1887, 1896. Reworked earlier canvases after late 1890s. Exhibited ten paintings at Armory Show, New York, 1913. Died 1917 in Elmhurst, New York.

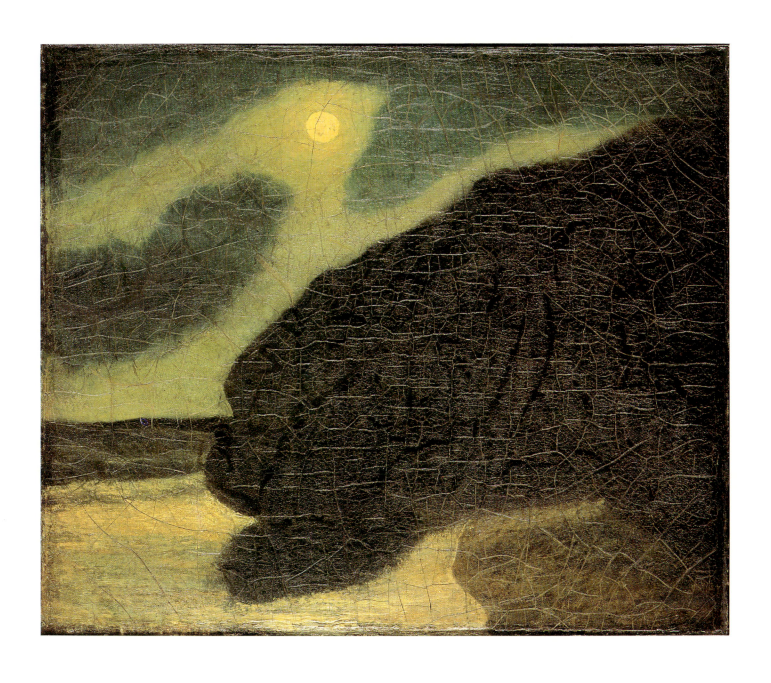

RALPH ALBERT BLAKELOCK
1847–1919

Moonlight

c. 1890
oil on canvas
27⅛ × 37⅛ in (69.0 × 94.3 cm)
The Corcoran Gallery of Art
Bequest of William A. Clark, 1926

Blakelock like Albert Pinkham Ryder belonged within the Tonalist orbit and shared with him a fascination for the mystery and poetry of the crepuscular and nocturnal. His repertory, confined to the land rather than the sea, was even more limited than Ryder's, with dark foreground trees silhouetted in a fretwork of leaves against a sunset or moonlit sky, as in this painting, often with an encampment of Indians around a glowing fire, remembered from his western sojourn. The arabesque of foliage, the sparkle of light through the dark mass, the small firelit figures create a shimmering surface. The luminescence is much like Ryder's, though rather golden than silvery, but Blakelock projects a gentler lyricism that has none of Ryder's dramatic tension. Blakelock also reworked his poetic images over and over and found a fascination in nuance and variation. Using small touches of pigment, he built up the paint to a heavy impasto, which he then polished with pumice before applying the final layer of color. *Moonlight* is rather unusual in its openness and simplicity, lacking the dark picturesque massing of trees against a luminous sky. Here it is the light of the moon itself that seems to be the subject, mirrored in the water, suffusing earth and sky, reducing forms to hallucination. Blakelock's paintings began to bring record prices and fakes were made of his work, while he was still alive and living in an asylum. The problem of authenticity in Blakelock's work is probably as difficult as for Ryder.

BORN 1847 in New York. Studied at Free Academy of the City of New York, 1864–66; but basically self-taught. Exhibited at National Academy of Design, New York, 1867–73, 1878–88, 1894–98, 1910. Elected associate, National Academy of Design, 1914; academician, 1916. Traveled to Kansas, Colorado, Wyoming, Utah, Nevada, California, Mexico, 1869–72. Opened studio in New York, 1876; unsuccessful in selling work. Painter Harry Watrous became friend and patron, c. 1885. Had first mental breakdown, 1891. Confined to Long Island Hospital, 1899–1901; Middletown State Hospital for the Insane, New York, 1901–16, 1918–19. Died 1919 in Elizabethtown, New York.

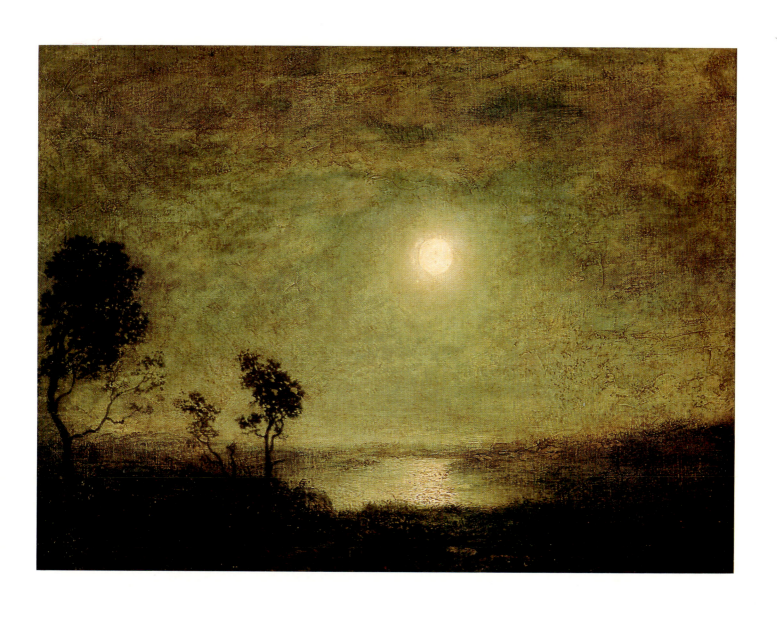

GEORGE INNESS
1825–1894

Harvest Moon

1891
oil on canvas
30 × 44½ in (76.2 × 113.0 cm)
The Corcoran Gallery of Art
Bequest of Mabel Stevens Smithers, 1952
The Francis Sydney Smithers Memorial

Inness was a pivotal figure in the evolution of landscape painting in the United States during the late nineteenth century, straddling as he did two eras, and although many of his contemporaries lived along with him toward the turn of the century and continued the tradition of naturalism, only Inness, responding to the changing artistic climate, evolved a new and distinct style. His career can be divided into an early period when he worked in the panoramic Hudson River school tradition, with some conscious reference to Dutch and English landscape painting; a middle period in which he synthesized that manner with his discovery of the Barbizon school on a trip to France; and a late style after his return from Europe in 1875, when he arrived at the poetic Impressionism for which he became famous. A Swedenborgian, Inness had a profoundly spiritual attitude toward nature, which deepened with time. *Harvest Moon* is an excellent example of his conception of landscape painting as an expression of the totality of the emotional response to nature rather than a description of physical detail. He sought aesthetic harmony through the poetic amalgam of space, form, and color, which is quite Whistlerian in its atmospheric effect and lyrical mood and which had a marked influence on followers like Alexander Wyant, Dwight Tryon, and Homer Martin.

BORN 1825 near Newburgh, New York; moved with family to Newark, New Jersey, 1830. Apprenticed to Sherman and Smith, New York engravers, 1841–43. Studied briefly with François Régis Gignoux. Opened studio in New York, c. 1843. Exhibited at National Academy of Design, 1844; American Art-Union, 1845. Traveled to Europe, 1847. Moved to Europe, 1850–52; Medfield, Massachusetts, 1859; Eagleswood, New Jersey, 1864; Brooklyn, 1867. Elected member, National Academy of Design, 1868. Traveled to Italy, sketching and painting landscapes, 1870. Returned briefly to New York. Lived in France and England, 1873–75. Settled in Montclair, New Jersey, 1878. Died 1894 on a visit to Scotland.

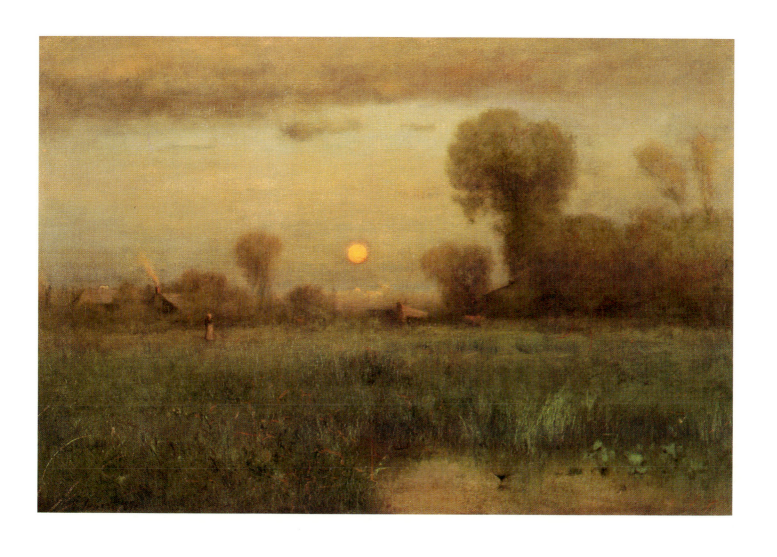

ARTHUR B. DAVIES
1862–1928

Along the Erie Canal

1890
oil on canvas
18 × 40 in (45.7 × 101.6 cm)
The Phillips Collection

Although his mature paintings of classical nudes disposed in idyllic outdoor settings parallel developments in European Symbolism, Arthur B. Davies began his career within the tradition of nineteenth-century American landscape painting. *Along the Erie Canal* is one of his earliest landscapes and not surprisingly reveals several influences. His somewhat naïve treatment of figures and vegetation is a provincial version of the by then old-fashioned style of the Hudson River school. This rustic country scene illuminated with a golden light, which intensifies the calm mood of the still water and trees, is clearly Romantic. Davies derived his free handling of paint and sense of an all-pervading light from the early paintings of George Inness, Homer Martin, and Alexander Wyant, which he had seen at an upstate New York art exhibition in 1874. The innocence and air of fantasy, which characterized this landscape and his other early scenes of children, Davies would retain in his mature work but in a transformed state: the dark, rich palette would be replaced by more spectral blues and grays, the atmospheric light would become mistier and even more evocative.

BORN 1862 in Utica, New York. Studied with Dwight Williams, Utica, 1877. Moved with family to Chicago, 1878. Studied at Chicago Academy of Design, c. 1878. Worked as draftsmen with civil engineering firm, Mexico, 1880–82. Studied at School of the Art Institute of Chicago, with Charles Corwin, 1882–86. Moved to New York; studied at Art Students League of New York, Gotham Art School, 1887. Contributed illustrations to *Century Magazine, Saint Nicholas,* 1887–90. Traveled to Europe, 1893–94. Included in an exhibition of the Eight held 1908, Macbeth Gallery, New York. Supervised execution of tapestry designs, Manufactures Françaises des Gobelins, Paris, 1924–26. Died 1928 in Florence, Italy.

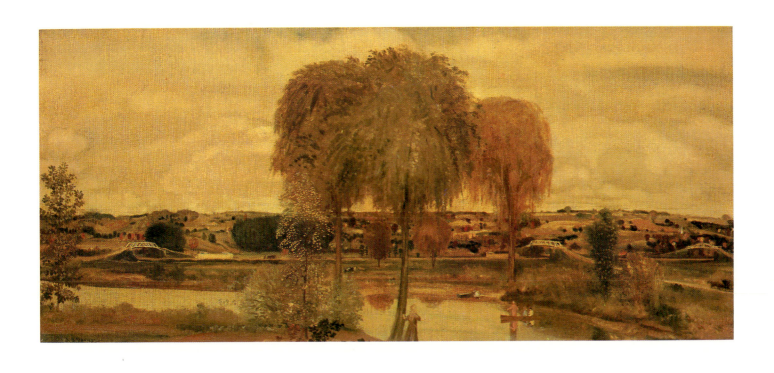

THOMAS WILMER DEWING
1851–1938

Lady with a Mask

c. 1907
oil on canvas
22³⁄₈ × 24¹⁄₄ in (56.9 × 61.6 cm)
The Corcoran Gallery of Art
Museum purchase, 1911

Silent, refined women existing in a world of contemplation and serenity populate Thomas Dewing's paintings. *Lady with a Mask* is representative of his interior scenes: a beautiful woman, elegantly dressed in a flowing gown, sits oblivious to her surroundings and even to the mask that she holds. The woman is set in a shallow space with only misty veils of atmosphere separating her from the viewer. She is ethereal, unapproachable, as was the ideal woman of genteel Victorian America. Like Abbott Thayer and George de Forest Brush, Dewing removes women into a cloistered world. Even the mask is somewhat ambiguous, perhaps another screen meant to conceal the personality. In his concentration on a single, contemplative female figure set in a delicately lit interior, Dewing evokes Vermeer whom he greatly admired. The painting's general mood, however, is Whistlerian in its harmonious arrangement of delicate tones and subdued lights. Dewing is in spirit a Tonalist, but in his focus on the human figure, the mood of revery, and the unexplained mask are intimations of Symbolism.

Other paintings by Dewing can be seen at the Freer Gallery of Art, National Gallery of Art, and National Museum of American Art.

BORN 1851 in Boston. Worked with lithographer, 1868. Studied at Académie Julian, Paris, with Gustave Boulanger, Jules Lefebvre, 1876–79; Royal Academy, Munich, with Frank Duveneck, 1878–79. Opened studio in New York, 1879. Member, Society of American Artists, 1880–97. Taught at Art Students League of New York, 1881–88. Elected member, National Academy of Design, 1887; cofounded the Ten, 1897. Moved to Mount Vernon, New York, 1898. Moved studio back to New York, 1921. Died 1938 in New York.

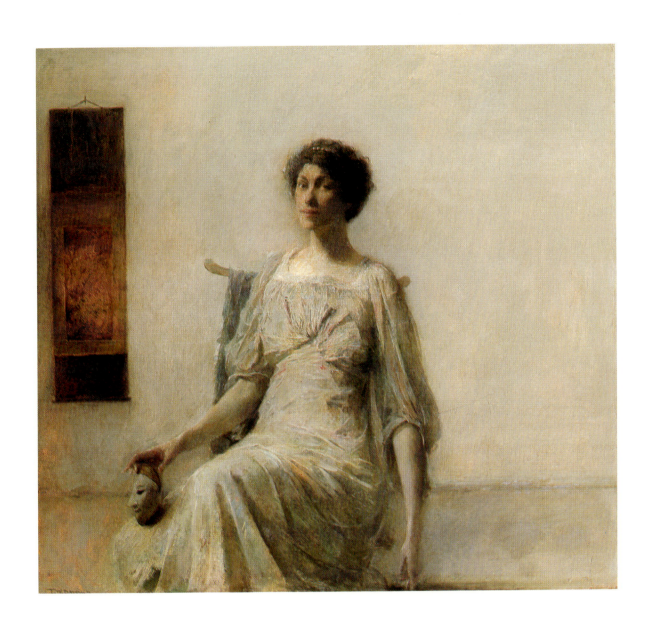

THEODORE ROBINSON
1852–1896

Valley of the Seine from Giverny Heights

1892
oil on canvas
25⅞ × 32⅛ in (65.7 × 81.6 cm)
The Corcoran Gallery of Art
Museum purchase, 1900

One of the most talented of the American Impressionists, Theodore Robinson sought out Monet at Giverny and under his guidance developed a heightened awareness of Impressionist method and outlook. *Valley of the Seine from Giverny Heights*, finished the year of his final return to the United States, reveals the artist's mature perception of the landscape and may be taken as a gauge of the American response to Impressionist technique. Robinson's palette tends to pastel shades; his short, alternating brushstrokes are discretely blended together in an approximation of plein air effects. Yet the overall mood is lyrical, almost melancholy, for Robinson never surrenders himself completely to the French Impressionist fascination with natural color and light. *Valley of the Seine from Giverny Heights* remains a presentation of a particular geographical spot; the subject matter of the valley itself is Robinson's constant point of reference. He retained an insistence on identifiable experience, which American Impressionists refused to relinquish. Robinson would not paint colors he could not see with his eye and found the later work of Monet, his mentor, unnecessarily extravagant.

BORN 1852 in Irasburg, Vermont; moved with family to Wisconsin, 1855. Studied art in Chicago, 1870; at National Academy of Design, New York, 1874. Traveled to France, 1876; studied with Carolus-Duran, Jean-Léon Gérôme. Exhibited at Paris Salon, 1877, 1879. Traveled to Venice; met Whistler, 1878. Returned to New York, 1879. Executed mural decorations with John La Farge, Will Low, 1879–84. Became good friends, and influenced by, Monet at Giverny, 1888. Traveled to Italy; returned to New York, 1892. Befriended fellow American Impressionists John Twachtman, J. Alden Weir. Taught at Brooklyn Arts School, summers, 1893–94; Pennsylvania Academy of the Fine Arts, Philadelphia, 1894. Died 1896 in New York.

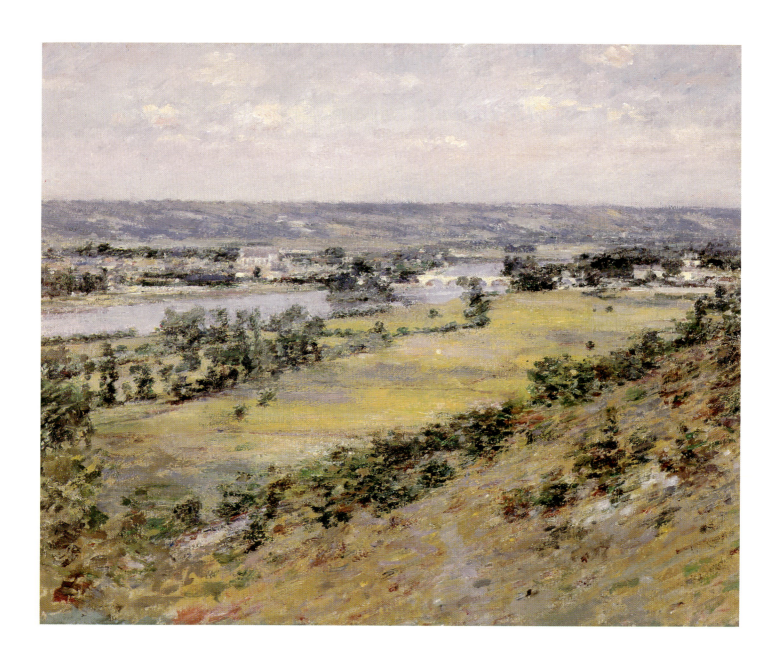

ERNEST LAWSON
1873–1959

Spring Night, Harlem River

1913
oil on canvas mounted on panel
25 × 30 in (63.5 × 76.2 cm)
The Phillips Collection

Following the example of Monet, the American Impressionist Ernest Lawson repeatedly painted the same or similar subjects in order to study various conditions of light and weather. In 1898 he established himself in a still rural section of Manhattan, and began painting High Bridge over the Harlem River. In *Spring Night, Harlem River*, a late depiction of High Bridge, Lawson captured the effect of a summer twilight casting a blue tinge on water, land, and bridge alike. The glowing fresh colors were thickly applied in small, even strokes in the Impressionist manner. Lawson's first instruction in Impressionism was from J. Alden Weir and John Twachtman, and, like American Impressionists in general, he retained a sense of the underlying solidity of forms. The large manmade structure spanning the river loses none of its massiveness despite the evening lighting. The year of this painting marked a turn in Lawson's reputation, beginning with his participation in the Armory Show.

BORN 1873 in Halifax, Nova Scotia, Canada; moved with family to Kansas City, Missouri, 1888. Worked as draftsman, Mexico City, 1889; briefly studied at Santa Clara Art Academy, Mexico. Moved to New York, 1891, studied at Art Students League of New York, 1891–92. Studied with American Impressionists John Twachtman, J. Alden Weir, Cos Cob, Connecticut, 1892; at Académie Julian, Paris, with Benjamin Constant, 1893–94. Exhibited in Paris Salon, 1894. Met Alfred Sisley, 1895. Returned to United States, 1896. Taught at University of Georgia, Columbus, 1897–98. Returned to New York, 1898. First solo exhibition held 1907, Pennsylvania Academy of the Fine Arts, Philadelphia. Elected associate, academician, National Academy of Design. Included in Society of Independent Artists Annual, 1917. Taught at Kansas City Art Institute and School of Design, 1926; Broadmoor Academy, Colorado Springs, Colorado, 1927. Executed mural commission: Federal Works Agency, U.S. Post Office, Short Hills, New Jersey, 1939. Died 1959 in Coral Gables, Florida.

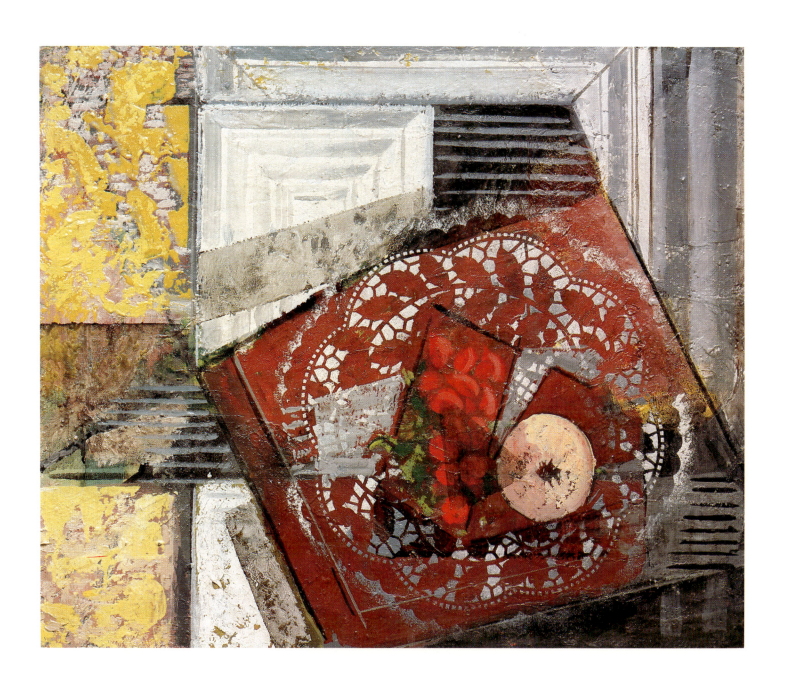

135

JOHN MARIN
1870–1953

The Sea, Cape Split

1939
oil on canvas
24 × 29 in (60.9 × 73.7 cm)
The Phillips Collection

For the past two centuries, Maine has provided artists with a fecund panoply of natural beauty and grandeur. Marin summered in Maine from 1914 on, particularly at Cape Split, on the northern reach of the Atlantic coast. The wildness of this area appealed to Marin—the inherent passion of the wind, waves, and rocks of the coast and the more quiescent weathered and forested mountains of the interior. It provided visual analogues of his view of life. *The Sea, Cape Split* is one of more than a dozen treatments of the same subject, seen at occasionally different angles or seasons. Marin adopted this tendency of working in series from the Impressionists and Cézanne, from whom he also learned to fuse drawing and color planes. The composition is highly activated by Marin's sense of natural forces, manifested by angular smears and slashes of the brush played against sinuous wanderings or more impassive daubs and scumbles. The force of the shifting sea as it pounds the rocky shore is represented by the individual brushstrokes as they slide and weave across the surface of the canvas and serve to express the vitality that Marin found in nature. This dynamic spread of painterly activity throughout the picture foreshadowed Abstract Expressionism's energetic technique.

BORN 1870 in Rutherford, New Jersey. Studied engineering, Stevens Institute of Technology, Hoboken, New Jersey, 1888. Worked as free-lance architect, New Jersey, early 1890s. Studied at Pennsylvania Academy of the Fine Arts, Philadelphia, with Thomas Anshutz, Huge Breckenridge, 1899–1901; Art Students League of New York, with Frank DuMond, 1901–3. Lived in Europe, 1905–11. Exhibited in Paris at Salon d'Automne, 1907, 1908, 1910; Salon des Indépendants, 1909. First solo exhibition held 1909, at Alfred Stieglitz's gallery, 291, New York. Moved to Cliffside, New Jersey, 1916. Summered at Taos, New Mexico, 1929, 1930. Died 1953 in Cape Split, Maine.

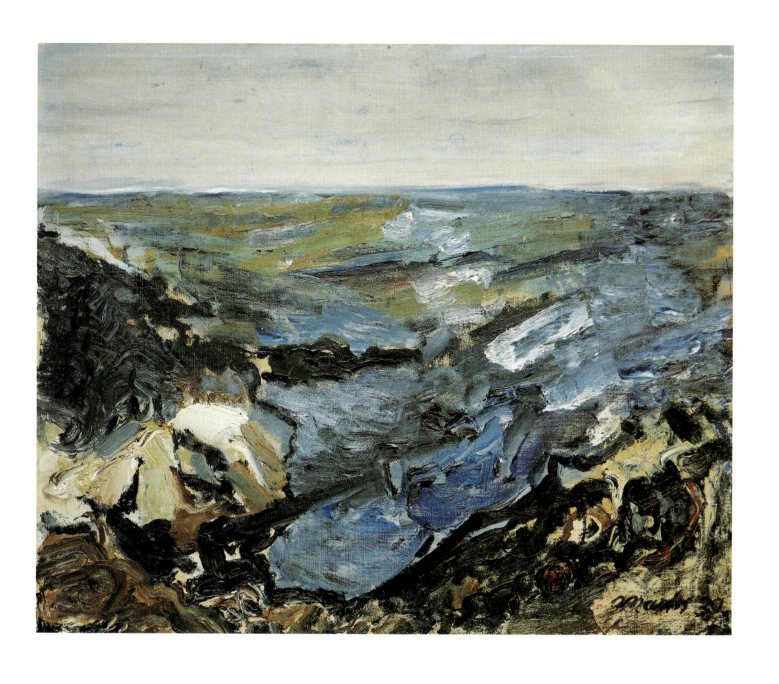

ARTHUR G. DOVE
1880–1946

Pozzuoli Red

1941
wax emulsion on canvas
22 × 36 in (55.8 × 91.5 cm)
The Phillips Collection

The paintings of Arthur Dove startled and annoyed the few people who saw them in 1910. His abstract pictures inspired a clever journalist to put critical opinion to rhyme: *But Mr. Dove is far too keen / To let a single bird be seen / To show the pigeons would not do / And so he simply paints the coo.* Like other American artists in Paris in 1907, Dove witnessed the excitement and vigor of the young avant-garde painters. He returned to New York and began his own battle to conceive the abstract forms of nature. Responding to the most extreme theories of modern art, and to the Dada experiments of Duchamp and Picabia, Dove enjoyed the precocious wit and bold technique of their collages. In the 1920s he left the conflicting debates of the New York art world and retired to the country where he made his living as both a farmer and a fisherman. For several years he lived and painted in the small cabin of a forty-two-foot yawl he sailed off the coast of Long Island. Dove painted *Pozzuoli Red* late in life. Still grappling with the problems of abstract forms, he sought the existing constants of nature, the shapes and colors that explained its inherent rhythm. Dove did not follow the analytical attitude of the Cubists but developed a highly personal style suggestive of land and sky, horizon and sea.

BORN 1880 in Canandaigua, New York. Studied at Hobart College, Geneva, New York, 1898–1900; Cornell University, Ithaca, New York, with illustrator Charles Furlong, 1900–1903. Worked as commercial artist and illustrator for *Saturday Evening Post, Harper's, Scribner's, Collier's,* 1903–7. Traveled to Europe, 1907; met Alfred Maurer, Arthur Carles. Lived in Cagnes-sur-Mer, France, with Maurer, 1907–9. Exhibited in Salon d'Automne, Paris, 1908, 1909. Returned to New York, 1909. Included in exhibition held at Alfred Stieglitz's gallery, 291, New York, 1910; first solo exhibition held 1912; continued to exhibit with Stieglitz. Lived in Halesite, Long Island, New York, 1929–33. Moved to Geneva, New York, 1933; Centerport, New York, 1938, where he died in 1946.

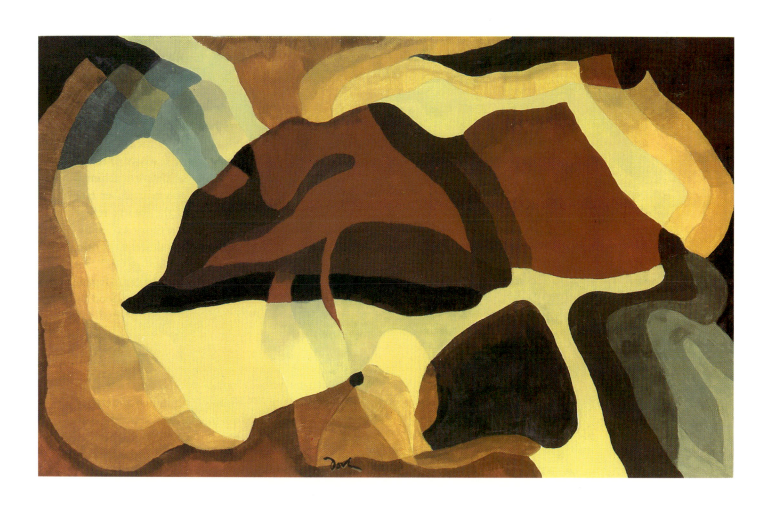

STANTON MACDONALD-WRIGHT
1890–1973

Conception Synchromy

1914
oil on canvas
36 × 30⅛ in (91.3 × 76.5 cm)
Hirshhorn Museum and
Sculpture Garden
Smithsonian Institution

Postimpressionist color theory and French Cubism tremendously influenced the young American painters studying in Paris before World War I, especially those who frequented Gertrude and Leo Stein's apartment. Paintings at the Steins', such as *Three Women* by Picasso, and the Orphism of Robert and Sonia Delaunay presided at the birth of Synchromism, the first American variant of Cubism, initiated by Morgan Russell and Stanton Macdonald-Wright in a landmark exhibition held in Munich in 1913. While visibly influenced by Robert Delaunay's 1912–13 series, Circular Forms, Sun and Moon, Macdonald-Wright's painting is compositionally more complex than any of Delaunay's. The notion of the first instant of conception and of the burgeoning germ of life is worked out in brilliant colors of the spectrum through interlocking, ever-enlarging circles extending into infinite space. The artist had earlier written, "space in my work is expressed by a spectrum that unfolds itself into depth." The title of this work, *Conception Synchromy*, recalls the Symbolist preoccupation with the depiction, in symbolic terms, of the life cycle of men and gods. While Macdonald-Wright's colleague Russell painted *Cosmic Synchromy*, Macdonald-Wright himself was working toward *Conception Synchromy*, which over the course of two years took shape in at least three canvases, of which this painting is the largest. Within two years of this work's execution, Synchromism began to gain an enthusiastic response among American artists as "an embodiment of the modern spirit."

BORN 1890 in Charlottesville, Virginia. Studied art privately with tutors, 1895–1900. Moved with family to Santa Monica, California, 1900. Studied at Art Students League, Los Angeles, 1904–5. Lived in Paris, 1907–13, where he studied at Sorbonne, Ecole des Beaux-Arts, Académie Julian, Académie Colarossi. Met Morgan Russell; studied color theory with Ernest Tudor-Hart, 1911. Developed principles of Synchromism with Russell, 1913. Included in first Synchromist exhibitions, with Russell, at Neue Kunstsalon, Munich; Galerie Bernheim-Jeune, Paris, 1913. Returned to United States, 1913. Back in Paris, 1914; lived in London, 1914–16. Collaborated with brother, Willard Huntington Wright, on several books on modern art. Returned to New York, 1916. First solo exhibition held 1917, at Alfred Stieglitz's gallery, 291, New York. Moved to Santa Monica; involved with film. Director, Art Students League, Los Angeles, 1922–30. Wrote *A Treatise on Color*, 1924. Executed mural commission: Public Works of Art Project, Santa Monica Library, 1934–35. Director, WPA Federal Art Project, southern California, 1935–37; technical advisor, 1938–42. Taught at University of California at Los Angeles, 1942–52; 1953–54; Tokyo University of Education, 1952–53. Interested in oriental art. Died 1973 in Pacific Palisades, California.

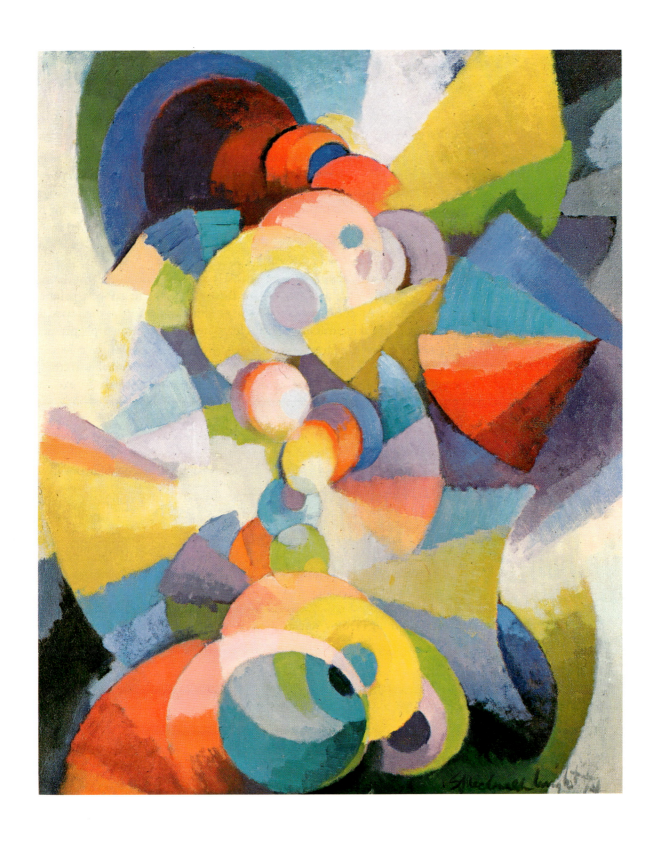

CHARLES SHEELER
1883–1965

Staircase, Doylestown

1925
oil on canvas
25⅛ × 21⅛ in (63.2 × 53.1 cm)
Hirshhorn Museum and
Sculpture Garden
Smithsonian Institution

Sheeler was a painter who supported his career for many years by work as a professional photographer. The artist found the motif of *Staircase, Doylestown* in a Pennsylvania house that he had rented for more than a decade for weekend sketching in the countryside. Painted two years after he had given up the house, it is the crystallization of an enigmatic sensation caused by the powerful twist of the spiral stair. The forms of risers and treads, essentially regular and repetitive but not as painted by Sheeler, are given new and startling vitality by the exaggeration of perspective; the treads plunge into the shallow space of the stairwell, and the tabletop in the room below tilts into a diamond shape. Color here is warm and muted. There is also an overall silvery tonality that might be found in a photograph, yet in photographs taken in the Doyleston house, Sheeler chose strongly lit closeups of interior details. He said of the painting: *Two things are going on at the same time in the picture, irrelevant to each other but relevant to the whole, one in the room downstairs, one leading to the room upstairs. I meant it to be a study in movement and balance.* Movement is the essence of the spiral staircase and informs the fanlike thrust of the overhead beams. Balance is thoughtfully articulated in both color and form, and the whole has the austere simplicity of the Shaker architecture and crafts that Sheeler so often painted and photographed.

BORN 1883 in Philadelphia. Studied in Philadelphia at School of Industrial Art, 1900–1903; Pennsylvania Academy of the Fine Arts, with William Merritt Chase, 1903–6. Summered in Europe, with Chase's class, 1904, 1905. First exhibited at National Academy of Design, New York, 1906. Lived in Philadelphia, from 1906. First solo exhibition held 1908, McClees Galleries, Philadelphia. Traveled to Europe, 1908. Took up commercial photography, 1912; later influenced his paintings. Gallery assistant for Marius De Zayas, 1918–23; with Paul Strand filmed *Manahatta*, 1920. Worked as photographer for *Vogue, Vanity Fair*, from 1923. Lived in South Salem, New York, 1927–32. Traveled to Europe, 1929. Moved to Ridgefield, Connecticut, 1933; Irvington-on-Hudson, 1943. Artist-in-residence, Phillips Academy, Andover, Massachusetts, 1946; Currier Gallery of Art, Manchester, New Hampshire, 1948. Died 1965 in Dobbs Ferry, New York.

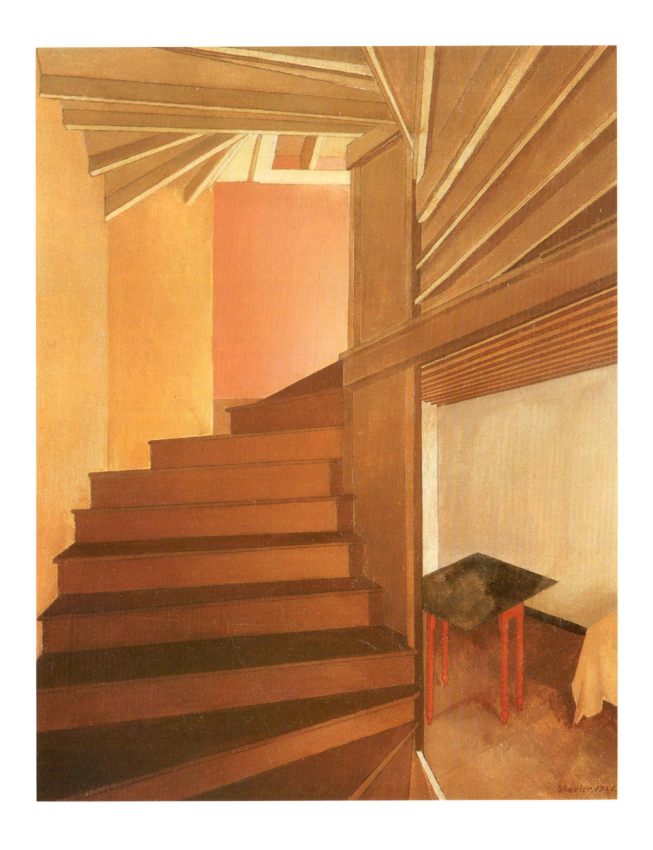

CHARLES BURCHFIELD
1893–1967

Woman in Doorway

1917
tempera on mounted cloth
24 × 30 in (61.0 × 76.2 cm)
The Phillips Collection

Burchfield was tied in a love-hate relationship to rural America where he grew up and lived all his life. A reclusive individual, he was deeply attached to the land and to nature, feeling a mysterious bond with the forces that resided in it and which he tried to externalize in a repertory of visual signs. His earliest work of 1916–18 was the expression of a profound personal anxiety. He found a fanciful symbolic mode, suggestive of Edvard Munch, fin de siècle Symbolism, and Art Nouveau, with which to exorcise his private demons. Within this context, *Woman in Doorway* is a startling picture because it is the prefiguration of the realist manner that was to make him famous after his return from military service in World War I. There is still some remnant of the calligraphic symbolism of the early style, especially in the wallpaper and woodwork, but the rest is directly and arrestingly realistic, a new kind of laconic yet revealing factualism about the environment that adds up to a definition of personality characteristic of American Scene painting. It is a remarkable achievement for one so young and a remarkable example within his total oeuvre. In the watercolors that were to follow in the early 1920s he worked this vein and managed to capture the postwar depression of the mining town of Salem, Ohio, and its rural environs with the same accuracy, poetic intensity, and symbolic imagery.

BORN 1893 in Ashtabula Harbor, Ohio; moved with family to Salem, Ohio, 1898. Studied at Cleveland School of Art, with Henry Keller, Frank Wilcox, William Eastman, 1912–16. Received scholarship to National Academy of Design, New York. Moved to New York, 1916; Buffalo, 1921. Worked as wallpaper designer, 1921–29. First solo exhibition held 1921, Art Institute of Chicago. Died 1967 in West Seneca, New York.

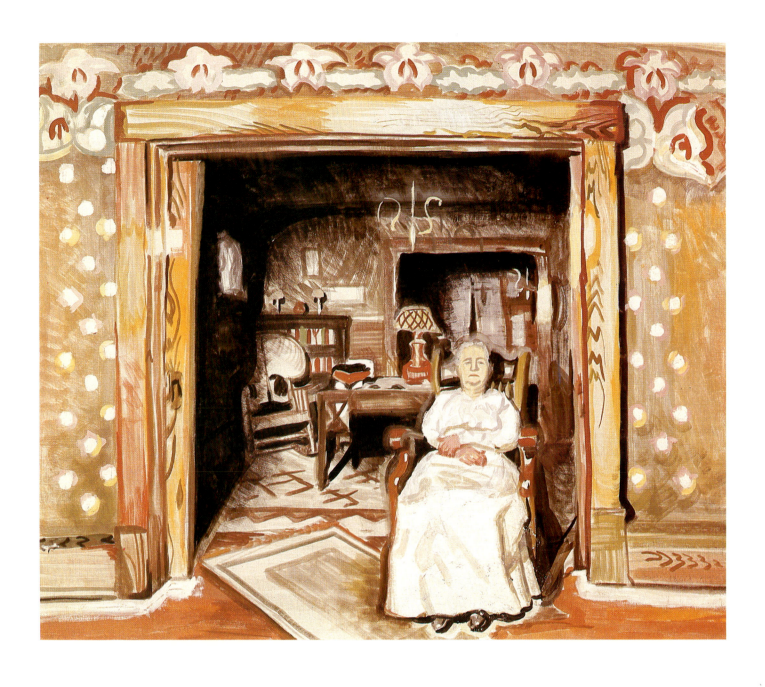

EDWARD HOPPER
1882–1967

Eleven a.m.

1926
oil on canvas
23⅛ × 36⅛ in (71.3 × 91.6 cm)
Hirshhorn Museum and
Sculpture Garden
Smithsonian Institution

Despite the aesthetic conflict between representational and abstract art in the United States during the twentieth century, Edward Hopper, generally recognized as the leading realist painter of his time, found acceptance in both camps. Although Hopper sold a painting out of the Armory Show in 1913, he was forced in the following years to make his living as an illustrator and confined his creative activities largely to etching. When he emerged again as a painter in the mid 1920s, it was to unveil a new kind of realism. Hopper owed an obvious debt to John Sloan and the Ashcan tradition in his urban subject matter, but it was now updated by a sharp, high-keyed, though cool light that defined form with clarity and force. The nature of American society had meanwhile also changed, and Hopper's vision was quite different from Sloan's. Gone was the optimism, social focus, and human warmth; doubt, alienation, and loneliness had entered the enchanted garden and a new sense of unease was pervasive. Among Hopper's major subjects was the lonely stranger in an anonymous room in some unknown city, which became with time for Hopper the symbol of urban alienation and to which he returned obsessively. It was never more subtly treated than in *Eleven a.m.* We see only a woman, naked except for her high-heeled shoes, seated and staring out of a window at an undefined wall. The very concrete reality of that moment paradoxically emphasizes its mystery and psychic ambiguity.

BORN 1882 in Nyack, New York. Studied illustration at commercial art school, New York, 1899–1900; New York School of Art, with Robert Henri, George Luks, Kenneth Hayes Miller, 1900–1906. Traveled to Europe, 1906–7; introduced to Impressionism by Patrick Henry Bruce. Settled in New York. Traveled to Europe, 1908, 1909, 1910; worked as commercial illustrator, 1908–24. Summered in New England, painting. First solo exhibition of paintings held 1920, Whitney Studio Club, New York. Summered in Cape Cod, with trips to Southwest and Mexico. Died 1967 in New York.

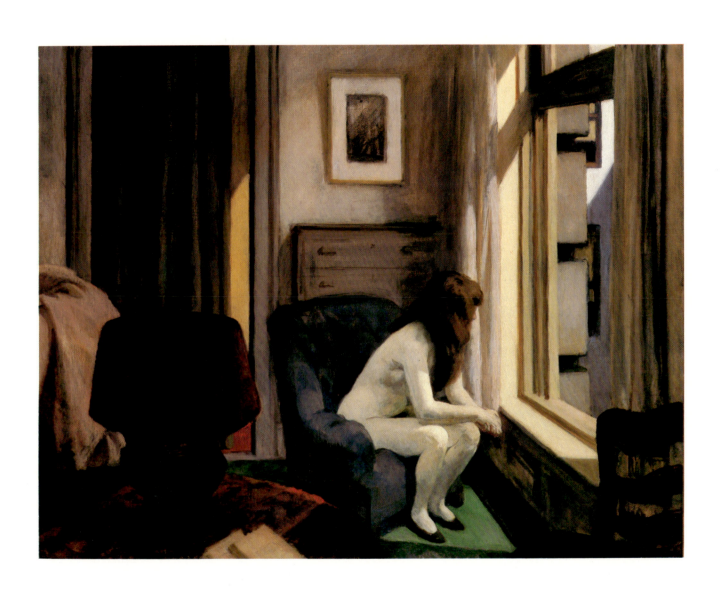

WALT KUHN
1877–1949

The White Clown

1929
oil on canvas
40¼ × 30¼ in (102.3 × 76.9 cm)
National Gallery of Art
Gift of the W. Averell Harriman
Foundation in memory of Marie N.
Harriman 1972

Although Walt Kuhn helped introduce avant-garde European art to the United States, he experimented only briefly with radical trends. The lessons that he learned from the Armory Show served more to strengthen his native realism. The subject of this painting—a circus performer—has been fruitful for the music and literature of the past century as well as the visual arts, inspiring Cézanne, Seurat, Rouault, and Picasso among others. The entertainer was often seen as a representative of creative life; for Kuhn, this type of portraiture became a preoccupation. Cézanne's monumental portraits and Derain's of the 1910s and 1920s taught Kuhn the massing of simplified forms into sculptural solidity. The white clown's imposing figure squares itself with, and virtually fills, the frame of the picture. Shot with light and modeled by only a few half-tone patches and dark accents, the figure thrusts out boldly against the obscure background. The figure's dramatic isolation underscores Kuhn's interest in the clown's psychological demeanor. His overt muscularity manifests more than simply the exertion necessary for his act. The tense, flexed anticipation of his pose is countered by the impassivity of his face. The slack, narrowed features seem to mask some inexplicit sadness or uneasy resolve. With remarkable economy, Kuhn suggests the powerfully disturbing contradictions of life—the artist's life in particular—and the strength needed to meet them.

BORN William Kuhn 1877 in Brooklyn. Studied at Polytechnic Institute, Brooklyn, evenings, 1893; Académie Colarossi, Paris, 1901; Royal Academy, Munich, 1901–3. Worked as cartoonist, San Francisco, 1899–1900; New York, 1905–14. Taught at New York School of Art, 1908. First solo exhibition held 1910–11, Madison Avenue Gallery, New York. Staged musical revues, 1922–23, 1925–26. Advisor to art collectors John Quinn, Lillie P. Bliss, Marie Harriman. Taught at Art Students League of New York, 1927–28. Died 1949 in White Plains, New York.

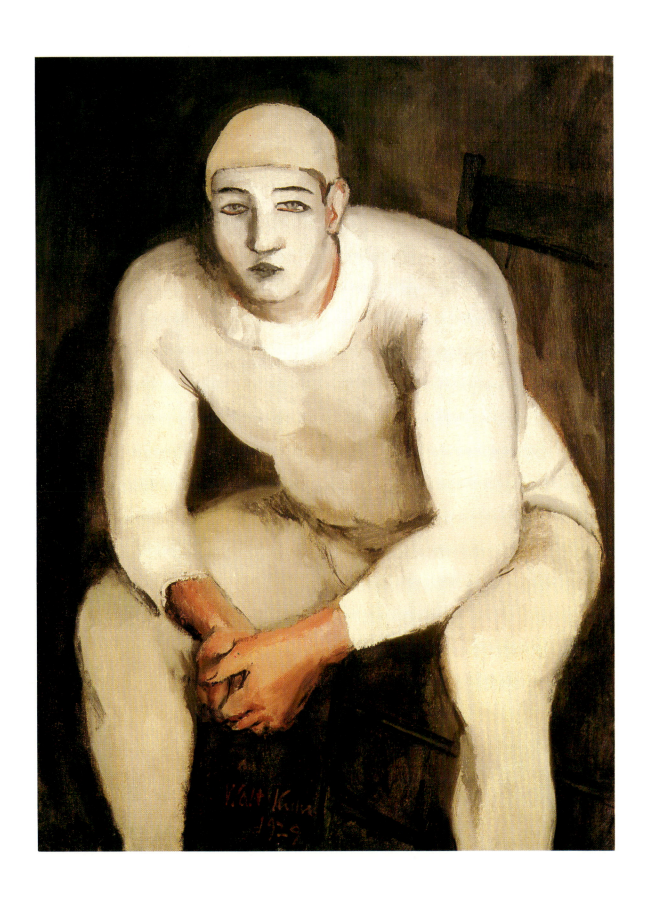

IVAN ALBRIGHT
born 1897

The Farmer's Kitchen

c. 1933–34
oil on canvas
36 × 30⅛ in (91.0 × 76.5 cm)
National Museum of American Art
Smithsonian Institution
Transfer from the U.S. Department
of Labor

Independent both financially and aesthetically, Ivan Albright works very painstakingly and slowly and sets what seems to be exorbitant prices on his canvases. His most famous painting, *That Which I Should Have Done I Did Not Do*, took him ten years to complete and was priced at one hundred thousand dollars. A fanatically meticulous realist with a passion for decay, his work has obvious affinities with Regionalism, Social Realism, and Magic Realism, though he does not fit into categories easily. Albright's overriding concern is with time and death as inexorable facts of life. His surgical precision and delight in rendering detail, which may have derived from his wartime apprenticeship as a medical illustrator, seem almost to peel the surface of detail to reveal the inner ugliness of being. The stark disclosure of reality, as he sees it, gives his work the appearance of critical social comment, but it is more philosophical and literary than social. *The Farmer's Kitchen* is less pointedly philosophical than most of Albright's work, and in its rural subject the closest he has ever come to Regionalism. Albright finds in the ordinary the profundity of the universal, and he uses his friends and neighbors as models. The model for *The Farmer's Kitchen* was his Warrenville, Illinois, neighbor, Mrs. George Washington Stafford, whose husband had earlier posed for the majestically harrowing *God Created Man in His Own Image*. *The Farmer's Kitchen* was painted during Albright's short tenure with the Public Works of Art Project and remains unsigned because he claimed he was never paid.

BORN 1897 in North Harvey, Illinois. Taught drawing by his father, 1905. Studied at Northwestern University, Evanston, Illinois, 1915; University of Illinois, Urbana, 1916; School of the Art Institute of Chicago, 1920–23; National Academy of Design, New York, 1924. Served in U.S. Army Medical Corps, France, 1918–19. Lived in Illinois, California, New Mexico, Pennsylvania, 1924–29. Employed on Public Works of Art Project, 1933–34. President, Chicago Society of Artists, 1934–36. Elected associate, National Academy of Design, 1942; academician, 1950. Moved to Vermont, 1963. Lives in Woodstock, Vermont.

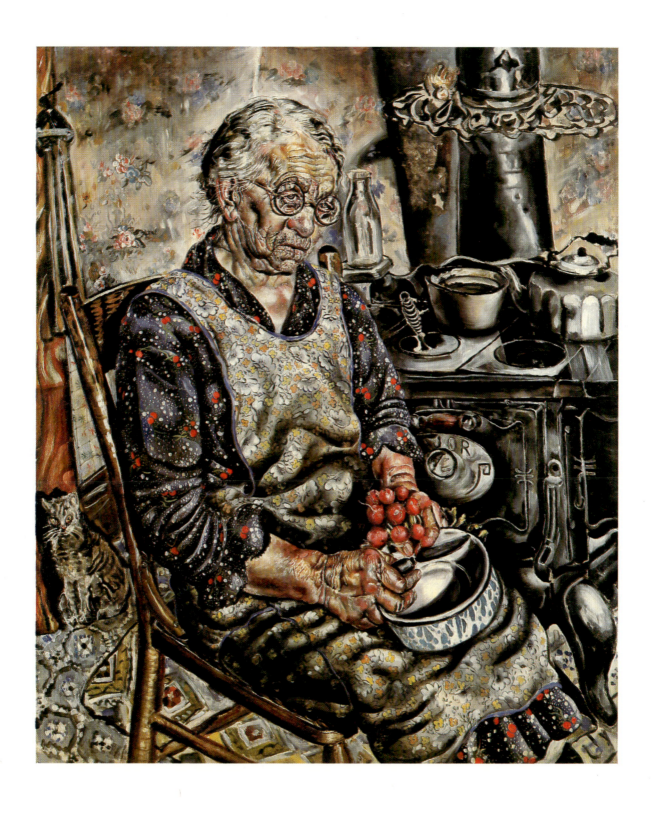

REGINALD MARSH
1898–1954

Smoke Hounds

1934
egg tempera on masonite
36 × 30 in (91.4 × 76.2 cm)
The Corcoran Gallery of Art
Gift of Felicia Meyer Marsh, 1958

As a free-lance newspaper artist and magazine illustrator, 1920–31, Marsh turned out a wide range of closely observed sketches, mostly crowd scenes of New Yorkers at the movies, burlesque houses, amusement parks, and beaches, which continued in the illustrative tradition of Boardman Robinson and were directly related to the Ashcan school. Marsh had studied at the Art Students League with John Sloan and George Luks. In the late 1920s, he became identified with a group that included Kenneth Hayes Miller—with whom Marsh had studied—the Soyer brothers, Isabel Bishop, Edward Laning, and Morris Kantor. Marsh's more somber depictions of derelicts and the jobless on the Bowery and in the Hoovervilles illustrate the impact of the depression during the 1930s. The Bowery with its flophouses and bars was the retreat of tramps, derelicts, and alcoholics. In *Smoke Hounds* a group is shown in the process of mass intoxication from cheap alcohol (sometimes the destitute even drank lighter fluid, hence the term "smoke hounds"). For Marsh such scenes revealed the color and variety of urban life, but during the depression, as hordes of unemployed and the displaced drifted down into such neighborhoods, the Bowery took on a new meaning. It became a metaphor for a dislocated society, a sign of hard times, and the degradation of man. In this context, in those days, Marsh could be interpreted as a Social Realist.

BORN 1898 in Paris, of artist parents; grew up in New Jersey. Studied at Yale University, New Haven, Connecticut, B.A., 1920; Art Students League of New York, with John Sloan, George Luks, Kenneth Hayes Miller, George Bridgeman, 1919–22, 1927–28. Worked as newspaper artist, magazine illustrator for *New York Evening Post, New York Herald Tribune, Vanity Fair, Harper's Bazaar,* 1920–25; *New York Daily News,* 1922–25; *New Yorker,* 1925–31. Began exhibiting paintings of New York life, 1920s. Studied dissection, Columbia University, College of Physicians and Surgeons, New York, 1931. Employed on Public Works of Art Project, New York, mural division, 1933–34. Executed mural commissions: Treasury Relief Art Project, U.S. Customs House, Bowling Green, New York, 1936–37. Wrote *Anatomy for Artists,* 1945. Died 1954 in New York.

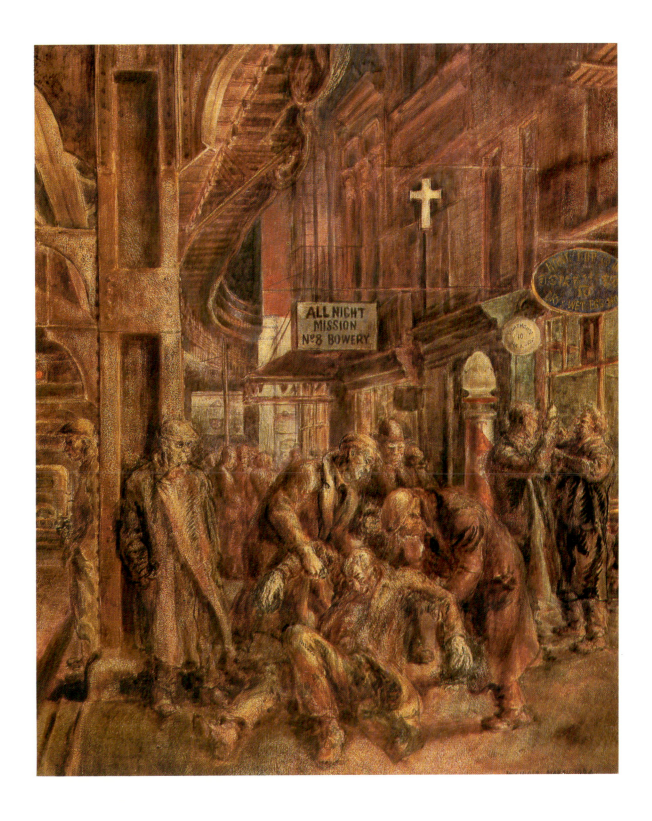

BEN SHAHN
1898–1969

Brothers

1946
tempera on rice paper mounted on
fiberboard and wood panel
38¹⁵/₁₆ × 25¹⁵/₁₆ in (98.5 × 65.8 cm)
Hirshhorn Museum and
Sculpture Garden
Smithsonian Institution

An artist of diverse abilities, Ben Shahn created paintings, posters, murals, illustrations, advertisements, and photographs that have achieved both artistic recognition and broad public appeal. He worked with Diego Rivera on the murals at Rockefeller Center and executed his own mural projects under the WPA Federal Art Project. He designed posters for the U.S. Government during World War II and contributed illustrations for books and magazines. Until 1930, the year of Shahn's first solo exhibition, he supported himself by working as a lithographer. His concern for calligraphy in those early years affected his work in its incorporation of written text and in the wiry line that pervades his art. Shahn's paintings combine distorted angular forms based on photographic images with strong statements about man's inhumanity. He frequently addressed himself to issues of discrimination and persecution, as in his famous series of paintings that depict the unjust accusations and execution of the two immigrant anarchists Sacco and Vanzetti. After World War II, Ben Shahn increasingly saw such themes of injustice and persecution as relevant to his own Jewish heritage. Moved by stories of the destruction and dislocation of Jewish families during the Holocaust, Shahn painted *Brothers* as a symbolic expression of the hope of reunion, peace, and the brotherhood of man.

BORN Benjamin Hirsch Shahn 1898 in Kovno (Kaunas), Lithuania; immigrated with family to Brooklyn, 1906. Studied in New York at Educational Alliance, 1911; Art Students League of New York, 1916; New York University; City College of New York; National Academy of Design, 1917–22; in Paris at Académie de la Grande Chaumiére, 1925. Traveled to Europe and North Africa, 1925, 1927–29. Returned to New York, 1929. Shared studio with Walker Evans. Became well known as Social Realist, 1930s. Joined Public Works of Art Project, 1934. Executed mural commissions: Prohibition series, studies for projected mural; Federal Housing Project, Roosevelt, New Jersey, 1938; Bronx Central Annex U.S. Post Office, with wife, Bernarda Bryson, 1938–39; Federal Social Security Building, Washington, D.C., 1940–42. Member, editorial staff, *Art Front*, 1934. Photographer, Farm Security Administration, 1935–38. Staff member, Graphics Division, Office of War Information, Washington, D.C., 1942–43. Director, Graphic Arts Division, Congress of Industrial Organizations, 1945–46. Wrote and illustrated *The Alphabet of Creation*, 1954; *The Shape of Content*, 1957; *Ecclesiastes or the Preacher*, 1965. Died 1969 in New York.

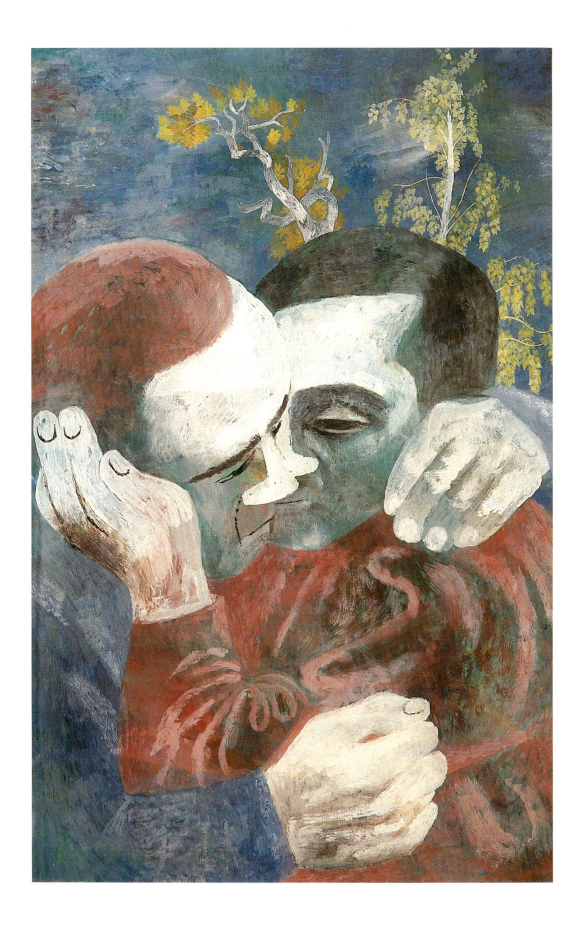

JACK LEVINE
born 1915

The Syndicate

1939
oil on canvas
30 × 45 in (76.5 × 114.5 cm)
Hirshhorn Museum and
Sculpture Garden
Smithsonian Institution

Born in the tenements of Boston and raised during the depression, Jack Levine found mythic events in the urban life around him. His art was a product of the social consciousness of the 1930s, and his earliest works as a painter under the WPA Federal Art Project placed him in the forefront of the Social Realists. He used caricature and a mordant wit to express his rage against poverty, oppression, injustice, and the corruption of power. *The Syndicate* is a metaphor for the organization of the corruption of power—wealth, politics or the law, and crime. As Levine himself has said: *That part of my work which is satirical is based on observations gathered . . . hanging around street corners and cafeterias [where] I often hear from urbane and case-hardened cronies about crooked contractors, ward heelers, racketeers, minions of the law, and the like. It is my privilege as an artist to put these gentlemen on trial, to give them every ingratiating characteristic they might normally have, and then present them, smiles, benevolence and all, in my own terms.* Levine has a strong sense of continuity in art and of the relationship of his art to the social art of the past but even more than that to the great masters and traditions of painting— Rembrandt, Rubens, Velázquez, El Greco, and the Venetians. Although he has denied any conscious borrowing, early works like *The Syndicate* suggest an affinity with the Expressionistic passion of Rouault and Soutine.

BORN 1915 in Boston. Studied at West End Community Center, Roxbury, Massachusetts, with Harold Zimmerman, 1924–31; Museum of Fine Arts, Boston, 1929; privately with Denman Ross, Harvard University, Cambridge, Massachusetts, c. 1929–32. Traveled to Rome, 1932. Employed on WPA Federal Art Project, 1935–40. Included in Whitney annuals, 1938–67. First solo exhibition held 1938, Downtown Gallery, New York. Served in U.S. Army Corps of Engineers, 1942–45. Settled in New York, 1945. Taught at Pennsylvania Academy of the Fine Arts, Philadelphia, 1966–69. Lives in New York.

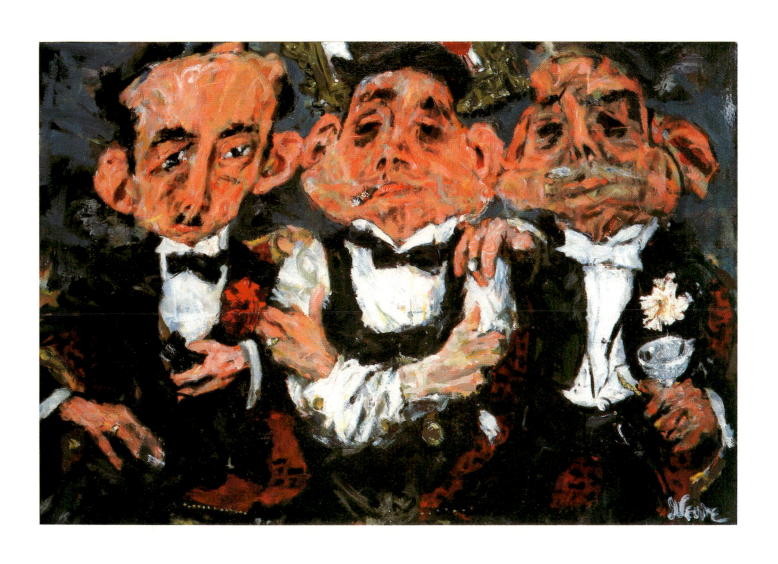

JACOB LAWRENCE
born 1917

Migration of the Negro #11

1940–41
tempera on masonite
12 × 18 in (30.5 × 45.7 cm)
The Phillips Collection

Jacob Lawrence was among the first American Black artists to be fully accepted in the American art world. Exposed to the depression in its more severe manifestations in the ghettos of Harlem, Lawrence recorded the details of slum life and the vitality of the Harlem streets. His art was influenced not only by the well-known Mexican muralists, Rivera and Orozco, but also by Brueghel, Käthe Kollwitz, and Arthur Dove. Inspired by Ben Shahn's serial paintings, Lawrence created several series based on his Black heritage. Like Shahn, Lawrence believed he could not fully express the multiplicity of an idea in a single painting. In the Migration series, begun in 1940, Lawrence's theme was the movement of Blacks from the rural South to the urban North after World War I. The sixty tempera panels of the series depict one of the largest historic shifts in U.S. population and the problems and abuses that followed. Presented in a narrative context, the panels are accompanied by text. The caption of *Migration of the Negro #11*, for example, reads: *In many places, because of the war, food had doubled in price.* In a stylized abstract manner, Lawrence conveys an apparent primitivism and childlike directness. Yet he manages to create a sophisticated style of angular forms, bold colors, and exaggerated perspective to express an emotional identification with the heritage of his own people.

BORN 1917 in Atlantic City, New Jersey; moved with family to Easton, Pennsylvania, 1919, then to Philadelphia, 1924. Moved to New York, 1930. Studied in New York at Harlem Art Workshop, with Charles Alston, 1932; WPA classes, with Henry Bannarn; 141st Street Studio, 1934–37; American Artists School, with Anton Refregier, Sol Wilson, Eugene Moreley, 1937–39. First solo exhibition held 1938, Harlem YMCA, New York. Employed on WPA Federal Art Project, 1938–39. Traveled to New Orleans, 1941–42. Served in U.S. Coast Guard, 1943–45. Taught at Black Mountain College, North Carolina, summer 1946; Pratt Institute, Brooklyn, 1956–71; artist-in-residence, Brandeis University, Waltham, Massachusetts, 1965; New School for Social Research, New York, 1966; Art Students League of New York, 1967–69; University of Washington, Seattle, since 1971. Traveled to Nigeria, 1964. Executed mural commission: State Capitol, Olympia, Washington, 1972. Lives in Seattle.

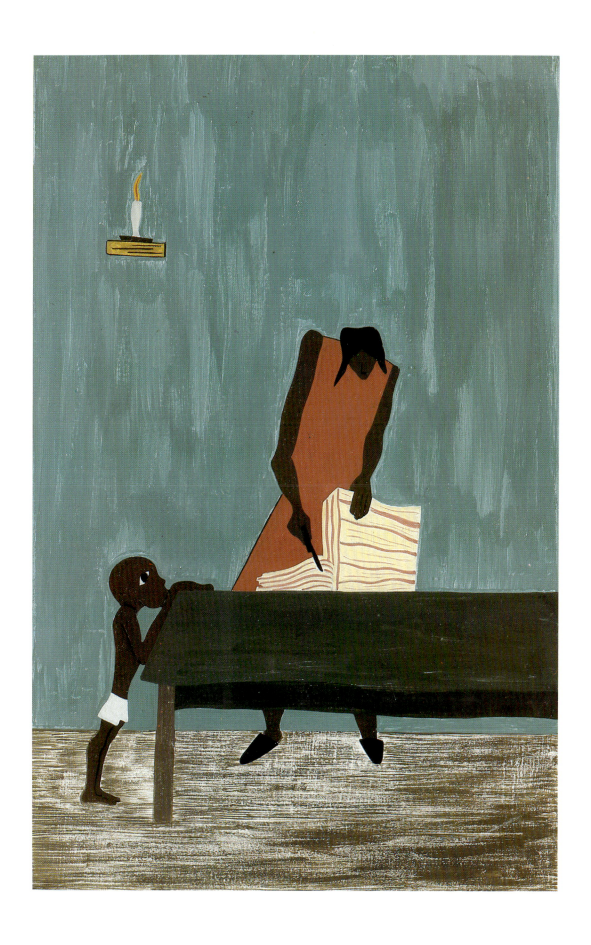

PHILIP EVERGOOD
1901–1973

Sunny Side of the Street

1950
egg-oil varnish emulsion with marble
dust on canvas
50 × 36¼ in (127.0 × 97.2 cm)
The Corcoran Gallery of Art
Museum purchase
Anna E. Clark Fund, 1951

Philip Evergood played an active role in the art and politics of the 1930s. He developed a concern for social causes and a belief that art could be used as a means of political expression. An admirer of children's art, he adapted its bold directness and conscious naïveté to create a balance between the imaginary and the real, sensuosity and satire, vulgarity and decoration. He combined social commentary with humor and satire in the 1930s and with fantasy in the 1940s. In the 1950s, as in *Sunny Side of the Street*, Evergood turned to new social themes, treating them with more subtlety and temperance. There is a mellowness and change in atmosphere that is less bitter and more detached. His subjects no longer emerge from topical issues but are concerned with the general human predicament. Evergood wrote that *Sunny Side of the Street* was created from his impressions of a depressed Black section of New York. He was deeply moved by the crippled woman who sat at her window, the blind man who fumbled down the street, the dank hallways, graffiti, uncollected garbage, hopscotch game, noise, and smells. The title of the painting is from the lyrics of a popular song: *If I never had a cent I'd be rich as Rockefeller / Gold dust at my feet on the sunny side of the street.*

BORN Philip Blashki 1901 in New York; son of painter Meyer Evergood Blashki; lived in England, 1909–23. Studied at University of Cambridge, England, 1918–20; Slade School, London, 1921–23; Art Students League of New York, Educational Alliance Art School, evenings, 1923; Académie Julian, Paris, 1924; British Academy, Rome, 1925; Stanley William Hayter's Atelier 17, Paris, 1930. Returned to United States, 1926. First solo exhibition held 1927, Dudensing Galleries, New York. Executed murals: WPA Project, *Government Report on the North River*, 1934; Federal Art Project, *The Story of Richmond Hill*, Richmond, Long Island, Public Library, 1937; Treasury Department, Section of Fine Arts, U.S. Post Office, *Cotton from Field to Mill*, Jackson, Georgia, 1938; Kalamazoo College, Michigan, 1941. Joined Artists Congress, 1936; president, Artists Union. Managing supervisor, WPA Federal Art Project, New York, easel division, 1938. Artist-in-residence, Kalamazoo College, 1940–42. Died 1973 in Bridgewater, Connecticut.

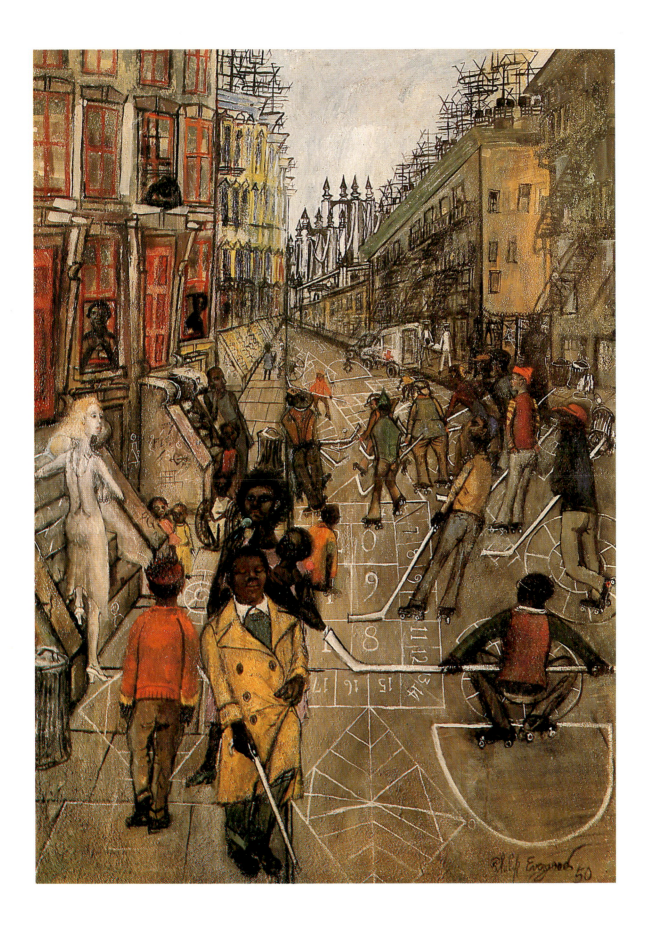

173

O. LOUIS GUGLIELMI
1906–1956

Connecticut Autumn

1937
oil on fiberboard
23⅞ × 30⅛ in (60.5 × 76.3 cm)
National Museum of American Art
Smithsonian Institution
Transfer from Museum of Modern Art

Guglielmi began his career in the 1930s on the WPA Federal Art Project, and his paintings of this period exemplify the prevailing social issues and spirit. Having grown up in a poor tenement area of New York, Guglielmi could sympathetically record the hardships of urban life. In a similar spirit, he sometimes also depicted the plight of rural people. Guglielmi, however, was neither a Social Realist nor a Regionalist but a Magic Realist. Influenced by Surrealism, he depicted reality in an ambiguous and allegorical sense. In *Connecticut Autumn*, a country road is empty of all activity except for the solitary figure of a small boy flying a kite. Nothing productive is occurring. In fact, the stone angel of a funerary monument mysteriously beckons, but no one is there to heed its warning—a reminder that death lurks even in such emptiness. The sparseness of the surrounding buildings—stylistic descendants of the geometricism of 1920s Precisionism—reinforces the scene's desolation. Guglielmi created a similar disquieting feeling in his urban views when he depicted them as American versions of the empty courtyards and streets of the Italian Giorgio de Chirico.

BORN 1906 in Cairo, Egypt, of Italian parents; immigrated with family to New York, 1914. Studied at National Academy of Design, New York, 1920–25; received fellowship from MacDowell Colony, 1932. Began making easel paintings, New York, 1932. Employed on WPA Federal Art Project, New York, easel division, 1930s. First solo exhibition held 1938, Downtown Gallery, New York. Served in U.S. Army, 1943–45. Taught at Louisiana State University, Baton Rouge, 1952–53. Died 1956 in New York.

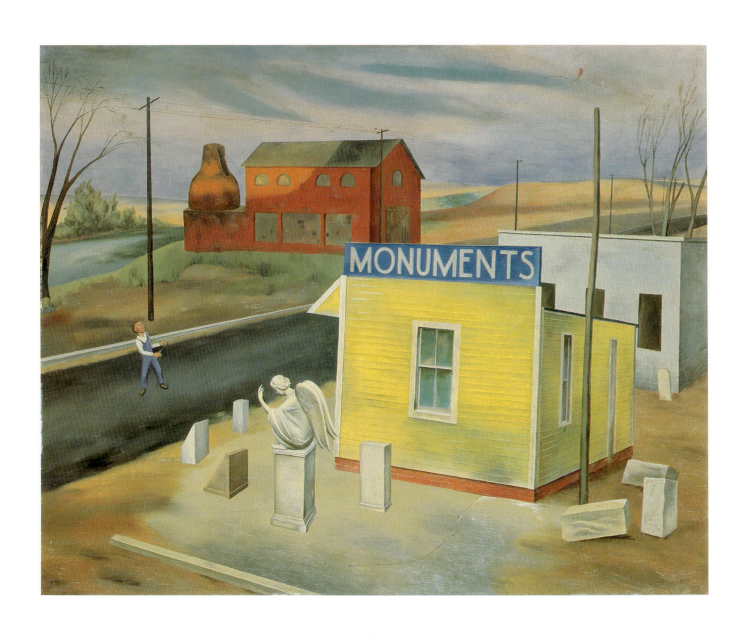

ANDREW WYETH
born 1917

Snow Flurries

1953
tempera on panel
37¼ × 48 in (94.5 × 122.0 cm)
National Gallery of Art
Gift of Dr. Margaret I. Handy 1977

Wyeth has described *Snow Flurries* as the "portrait of a hill I have walked many times," a hill on a neighbor's farm in Chadds Ford, Pennsylvania, where he has lived and painted all his life. And in doing so, he has consciously sought to maintain his roots in an ancestral land with the social and artistic traditions of the Brandywine area as exemplified by the illustrators N. C. Wyeth, Andrew's father, and Howard Pyle, his father's mentor. In his identification with the past and tradition, Wyeth is close to the Regionalism of Benton and Wood, although without their sentimental optimism or idealizing nostalgia. It was not an accident that when Wyeth emerged in the early 1940s, he was identified as a Magic Realist; his art is not strictly realist except in its illusionism. Wyeth is a romantic and symbolic painter and in such a landscape closer to the transcendentalism of the Hudson River school than to the visual realism of Eakins and Homer. *Snow Flurries* is a metaphor for the human condition, and, as in almost all his art, Wyeth is concerned with time, death, and tragedy. Wyeth's fame and popularity may be based on his meticulous realism and almost obsessive attention to detail, but his greatest gift is creating memorable visual images. Thus, the austere landscape of *Snow Flurries*, in its endless recession into the distance, heightened by the light sprinkling of snow; in its emptiness and stillness; in the emphasis on the harsh, boney skeleton of the earth, not so much desolate as dormant; in the human reference of the winding narrow road and the lonely posts, creates a mood of brooding introspection on the cycle of life, mortality, and America's agricultural past.

BORN 1917 in Chadds Ford, Pennsylvania. Trained largely by his father, distinguished illustrator N. C. Wyeth. Quit school at age twelve to study painting with private tutors. First solo exhibition held 1937, Macbeth Gallery, New York. Inaugurated Wyeth Gallery, Brandywine River Museum, Chadds Ford, 1971. First living American-born painter to receive retrospective exhibition at Metropolitan Museum of Art, New York, 1976. Lives in Chadds Ford, summers in Cushing, Maine, locations that are the subjects of many of his paintings.

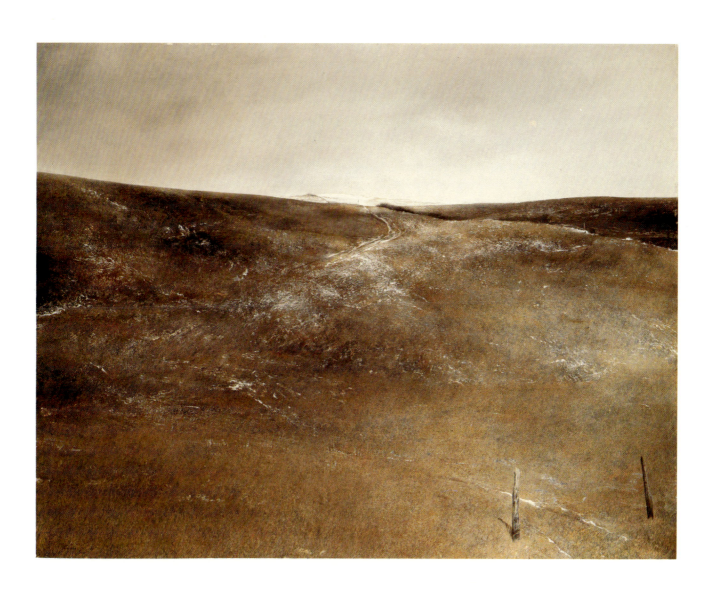

MILTON AVERY
1893–1965

Girl Writing

1941
oil on canvas
48 × 32 in (122.0 × 81.2 cm)
The Phillips Collection

I work on two levels. I try to construct a picture in which shapes [and] colors form a set of unique relationships, independent of my subject matter. At the same time I try to capture and translate [the excitement and] emotion aroused in me by the impact with the original idea.

Milton Avery always sketched from the model, but, as in this study of March, his nine-year-old daughter, he worked his figures into powerful pictorial structures: the girl's ruffles are sensitively observed but do not detract from the architectonic strength of her angular body. He pursued a Cubist flattening of forms and space into simplified planes of color, replacing sculptural form and perspectival space with high-key chromatic tensions that put the various planes in a dynamic balance. His deep understanding of color as a creative means made a deep impression on Hans Hofmann, Mark Rothko, Adolph Gottlieb, Barnett Newman, and Helen Frankenthaler. Avery learned valuable lessons in color harmony from Matisse, Bonnard, and Klee, but more than Matisse or Bonnard, Avery used sharp value contrasts and half-tones for drama and mood. The harmonies and dissonances of the tertiary hues preferred by Avery served his desire for vivid emotional impact as well as striking decorative statement. Likewise, his drawing and shape-making often carry emotive weight. In *Girl Writing* the delicacy of the still-life spray and the scored floorboards is belied by the arhythmic angularities of the right arm, seat, table, and floor itself. And the torsion of March's thickened legs is abated by their flattening into strikingly individual shapes.

An extensive collection of paintings by Avery can be seen at the Hirshhorn Museum and Sculpture Garden.

BORN 1893 in Altmar, New York; moved with family to Hartford, Connecticut, 1905. Studied at Connecticut League of Art Students, Hartford, with Charles Noell Flagg and others, 1913–16. Moved to New York, 1925. First solo exhibition held 1928, Frank K. M. Rehn Galleries, New York. Began making drypoints, 1933. Summered in Mexico, 1946. Traveled to Europe, 1952. Died 1965 in New York.

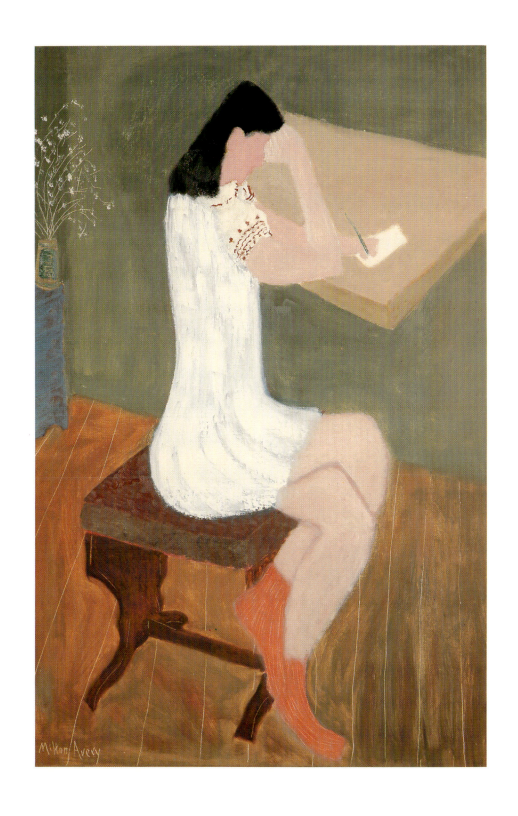

MORRIS GRAVES
born 1910

Surf and Bird

c. 1940
gouache on rice paper
26¼ × 29¼ in (66.4 × 74.3 cm)
The Phillips Collection

A painter associated with the Pacific Northwest, Morris Graves has been profoundly influenced by the art of the Orient and Asian systems of thought. Between 1928 and 1929, he made several trips to the Far East where his art became permeated by Eastern philosophy. In 1936–37, when he worked under the WPA Federal Art Project, his art began to change in scale, subtlety, and relationship of images, which thereafter seemed to float. His use of gouache on thin rice paper is motivated by a desire to express his feeling about insecurity and the brevity of life. Around 1940 he was influenced by Mark Tobey's white-writing technique, using it both as a structural device, filling large areas of a painting, and as a thematic element. He increasingly came to use birds as images representative of solitude. Precariously located between the real and the imaginary, such paintings as *Surf and Bird* give us an image or symbol propelled into a void that has yet to be disciplined by time and space.

BORN 1910 in Fox Valley, Oregon; moved with family to Washington State, 1911. Largely self-taught. Moved to Los Angeles, 1931. Returned to Seattle, 1932. First solo exhibition held 1936, Seattle Art Museum. Worked in Seattle Art Museum, 1940–42. Served in U.S. Army, 1942–43. Studied at Honolulu Academy of Art. Traveled to Europe, 1948–49; Mexico, 1950; Japan, 1954. Lived in County Cork, Ireland, 1957–65. Traveled to India, Japan, 1961–64. Returned to United States; settled in Loleta, California. Traveled to Asia, 1971; Africa and South America, 1972; Far East, 1973. Lives in Loleta.

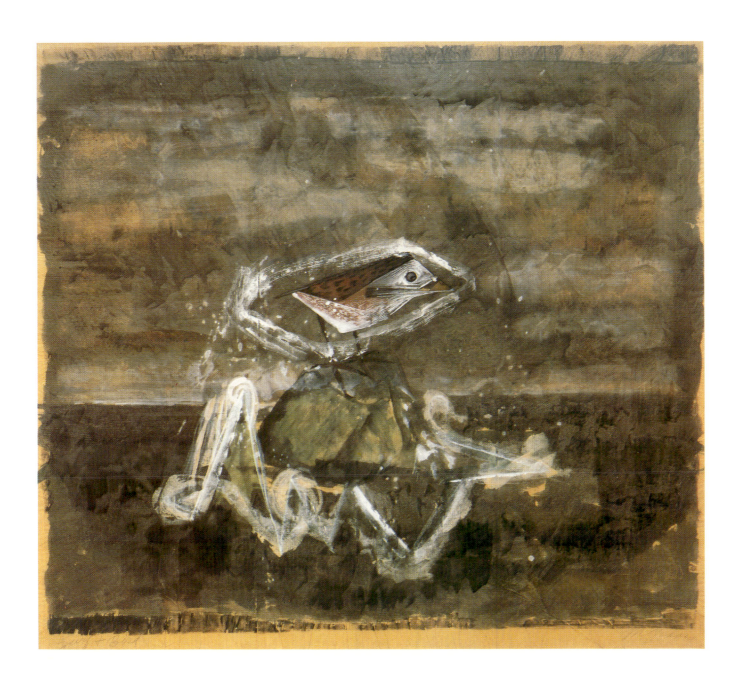

MARK TOBEY
1890–1976

After the Imprint

1961
wash on paper
39¼ × 27⅜ in (99.7 × 69.6 cm)
The Phillips Collection

Mark Tobey was the leader of a group of artists living in the Pacific Northwest who were intrigued with oriental aesthetics. Early in his career, he became interested in Asian art and philosophy, frequenting the Seattle Art Museum, which has an exceptional oriental collection. In 1918 he became a member of the Bahai faith. In 1934 he traveled to the Orient and spent a month in a Zen monastery in Kyoto, studying calligraphy and painting. Upon his return to the United States, he consciously sought to create an art that would unite East and West. In 1935 Tobey painted *Broadway Norm*, the first of his paintings to incorporate a continuous white calligraphic line that would become known as "white writing." These mazes of calligraphic lines, while forming abstract images of western subjects, symbolize the web of universal forces that emerge from a direct exposure to nature. As in Zen Buddhism, Tobey believed that the creation of the work of art should be simultaneous with its inspiration, the strokes of paint suggesting an interrelationship between matter and nonmatter, space and nonspace. In the 1940s Tobey turned to "black writing" with Sumi ink. As with his "white writing," he deemphasized precise focal points and compositional centers, developing what he called "multiple space." The rejection of western notions of perspectival space bound by a frame pioneered a form of abstraction that became critical to the work of many artists, most notably Jackson Pollock.

BORN 1890 in Centerville, Wisconsin; moved with family to area of Jacksonville, Tennessee, 1893; Trempealeau, Wisconsin, 1894–1906; Hammond, Indiana, 1906–8; Chicago, 1909. Studied at School of the Art Institute of Chicago, Saturdays, 1908. Moved to New York, 1911. Worked as fashion illustrator, interior designer, portraitist, New York, Chicago, 1912–17. First solo exhibition held 1917, M. Knoedler & Co., New York. Moved to Seattle, 1922. Met Teng Kwei, who introduced Tobey to Chinese brushwork, 1923–24. Taught at Cornish School of Allied Arts, intermittently, 1923–29. Traveled to Europe and Near East, 1925–26; became interested in Persian and Arabic calligraphy. Returned to Seattle, 1927. Taught at Dartington Hall School, Devonshire, England, 1931–38. Traveled to Mexico, 1931; Europe and Palestine, 1932. Returned to Seattle, 1938. Employed on WPA Federal Art Project, 1938. Executed mural commission: Washington State Library, Olympia, 1959. Settled in Basel, Switzerland, 1960, where he died in 1976.

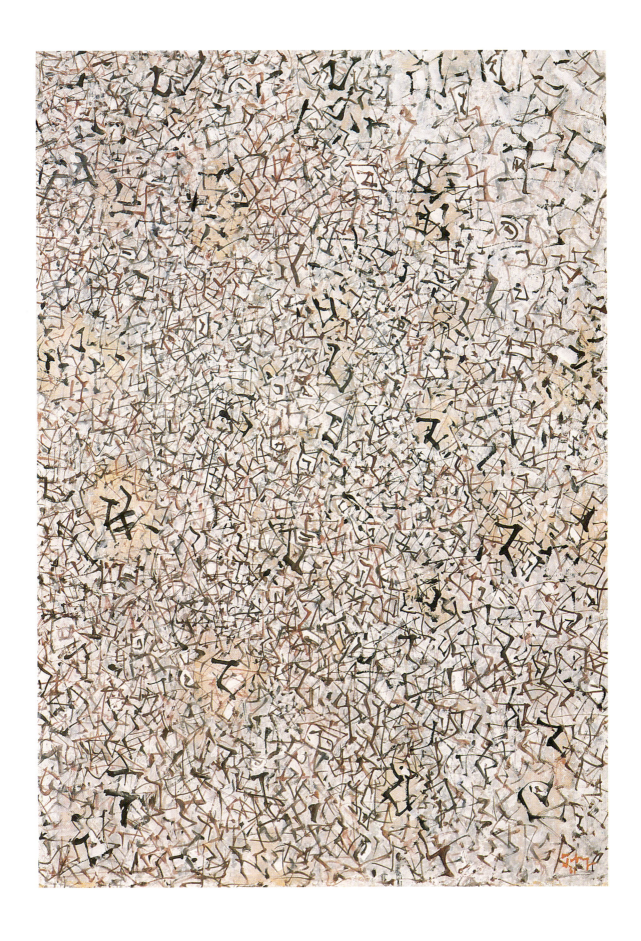

STUART DAVIS
1894–1964

Rapt at Rappaport's

1952
oil on canvas
52 × 40 in (131.8 × 101.4 cm)
Hirshhorn Museum and
Sculpture Garden
Smithsonian Institution

In a career spanning seven decades of American art from Ashcan realism to Pop Art, *Rapt at Rappaport's* stands out as representative of Stuart Davis's very personal transformation of French Cubism into an American idiom. The painter's spirited wit engendered a score of personalized clues to the jazz and joy of *Rapt at Rappaport's*, starting with the title. Though Davis claimed never to have a specific place association with the title, Rappaport's is a famous toy bazaar still standing on upper Third Avenue in Manhattan; moreover, the painting was conceived and executed the same year that Davis's only child was born and given the name George Earl Davis, in honor of two famous jazz musicians, George Wettling and Earl "Fatha" Hines. Davis, "the Cool Spectator-Reporter at the Arena of Hot Events," likened this painting to a tabloid headline and, in fact, labeled it with a headlinelike title, which rings with the jauntiness of the jazz world that the artist loved so much. Speaking of the colors in musical terms, as "six-color intervals," Davis carefully articulated a series of complementaries: green, red orange, blue, crimson, black, and white. Scattered among the complementaries are certain words and signs that serve as clues to Davis's own art theories; "X," "any," "it," and "8" (an upended infinity sign) are all devices—orchestrated into the already brassy composition—which point to Davis's unique resolution of the problem of form and content in painting, a resolution that set him apart from the Abstract Expressionists and gave his work its original character.

BORN 1894 in Philadelphia; mother was a sculptor, father, an art editor for *Philadelphia Press*, employing Ashcan painters as newspaper artists. Studied at Henri School of Art, with Robert Henri, New York, 1910–13. Included in *Exhibition of Independent Artists* held 1910 in New York. Contributed cartoons to *Harper's Weekly*, 1913; *The Masses*, 1913–16. Lived in Paris, 1928–29, met and influenced by Léger. Lived in New York and New England, 1930s. Taught at Art Students League of New York, 1931–32. Executed mural commission: Radio City Music Hall, Rockefeller Center, New York, 1932. Employed on Temporary Emergency Relief Administration Project, 1935. Executed mural commission: Williamsburg Federal Housing Project, Brooklyn, 1938. Employed on WPA Federal Art Project, New York, 1933–39. Taught at New School for Social Research, New York, 1940–50; Yale University, New Haven, Connecticut, 1951. Died 1964 in New York.

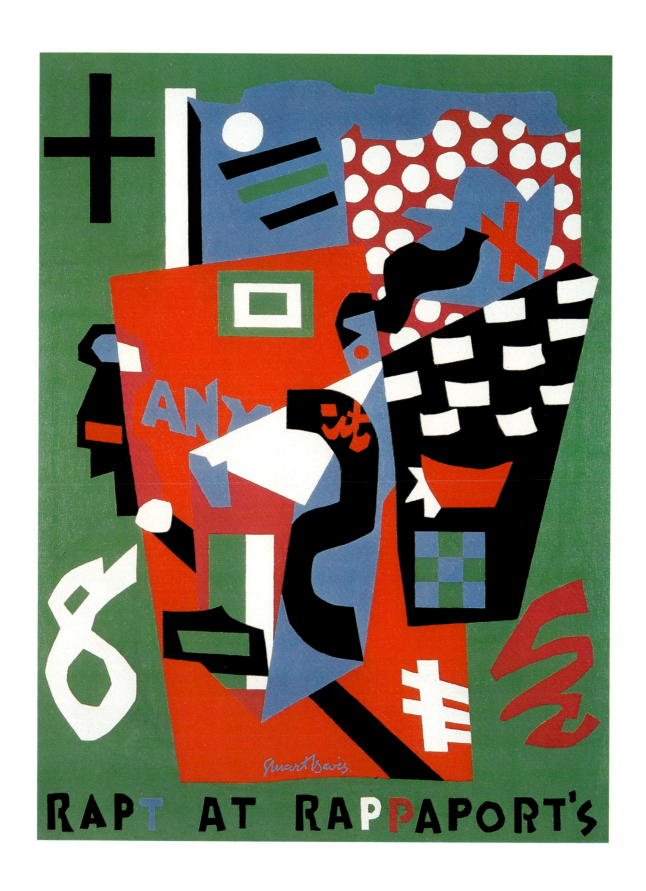

ARSHILE GORKY
1904–1948

One Year the Milkweed

1944
oil on canvas
37 × 47 in (94.2 × 119.3 cm)
National Gallery of Art
Ailsa Mellon Bruce Fund 1979

Arshile Gorky is a transitional figure between Surrealism and Abstract Expressionism, and his most mature form from 1944 to 1947 predates the work of all the artists of the New York school, including Jackson Pollock, Willem de Kooning, Barnett Newman, Clyfford Still, and Mark Rothko. Gorky worked his way through the many important art styles of the twentieth century. Along with his friends John Graham and de Kooning he did paintings in the 1930s and early 1940s that show overt borrowings from the biomorphism of Miró, Matta, and Masson as well as the structural formulations of Picasso's Synthetic Cubism. By the early 1940s, Gorky had assimilated these lessons and proceeded to make works of art that incorporated aspects of Picasso, Surrealism, and even Kandinsky's earliest Expressionistic abstractions. *One Year the Milkweed* is an excellent example of Gorky's early mature style, combining open biomorphic forms and iridescent colors applied in thin washes. The paint is actually rubbed into the canvas, predating the stain techniques that Helen Frankenthaler and Morris Louis would explore in the 1950s and early 1960s. The transparency of the paint permitted the artist a new freedom, especially in those areas where he allowed the thinned material to drip and run in accidental ways. Gorky's colorism is matched by his draftsmanship. Drawing is primary in all the late paintings, used as an independent aspect of the work rather than as a means to define forms, remaining always distinct from the color.

A unique collection of portraits and transitional paintings from the 1930s by Gorky can be seen at the Hirshhorn Museum and Sculpture Garden.

BORN Vosdanig Manoog Adoian 1904 in Khorkom Vari, Armenia; Turkish massacre drove him from his birthplace, 1914; immigrated with sister Vartoosh to United States; settled in Watertown, Massachusetts, 1920. Attended Technical High School, Providence, Rhode Island, 1920–23; New School of Design, Boston, 1923, assistant instructor, 1924. Changed name, moved to New York, 1925. Studied at Grand Central School of Design, New York, 1925, taught there, 1925–31. Employed on WPA Federal Art Project, New York, 1933–34; mural division, 1935–41. Executed mural commissions: Administration Building, Newark Airport, 1935–37; Aviation Building, New York World's Fair, 1938. Studio and paintings destroyed by fire, Sherman, Connecticut, 1946. Seriously injured in automobile accident; died 1948 by suicide in Sherman.

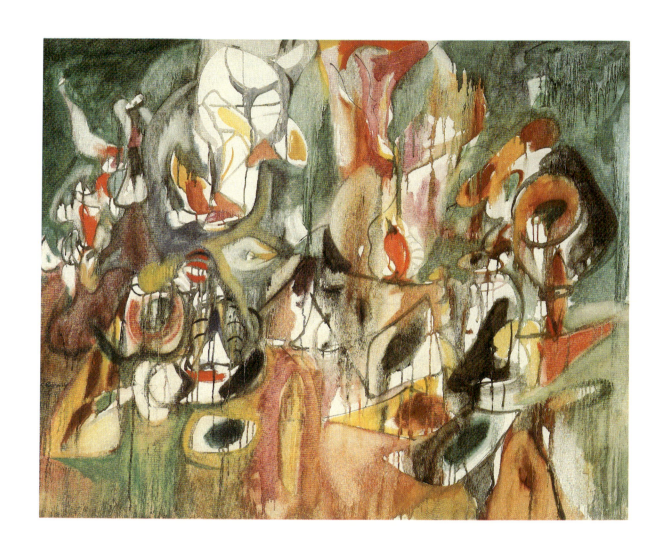

BARNETT NEWMAN
1905–1970

Covenant

1949
oil on canvas
48 × 60 in (121.3 × 151.4 cm)
Hirshhorn Museum and
Sculpture Garden
Smithsonian Institution

Like his peers, Clyfford Still, Mark Rothko, and Adolph Gottlieb, Barnett Newman sharply curtailed his use of materials and imagery in an attempt to present fundamental truths. He concentrated on one or two elements, usually vertical bands or zips placed across a monochromatic ground. With these simple tools, he approached a complex of serious issues: man's personal independence, relationship with the sublimity of the universe, and contact with the spiritual. *Covenant* focuses on the last of these, but in Newman's art, the three are inextricable. He explained the title as: *What the people promised, "We will do and we will listen."* In the picture, two stripes rest on a calm, dark maroon field. One stripe is relatively straight edged and flatly painted— the other is loosely worked; one is broad and dark and seems to settle into the field— the other is thin and light and appears to radiate from a breach in the field. Thus, there are two elements of similar yet opposite characteristics put into an apparent agreement or balance; the real point of balance, however, lies in their relation to the unifying field. Even in its simplicity, *Covenant* attempts a commentary on the symbolic agreement between man and God. Though there are clear formal connections between Mondrian's purist Neoplasticism and Newman's reductive placements and declarations of space (and with the Minimalist art that followed), Newman's art gave spiritual meaning to those placements that were outside the concerns of his predecessors and successors.

BORN 1905 in New York. Studied at City College of New York, B.A., 1927; Art Students League of New York, with Duncan Smith, William von Schlegell, John Sloan, 1922–24, 1929–30. Worked for father's clothing manufacturing company, 1927– 37. Taught art as substitute high school teacher, New York, 1931–39. Stopped painting, c. 1939–44. Studied ornithology, Cornell University, Ithaca, New York, summer 1941. Contributed to periodical *Tiger's Eye*, 1947–49. First solo exhibition held 1950, Betty Parsons Gallery, New York. Directed Artists' Workshop, Emma Lake, Saskatchewan, Canada, summer 1959. Taught at University of Pennsylvania, Philadelphia, 1962–63. Died 1970 in New York.

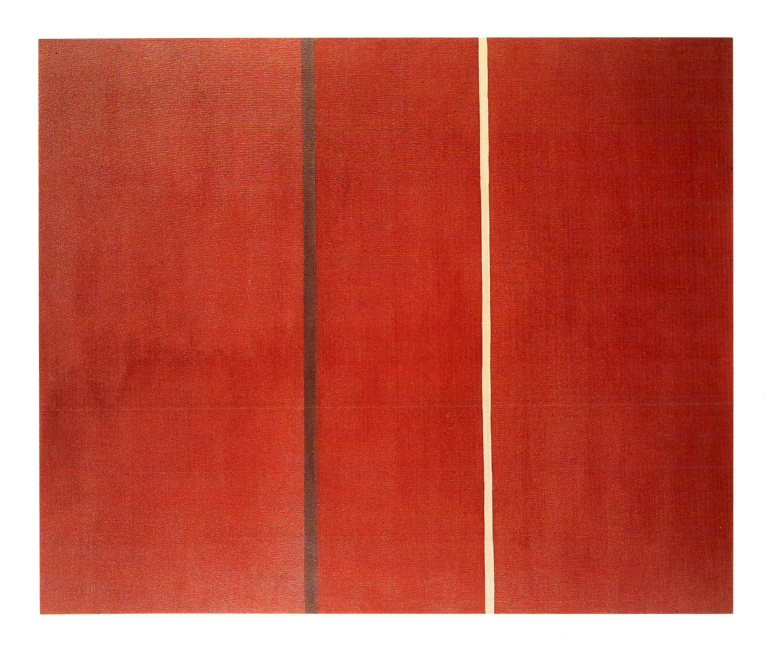

201

MARK ROTHKO
1903–1970

Blue, Orange, Red

1961
oil on canvas
90¾ × 81 in (229.2 × 205.9 cm)
Hirshhorn Museum and
Sculpture Garden
Smithsonian Institution

Rothko was one of several nongestural painters of the New York school: his art did not result from energetic self-expression but from a more intimate, admittedly metaphysical experience of artistic creation. In the 1940s he used totemic imagery, placed in vague, imaginary landscapes, to evoke a mythic, spiritual world. By the middle of the decade figures began to dissolve into floating veils and allusions to landscape became increasing indistinct. He found that his simplified imagery was appropriate to his aspirations. In a statement cosigned by Adolph Gottlieb, Rothko asserted: *We favor the simple expression of the complex thought*. Here, the floating scrims of translucent blue and orange—because of the subtlety of their execution—reveal themselves slowly to the viewer's perception, unfolding their spectacle against the brilliant red field. In time, the floating blue rectangles begin to assume greater weight, pressing the orange band into a radiant luminosity, which, in turn, buoys them up again. The interrupted, scumbled, or feathered application of paint within the rectangular veils allows glimpses of the underlying color, which appears to shine through. This flickering emanation sets a mood. Rothko strips his art of given associations; he is not aiming for specific recall but for the dim, yet powerfully felt welling of deep-seated emotions, feelings that may be shaped by private experience but that also touch the universal core of that experience.

An impressive group of paintings by Rothko is permanently displayed at the Phillips Collection.

BORN Marcus Rothkowitz 1903 in Dvinsk (Daugarpils), Russia; immigrated with family to Portland, Oregon, 1913. Studied at Yale University, New Haven, Connecticut, 1921–23; Art Students League of New York, with Max Weber, 1925. Taught at Center Academy, Brooklyn Jewish Center, 1929–52; California School of Fine Arts, San Francisco, summers, 1947, 1949. First solo exhibition held 1933, Contemporary Arts, New York. Cofounded the Ten, 1935. Employed on WPA Federal Art Project, New York, 1936–37. Taught at Brooklyn College, 1951–54; University of Colorado, Boulder, 1955; Tulane University, New Orleans, 1956. Visited Europe, 1950, 1959. Died 1970 by suicide in New York.

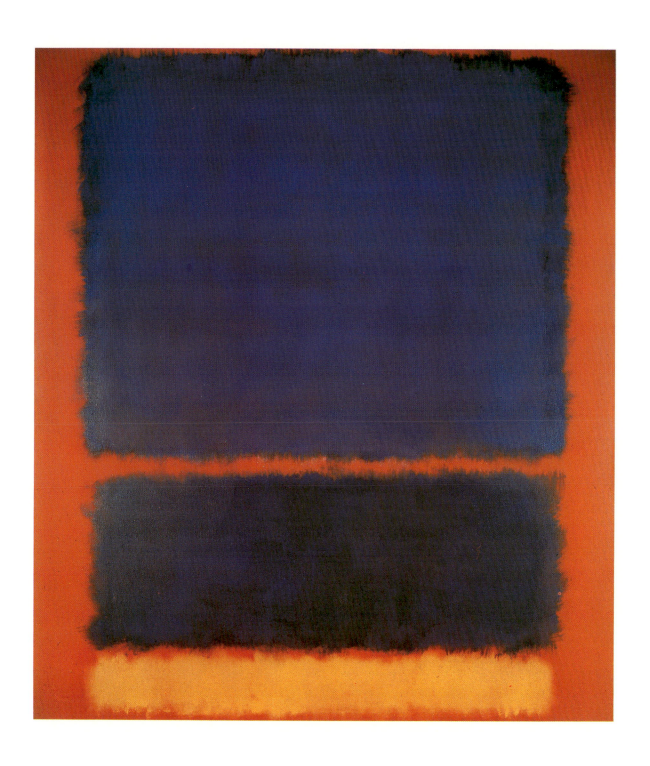

AD REINHARDT
1913–1967

Black Painting No. 34

1964
oil on canvas
60¼ × 60⅛ in (153.0 × 152.6 cm)
National Gallery of Art
Gift of Mr. and Mrs. Burton G.
Tremaine 1970

In a search for purity, Ad Reinhardt sought to minimize personal touch, meaning, and all extraneous references. His canvases of the 1930s were hard-edged compositions derived from Cubism and Constructivism, but by 1950 he had begun to produce paintings composed of bars of close-valued colors, predominantly blue or green. In 1960 he created his first black compositions in nonreflecting, barely perceptible variations of black pigment. *Black Painting* is an example of the square format in which the canvas is symmetrically disposed into a Greek cross form or nine equal squares, depending on how it is read. All the late paintings adhere to the principles Reinhardt laid down for art: art should have no texture, brushwork, sketching or drawing, no forms, designs or color, no light, space, time or movement, and above all no subject, symbol, images or ready-mades. He sought to create work that, like the art of the East, is self-contained, serene yet monumental, and universal. The Buddhist concept of nothingness is paramount in his work: it is the nothing and the void, yet it embodies everything.

BORN 1913 in Buffalo, New York; moved with family to New York, 1915. Studied in New York at Columbia University, 1931–35; American Artists' School, with Carl Holty; National Academy of Design, with Karl Anderson, 1936. Employed on WPA Federal Art Project, New York, easel division, 1936–41. Member, Artists' Union, 1937–40; American Abstract Artists, 1937–47; founding member, the Club, 1948. First solo exhibition held 1944, Artists' Gallery, New York. Cartoonist and critic for *PM*, 1944–46; *Art News*, 1954–67. Specialized in oriental studies, Institute of Fine Arts, New York University, 1946–50. Traveled to Greece, 1952; Japan, India, Iran, Egypt, 1958; Turkey, Syria, Jordan, 1961. Taught at Brooklyn College, 1947–67; California School of Fine Arts, San Francisco, 1950; University of Wyoming, Laramie, 1951; Yale University, New Haven, Connecticut, 1952–53; New York University, 1955; Syracuse University, New York, 1957; Hunter College, New York, 1959–67. Died 1967 in New York.

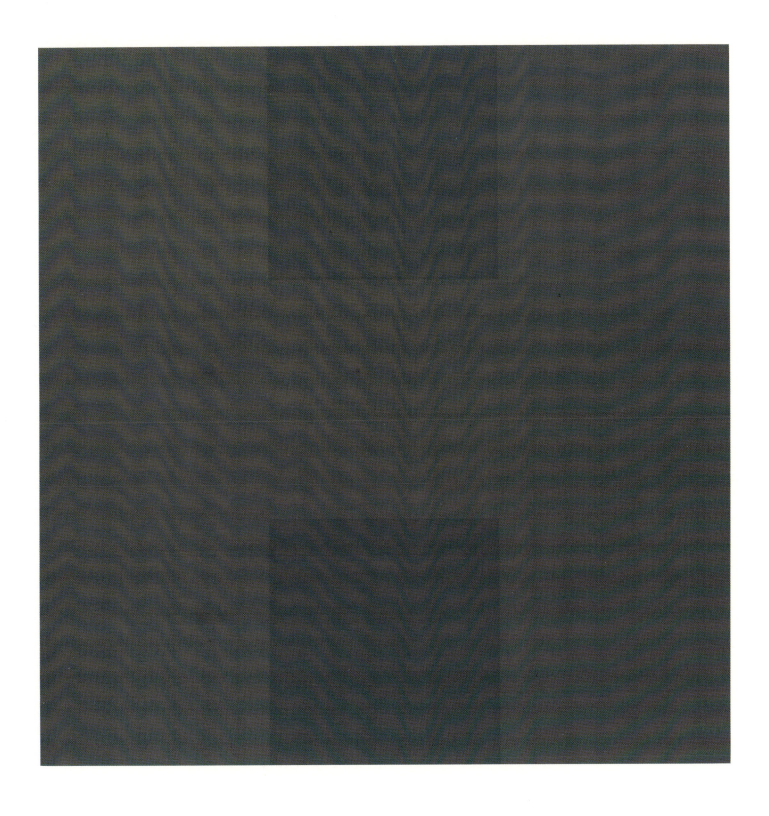

BURGOYNE DILLER
1906–1965

First Theme

c. 1962
oil on canvas
95¾ × 38 in (243.2 × 96.5 cm)
The Corcoran Gallery of Art
Gift of the Ford Foundation, 1962

In his late twenties, under the tutelage of Jan Matulka and Hans Hofmann, Burgoyne Diller quickly evolved from late Synthetic Cubism his own variation of Neoplasticism. Long before Mondrian's arrival in the United States, Diller was thoroughly familiar with his work and that of other De Stijl masters, particularly van Doesburg and Vantongerloo. Diller was the first American artist to espouse Neoplastic principles, which stressed pure horizontal-vertical relationships, rectilinear shapes, and primary colors. As supervisor of the mural division of the WPA Federal Art Project, he hired and nurtured such abstract painters as Stuart Davis, Arshile Gorky, Willem de Kooning, and Ilya Bolotowsky. Diller devoted his mature effort to austere compositional themes, each slightly more complicated than the last. *First Theme* is the simplest of the three: a few independent squares or rectangles are placed on a ground plane, each plane is either one of the three primary colors or a noncolor (white, black, or gray). The individual compositions were carefully determined through preparatory drawings or colored paper collages. Despite the sharply reduced artistic means, the effects of these works are rich and remarkably varied. Diller's sensitivity to color is notable, ironically, in his extraordinary use of black. The symmetry and spare geometry of his later works presaged Minimal tendencies in the 1960s.

BORN 1906 in New York; grew up in Battle Creek, Michigan. Studied at Michigan State University, East Lansing, 1926–27; Art Students League of New York, with Boardman Robinson, Jan Matulka, George Grosz, Hans Hofmann, 1928–33. First solo exhibition held 1933, Contemporary Arts Gallery, New York. Supervisor, WPA Federal Art Project, New York, mural division, 1935–40; assistant technical director, 1940–41. Director, New York City War Service Art Section, 1941–43. Taught at Brooklyn College, Pratt Institute, 1945–64. Died 1965 in Atlantic Highlands, New Jersey.

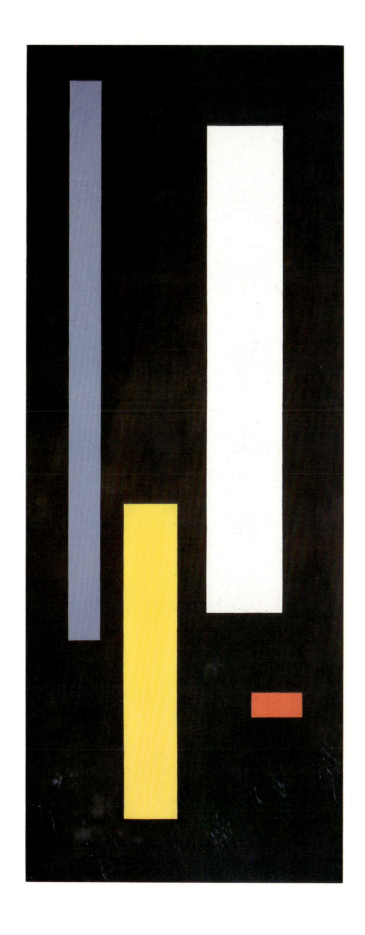

ILYA BOLOTOWSKY
1907–1981

White Diamond

1968
oil on canvas
48 × 48 in (122.0 × 122.0 cm)
Hirshhorn Museum and
Sculpture Garden
Smithsonian Institution

Bolotowsky and Burgoyne Diller were probably the most important American disciples of Mondrian and Neoplasticism. Bolotowsky, from the early 1930s on, had been working in an abstract vein, influenced at first by Cubism and Constructivism and later by the biomorphism of Miró. While working on the WPA mural project, he executed a series of murals that led him to refine his abstract style. Bolotowsky was a founding member of the American Abstract Artists, a group of the most prominent hard-edge or geometric abstractionists. It was not until the late 1940s, after Mondrian had come to the United States, that the Neoplastic influence became dominant in Bolotowsky's art. His paintings, along with those of Fritz Glarner, remain the most complex of the Neoplastic followers, full of vertical-horizontal tensions, spatial ambiguities, and diverse color harmonies. No wonder some of his colleagues dubbed him a romantic. Bolotowsky's color range is much wider than the primary canon of most Neoplasticists. He himself postulated a reemergent interest in the jewellike color of Russian icons remembered from his youth. *White Diamond* is an example of Bolotowsky's predilection for variant shapes such as the diamond, tondo, and ellipse. At the time Bolotowsky's mature style was being formed, the rise of the inner-directed art of Abstract Expressionism pushed the art of "balanced relations" into the background, and it was not until the 1960s that the "purist" followers of Mondrian came into prominence again. In the interim, Bolotowsky, unmoved by popular neglect, had continued to work in his own manner, extending and enriching its range, power, and elegance.

BORN 1907 in Saint Petersburg (Leningrad), Russia; immigrated to United States, 1923. Studied at National Academy of Design, New York, 1924–30. Received fellowships from Louis Comfort Tiffany Foundation, 1929, 1930; Yaddo Foundation, 1933. First solo exhibition held 1930, G.R.D. Studios, New York. Traveled to Europe, 1932. Cofounded the Ten, 1935; included in exhibition *The Ten: Whitney Dissenters* held 1938, Mercury Gallery, New York. Executed mural commissions: Williamsburg Housing Project, New York, 1936; Chronic Diseases Hospital, New York, 1941. Served in U.S. Army Air Corps, Nome, Alaska, 1942–45. Taught at Black Mountain College, North Carolina, 1946–48; University of Wyoming, Laramie, 1948–57. Received grant for experimental film work, University of Wyoming Graduate School, 1953–54. Taught at Brooklyn College, 1954–56; State Teachers' College, New Paltz, New York, 1957–65; Hunter College, New York, 1963–64; University of Wisconsin, White Water, 1965–71; Southampton College of Long Island University, New York, 1965–77. Died 1981 in New York.

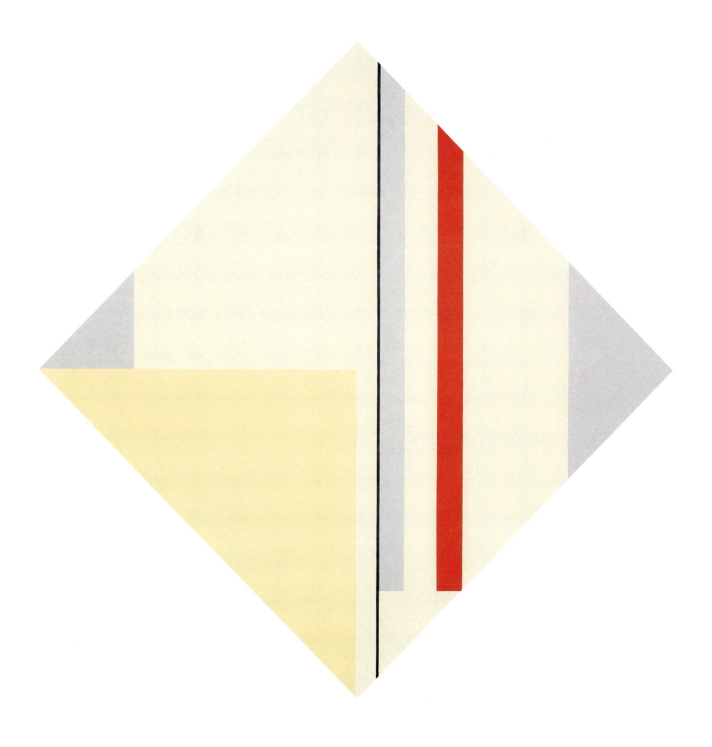

FRANK STELLA
born 1936

Honduras Lottery Company

1962
synthetic polymer with pencil
underdrawing on canvas
85 × 85 in (216.8 × 216.8 cm)
Hirshhorn Museum and
Sculpture Garden
Smithsonian Institution

In his early works, Frank Stella was reacting against the personal and self-expressive tendencies of first- and second-generation Abstract Expressionists. By projecting the painting as neutral or objective, he avoided making any statement about his own emotions. Stella treats the painting as an object much as the Minimal artists did in the mid 1960s. He avoids figure-ground and internal, formal relationships not specifically involved with the structure of the canvas. As he has said: *My painting is based on the fact that only what can be seen there* is *there. It really is an object.* The painting *Honduras Lottery Company* is part of the concentric square series that follows the black pinstripe paintings of 1959–60 and the shaped-canvas, metallic paintings of 1961–62. As in all the works of this series, the configuration is that of five concentric bands of color painted around a central square. The sequence of colors is then repeated until the entire surface of the canvas is covered to the framing edge. Stella had restricted his palette to one color in the earlier series, but these paintings mark a departure by the use of multiple colors that enrich the structural content.

BORN 1936 in Malden, Massachusetts. Studied at Princeton University, with William Seitz, Stephen Greene, A.B., 1958. Moved to New York, 1958. Visited Europe and Morocco, 1960. First solo exhibition held 1960, Leo Castelli Gallery, New York. Visited Iran, 1963. Artist-in-residence, Dartmouth College, Hanover, New Hampshire, summer 1963. Lectured at Yale University, New Haven, Connecticut, fall 1965. Visiting critic, Cornell University, Ithaca, New York, 1965. Taught at University of Saskatchewan, Canada, summer 1967; Brandeis University, Waltham, Massachusetts, 1968. Lives in New York.

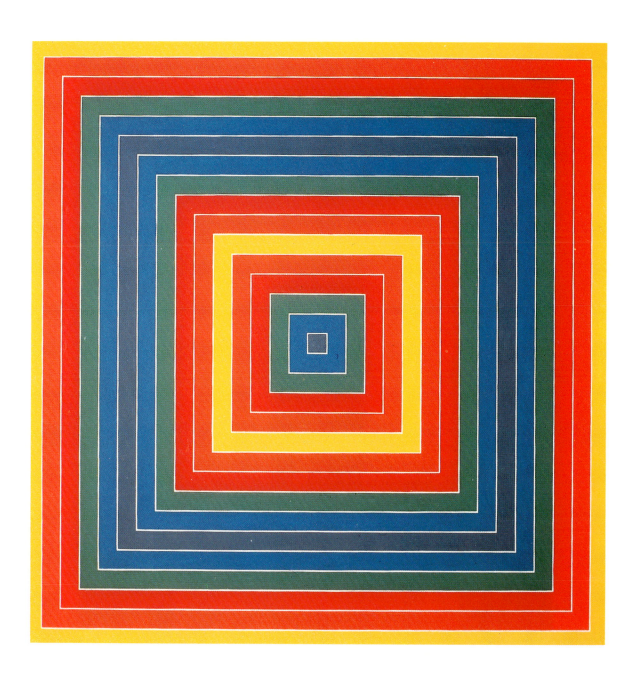

ELLSWORTH KELLY
born 1923

Red White

1961
oil on canvas
66 × 88 in (159.5 × 216.6 cm)
Hirshhorn Museum and
Sculpture Garden
Smithsonian Institution

One of the Hard-Edge painters to experiment with unmodulated color and the shaped canvas, Ellsworth Kelly, emerged as an important figure in the late 1950s. His work then and now has been an obsession with shape, either internally or with the canvas structure, with color as an adjunct. Kelly consciously tried to eliminate variations in color as well as any evidence of the manual application of paint. Compared with the canvases of Mark Rothko and Barnett Newman, his surfaces appear almost machine made. In the early 1960s, as in *Red White*, he was involved with the stark juxtaposition of clearly defined shapes and intense colors, exploiting the tensions arising from their reciprocal relationships. Kelly's consciousness of edges and the charge their proximity created, in some way, was also dependent on his awareness of the more subtle relationships achieved by Rothko and Newman in the nuances of their edges. Kelly's dialectic is clearer and more striking, achieving an equilibrium that remains always in motion, with color and shape interacting and interchanging as positive and negative polarities. In *Red White*, an early work in this sequence, the swelling color shapes interlock in a loose but irreducible bond with each other and the frame. Even the simple title of the painting evokes the opposition between red and white within the canvas.

BORN 1923 in Newburgh, New York. Studied at Pratt Institute, Brooklyn, 1941–42. Served in U.S. Army, Europe, 1943–45. Attended School of the Museum of Fine Arts, Boston, 1946–48; introduced to work of European Expressionists by Karl Zerbe. Interested in work of Max Beckmann. Studied at Ecole des Beaux-Arts, Paris, 1948. Lived in France, 1948–54. First solo exhibition held 1951, Galerie Arnaud, Paris. Returned to New York, 1954, where he now lives.

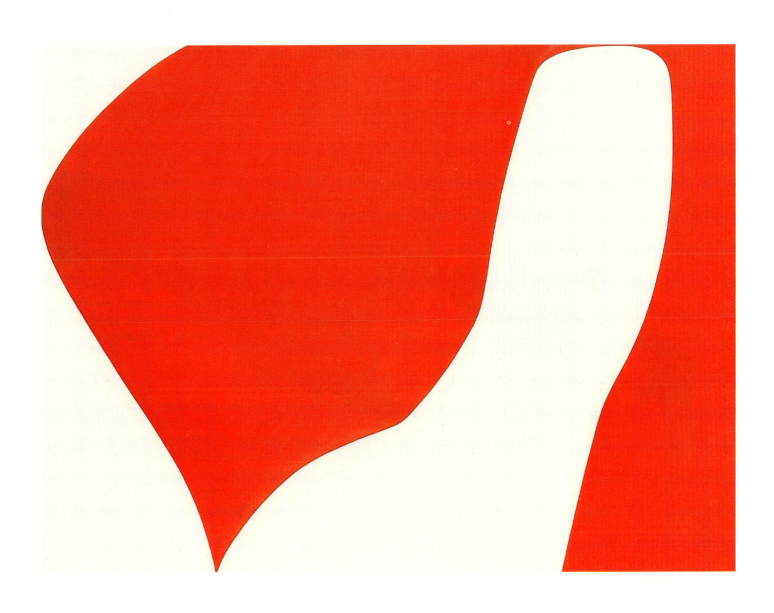

HELEN FRANKENTHALER
born 1928

Small's Paradise

1964
acrylic on canvas
100 × 93⅝ in (254.0 × 237.7 cm)
National Museum of American Art
Smithsonian Institution
Gift of George L. Erion

By the early 1960s, Frankenthaler turned from delineating space with poured color lines to declaring it with larger color shapes. In a series of works from 1964 that includes *Small's Paradise*, the shapes become more centered, geometrical, and opaque—perhaps in response to the trend toward Hard-Edge Painting. The lyrical capriciousness of contours has almost disappeared. The configurations in these paintings form frames within frames, and the titles reinforce the sensation of an interior space: *I usually name [a painting] for an image that seems to come out of the picture. . . . A picture like* Small's Paradise *had an image in it reminiscent of Persian miniatures of paradise; also, I'd been to that nightclub recently.* The framing device and lapidary beauty of saturated hues are suggestive of miniatures, despite the large size of the painting. The title further intimates the power of color for immanent spirituality—its power to transmit a message intuitively like music. Small's Paradise was a Harlem jazz club, one of several frequented by artists in the 1950s and 1960s. The light brown horseshoe hints of the club's proscenium arch; the nightclub allusion connotes, more pertinently, a relationship between music and abstract painting. Many New York school artists felt that jazz possessed a tremendously inventive, affective power—that its spontaneity and direct, visceral impact on the emotions were desirable characteristics—available to line and color as well as rhythm and tone.

BORN 1928 in New York. Studied with Rufino Tamayo, New York, 1945; Bennington College, Vermont, with Paul Feeley, 1949; Columbia University, New York, 1949; Hans Hofmann School of Fine Arts, Provincetown, Massachusetts, summer 1950. First solo exhibition held 1951, Tibor de Nagy Gallery, New York. Lives in New York.

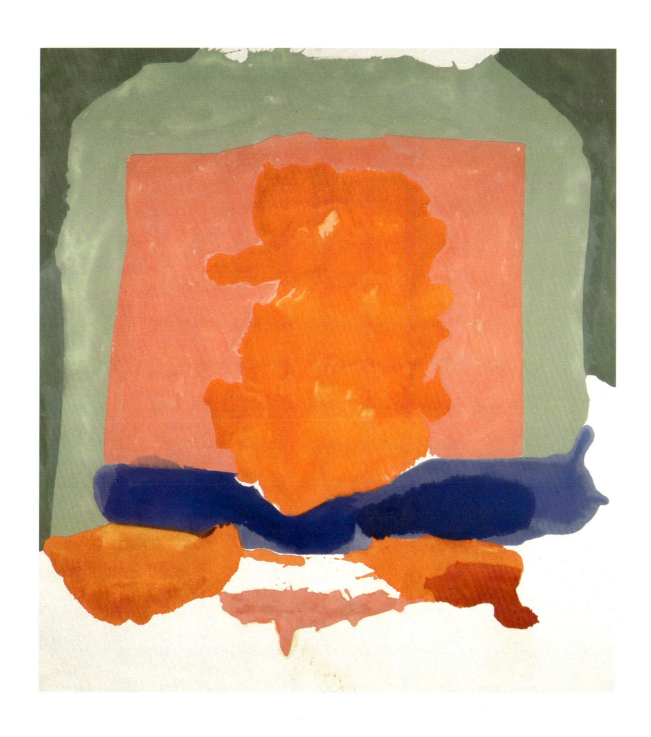

MORRIS LOUIS
1912–1962

Beta Upsilon

1960
acrylic on canvas
102½ × 243½ in (260.3 × 617.2 cm)
National Museum of American Art
Smithsonian Institution
Museum purchase from the collection of
Vincent Melzac

Along with Helen Frankenthaler, Morris Louis has been recognized as one of the inventors of the technique of staining in which thinned paint is poured onto an unprimed canvas. Although Louis lived in Washington, D.C., he stayed in close contact with the art scene in New York and with the artists Sam Francis, Kenneth Noland, and Jules Olitski brought about in the 1950s radical changes in ideas regarding painting. Louis was interested in painting very large, open-field abstractions. In his veil series of the late 1950s, he poured color over color, the paint often covering the entire canvas surface. In his unfurled series, Louis separated the colors into discrete bands located only on the outer edges of the unprimed canvas. *Beta Upsilon* is an unfurled painting characterized by bands of color with bare canvas exposed between the bands and occupying the vast center section of the rectangular structure. The saturated colors emphasize the emptiness or whiteness of the center, and it is that infinity of expanse that becomes the focus of the painting itself.

An extensive collection of paintings by Louis can be seen at the Hirshhorn Museum and Sculpture Garden.

BORN Morris Bernstein 1912 in Baltimore. Studied in Baltimore at Maryland Institute of Art, 1929–33. Executed mural commission: Hampstead Hill School, Baltimore, 1934. Elected president, Baltimore Artists' Union, 1935. Participated in David Alfaro Siqueiros's experimental workshop, New York, 1936. Employed on WPA Federal Art Project, New York, easel division, 1937–40. Included in *American Art Today*, New York World's Fair, Flushing Meadows, 1939. Moved to Washington, D.C., area, 1947. Taught at Washington Workshop Center of the Arts, 1952–62. Died 1962 in Washington, D.C.

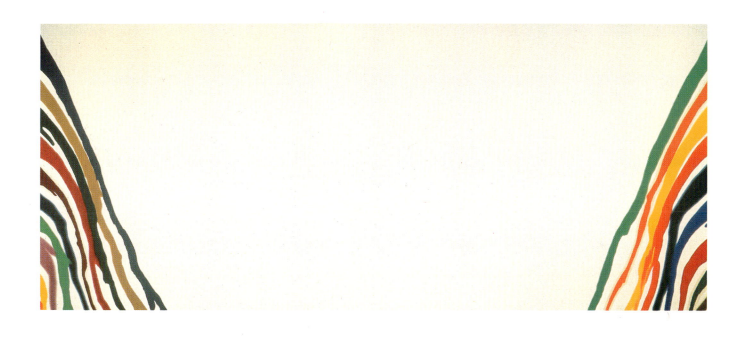

KENNETH NOLAND
born 1924

Split

1959
acrylic on canvas
94 × 94⅓ in (237.8 × 238.5 cm)
National Museum of American Art
Smithsonian Institution
Gift from the collection of Vincent Melzac

In a filmed interview, Kenneth Noland spoke of the importance of impact painting, a type of painting stemming from the perception of the entire content of the work at a single moment in time. The immediacy that such a work would provide, the comprehension of the image as a whole at once and not as an amalgamation of parts, marks Noland and his later development as a Hard-Edge painter as a source of interest to the Minimalists of the mid 1960s. Noland's strategy for achieving that immediate image involved a number of devices, the elimination of any painterly detail, the importance of a symmetrical image centered on the canvas, the use of opaque, often poured color, with little variation of saturation into the unprimed canvas, all of which appear in the 1959 painting *Split*. Noland began painting such bull's-eye pictures one year earlier, and the centralized image of a target owes much to the emergence, in 1955, of the target in the paintings of Jasper Johns. In *Split*, of particular interest is the slight irregularity that mars its otherwise perfect symmetry. The slightly off-centered square provides a sense of drama precisely because it demands a reconciliation between that strong image with the equally demanding concentric symmetry of the surrounding poured rings. Equally arresting is the use of such sensuous colors as salmon rose, lavender, and ultramarine contrasted with the black and off white of the raw canvas.

An extensive collection of paintings by Noland can be seen at the Hirshhorn Museum and Sculpture Garden.

BORN 1924 in Asheville, North Carolina. Studied at Black Mountain College, North Carolina, with Josef Albers, Ilya Bolotowsky, 1946–48; Académie de la Grande Chaumière, Paris, with Ossip Zadkine, 1948–49. Settled in Washington, D.C., 1949; taught at Institute of Contemporary Arts, 1949–51; Catholic University, 1951–52; Washington Workshop Center of the Arts, from 1952. Formed close friendships with Morris Louis, Clement Greenberg, David Smith, late 1940s, early 1950s. Moved to New York, 1961; South Shaftsbury, Vermont, 1964. Taught at Bennington College, Vermont, 1967. Lives in New York.

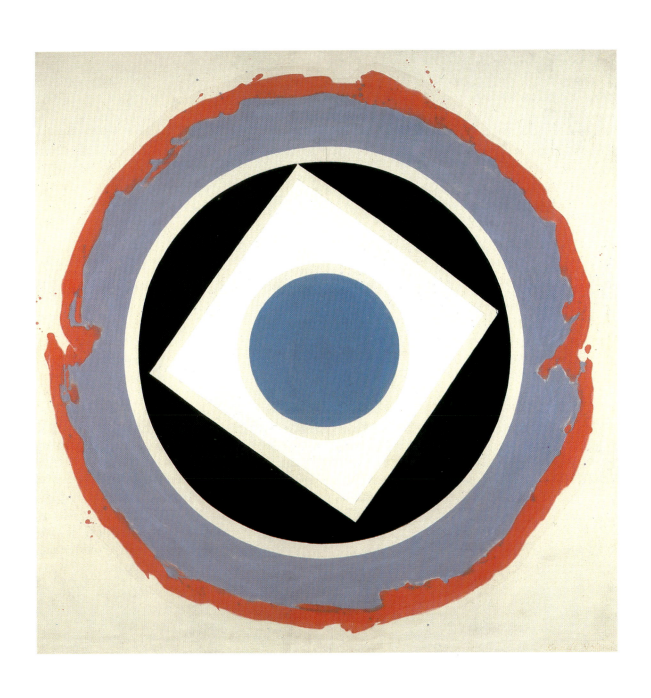

JASPER JOHNS
born 1930

Numbers 0 through 9

1961
oil and charcoal on canvas
54 × 41³⁄₈ in (137.3 × 104.9 cm)
Hirshhorn Museum and
Sculpture Garden
Smithsonian Institution

The apparent simplicity of a banal motif often disguises the wit and sensitivity of Johns's art. In *Numbers 0 through 9*, the motif can be recognized and associated with commercial practices (stenciling of figures) and classroom exercises (learning to count by rote). Yet, the very placement of one number on the next assures the illegibility of the resulting image. The impersonal stenciling of the numerals seems to deny the validity of Abstract Expressionist gesture, but the painting is clearly hand-wrought. In fact, recognition of the numerals is confounded by a diffused composition and an aesthetic borrowed from the older style. The patches of blue and orange more or less follow the numeral outlines, but the overlay of dots is capricious. The dots may echo the Pointillism of Seurat or Signac, but they mimic most pertinently the overall compositions of Pollock (as do the interwoven figural outlines). Johns often gibes at the style of the older generation, adding a cooler, intellectual tag, but his taste for the materials and processes of painting remains undiminished. Johns breaks decisively with Abstract Expressionism by the inclusion of imagery. The banality of depicting numbers challenges the high seriousness that marked the 1950s, but his choice of imagery has a seriousness of its own. Numerals are among the most fundamental tools of knowledge, and their preeminence here focuses attention on art as a source of knowledge. The visual compromising of the figures puts art's ability to transmit knowledge in question. John replaces the transcendance of Rothko and the psychic turmoil of de Kooning with a weaving of enigmas, hidden meanings, and unresolved situations.

BORN 1930 in Augusta, Georgia. Studied at University of South Carolina, Columbia, 1947–48. Served in U.S. Army, Japan, 1949. Moved to New York, 1949. Worked closely with Robert Rauschenberg, mid 1950s; designed window displays for Tiffany & Co. and other New York stores. Lives in New York.

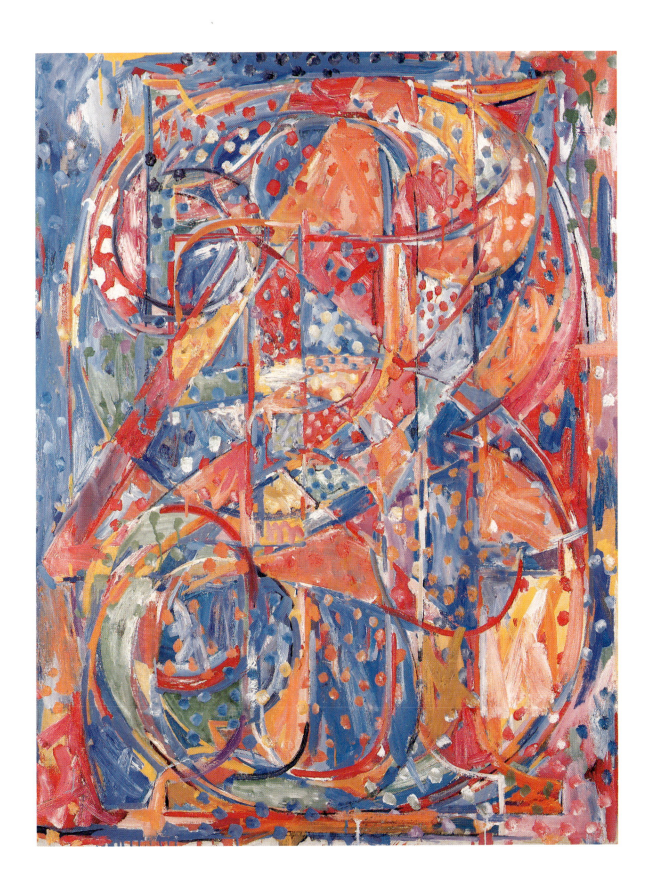

LARRY RIVERS
born 1923

History of the Russian Revolution

1965
mixed media
160⅞ × 399¼ in (403.7 × 1014.1 cm)
Hirshhorn Museum and
Sculpture Garden
Smithsonian Institution

With Jasper Johns and Robert Rauschenberg, Larry Rivers played a key role in the shift from the gestural immediacy of Abstract Expressionism to the reintroduction of conscious figuration in painting in the 1950s. All three artists had been nurtured in the tradition of painting as a unique and personal spiritual experience, but they felt a growing need for reestablishing a more objective connection between life and art, and each did in his own way, though retaining some attitudes and features of Action Painting. Rivers's art is sophisticated, self-conscious, and ironic, full of quotations from and allusions to reality, usually with tongue in cheek. Although Rivers is not strictly speaking a Pop artist, especially in the retention of his painterly touch, he served as a bridge to Pop Art in his innovative use of materials and images, as for instance, the clichéd icons of American culture and the visual clichés of the mass media as well as their reproductive techniques; also, real objects, lettering, printed matter, and photographs; and montage and film techniques. While introducing a new imagery from popular culture, Rivers reminds us always nostalgically of the traditions of history and art. *History of the Russian Revolution* is Rivers's largest and most ambitious effort at history painting, the historic academic apogée of painting as an art. It is both serious and ironic, pretentious yet thoughtful, overweening in ambition and curiously successful. The painting is a montage of fifty-three separate pieces, including paintings and real objects, describing the Russian Revolution from Marx and the *Communist Manifesto* to the suicide of the revolutionary poet Mayakovski. Hardly a historic event or person has been omitted in the inspired collage of images. It may be that, given the fragmented nature of contemporary culture and perception, the only way that history can be encompassed by painting in our time is in this way.

BORN 1923 in the Bronx, New York. Worked as jazz saxophonist, 1940–45. Served in U.S. Army Air Corps, 1942–43. Studied in New York at Juilliard School of Music, 1944–45; Hans Hofmann School of Fine Art, 1947–48; New York University, B.A., 1951. Traveled to France and Italy, 1950. First solo exhibition held 1949, Jane Street Gallery, New York. Designed sets for Frank O'Hara's play *Try! Try!*, 1952. Lived in Paris, 1961–62. Artist-in-residence, Slade School of Fine Arts, University of London, 1964. Designed sets for Imamu Amiri Baraka's (LeRoi Jones's) plays, *The Toilet*, *The Slave*, 1964; sets and costumes for Igor Stravinsky's *Oedipus Rex*, New York, 1966. Traveled to Africa to make television film, with Pierre Gaisseau, *Africa and I*, 1967–68. Lives in New York and Southampton, New York.

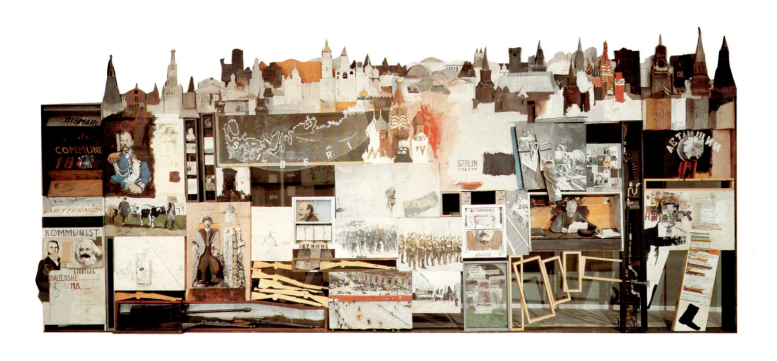

ANDY WARHOL
born 1928

Marilyn Monroe's Lips

1962
synthetic polymer and enamel on canvas
diptych
82⅞ × 163⅛ in (210.7 × 223.6 cm)
Hirshhorn Museum and
Sculpture Garden
Smithsonian Institution

In his fashion, Andy Warhol has chronicled the postwar economic boom. From the beginning of his career, he has focused on consumer goods and the acquisitive desire that converts anything attractive into merchandise. During her life, the actress Marilyn Monroe personified sexuality as it was exploited for entertainment. Warhol has distilled her erotic appeal into its simplest, most available aspect—her lips. In a clever stroke, he marries consumer subject matter with the advertising techniques he learned during a successful career as a commercial artist. The photo-silkscreened image is repeated again and again into two phalanxes of sensuous mouths. This mechanical process, carried out by assistants, not only evokes commercial printing but defies the personal involvement of Action Painting. The printed imperfections, particularly in the right-hand panel of the diptych, mimic the effects of hand-crafting. Warhol's choice of popular subject matter, as well as his indifference to its execution, takes a slap at the high seriousness of mainstream art, replacing it with a cool, ironic urbanity. In a somewhat cynical combination of crass marketing and high culture, he gives his images the look of iconic timelessness on the one hand, punning on the metaphysical fields and grids of abstract art. On the other, he parodies the disposable redundance of pornography and advertising. His art takes aim not at transcendence but at titillation, consumerism, and boredom.

BORN 1928 in Pittsburgh. Studied at Carnegie Institute of Technology, Pittsburgh, 1945–49. Moved to New York, 1949. Worked as commercial artist, 1950–60. Began making silkscreen paintings, 1962. Since 1963 has made films: *Haircut*, 1963; *Eat, Empire, Henry Geldzahler, Kiss*, 1964; *Chelsea Girls*, 1966; *Lonesome Cowboys*, 1967–68; *Blue Movie*, 1969; and many others. Wrote *Andy Warhol's Index Book*, 1967; *A: A Novel*, 1968; *Andy Warhol: Transcript of David Bailey's ATV Documentary*, 1972; *Ladies and Gentlemen, The Philosophy of Andy Warhol: From A to B and Back Again*, 1975. Lives in New York.

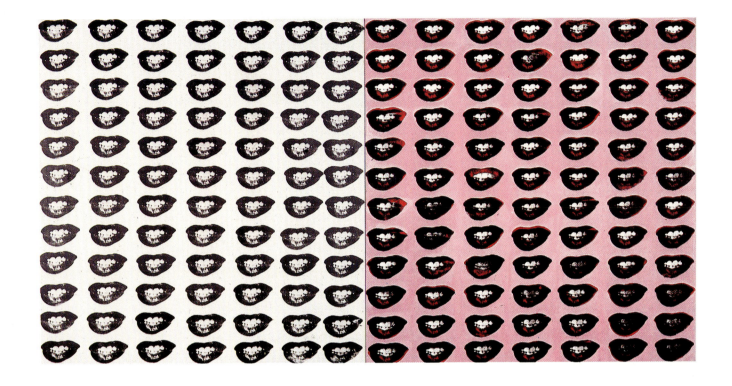

ROY LICHTENSTEIN
born 1923

Modern Painting with Clef

1967
oil, synthetic polymer, pencil on canvas
triptych
100 × 180 in (252.4 × 458.2 cm)
Hirshhorn Museum and
Sculpture Garden
Smithsonian Institution

Pop Art surfaced in 1962 in the fortuitous concurrence of solo exhibitions by Roy Lichtenstein, Andy Warhol, James Rosenquist, Tom Wesselmann, and Robert Indiana. From the range of media sources they espoused, each seemed to find his own specialty. The comic strip became Lichtenstein's subject and insignia. They were all reviled for debasing art through banality of subject and mechanized handling. But this was in essence exactly what they were aiming at in their revolt against the aestheticism of the "fine arts" as exemplified by Abstract Expressionism. They had found a new popular language with which they could confront the contemporary world. To Lichtenstein the comic strip was a rich source of contemporary mythology through which the American ethos could be read. His selection of somewhat dated comics gave them a kind of historic importance and an air of nostalgia, and his rendering in paint of the devices of printing added the bite of irony. *Modern Painting with Clef* is not precisely a Pop work in its original sense, but it does share certain aspects with Lichtenstein's earlier comic-strip paintings. Its subject is the Art Deco style of the 1930s; again, a nostalgic comment on the recent past. Ironically, it is an abstract painting in the Art Deco style.

BORN 1923 in New York. Studied at Art Students League of New York, with Reginald Marsh, 1939; School of Fine Arts, Ohio State University, Columbus, 1940–43, B.F.A., 1946, M.F.A., 1949. Served in U.S. Army as cartographic draftsman, Europe, 1943–46. Taught at Ohio State University, Columbus, 1949–51; College of Education, State University College at Oswego, New York, 1957–60; Douglass College, Rutgers University, New Brunswick, New Jersey, 1960–63. Executed mural commissions: New York State Pavilion, New York World's Fair, Flushing Meadows, 1964–65; College of Medicine, Düsseldorf University, 1970. Lives in New York.

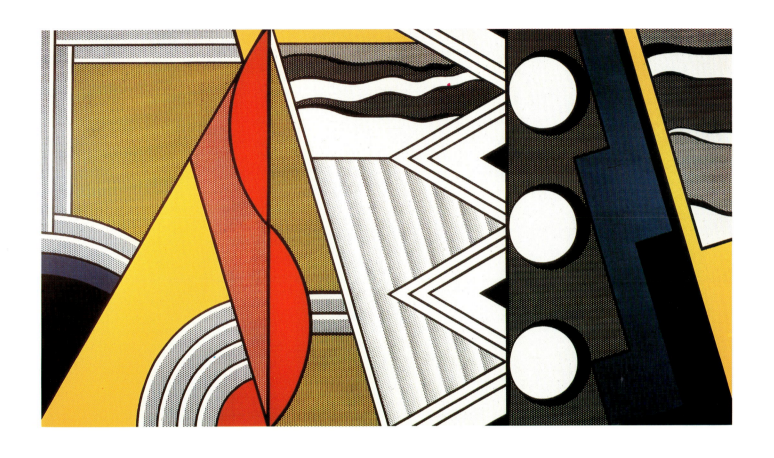

WAYNE THIEBAUD
born 1920

French Pastries

1963
oil on canvas
16 × 24 in (40.6 × 60.6 cm)
Hirshhorn Museum and
Sculpture Garden
Smithsonian Institution

Thiebaud has often been included among the Pop artists, although his work has close affinities with realism. When such still-life paintings as *French Pastries* surfaced in the early 1960s they were perceived as critically focused on American mass culture as consumerism, in Thiebaud's case on food, much in the way that Warhol's was on packaging, Lichtenstein's on comics, Indiana's on signs, or Wesselmann's on nudes. Thiebaud blatantly glorified the banal mass-produced fast foods of America—hot dogs and hamburgers, ice-cream cones, sundaes, and sodas, cakes and pies—in all their profligate repetition and excruciating opulence. The taste of the masses was transformed through art to revolt the sensibility of sophisticates. The underlying ironic ambiguity of *French Pastries*, as a representation of American food, is typical of Thiebaud's work during the sixties. It is, first of all, a very small picture of small consumable objects treated in symmetrical, architectonic, and monumental form. Then, the excessive richness of the confections is exaggerated by the very succulence of the pigment, and the painterly quality, which distinguishes Thiebaud's work from the flat, mechanical techniques of the other Pop artists, contradicts the patently commercial character of the lurid desserts. Thiebaud has said of the painting that it "is actually the American notion of French pastries."

BORN 1920 in Mesa, Arizona. Worked as sign painter, cartoonist, designer, advertising art director, Hollywood, New York, 1938–49. Served in U.S. Army Air Force, 1942–46. Studied at Sacramento State College, California, B.A., 1949, M.A., 1951. Design and art consultant, California State Fair and Exposition, Sacramento, 1950, 1952, 1955. First solo exhibition held 1951, Crocker Art Gallery, Sacramento. Taught at Sacramento City College, 1951–60; San Francisco Art Institute, 1958; University of California at Davis, since 1960. Produced eleven educational films, 1954–57. Lives in Sacramento.

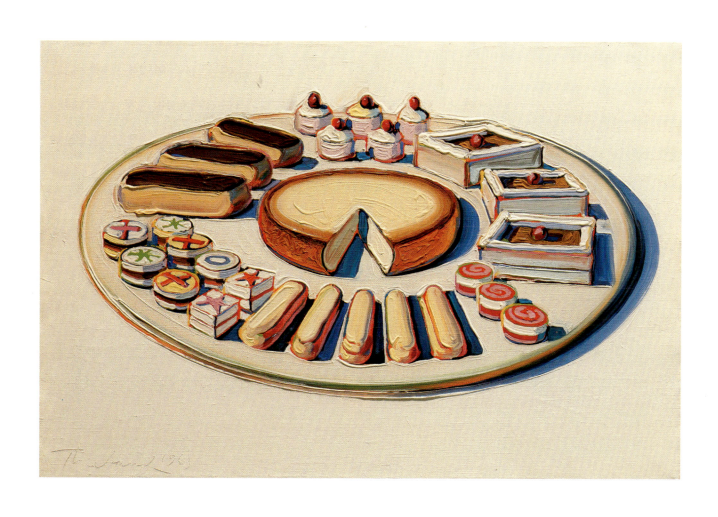

PHILIP PEARLSTEIN
born 1924

Male and Female Nudes with Red and Purple Drape

1968
oil on canvas
75¼ × 75⅝ in (191.2 × 191.8 cm)
Hirshhorn Museum and
Sculpture Garden
Smithsonian Institution

The sources of Philip Pearlstein's art are varied. As a youth he admired the American Scene painters, in Italy he studied the art of the Renaissance, and as a student at Carnegie Tech he became strongly influenced by ideas derived from the Bauhaus. Pearlstein's early work, however, does not reflect the discipline of the art he studied but rather concentrated on Abstract Expressionist landscapes. Pearlstein painted his first figural works in 1962. These took on a new-found sense of control, linearity, and precision. Though working from live models rather than photographs, Pearlstein creates compositions that seem to imitate the camera's ability to create closeup and cropped images. The figures have a catatonic appearance and are arranged as though they were still-life objects. His emphasis on the abstract relationship of forms seeks to deny psychological or sexual inferences. Posed in a barren studio setting, the figures in *Male and Female Nudes with Red and Purple Drape* are seen as abstract shapes in the total composition. The abstract disposition of forms is emphasized by the contorted poses, tilted ground plane, and radical disjunctions of scale and by allowing the frame to cut off parts of the body. Pearlstein's Neorealism is directed toward the problems of art rather than subject.

BORN 1924 in Pittsburgh. Studied at Carnegie Institute of Technology, Pittsburgh, with Sam Rosenberg, Robert Lepper, Balcomb Greene, 1946–49, B.F.A., 1949. Moved to New York, 1951. Studied at Institute of Fine Arts, New York University, 1951–55, M.A. Worked intermittently on industrial trade catalogs, with Ladislav Satner, 1949–57. Taught at Pratt Institute, Brooklyn, 1959–63; Yale University, New Haven, Connecticut, 1962–63; Brooklyn College, since 1963. Lives in New York.

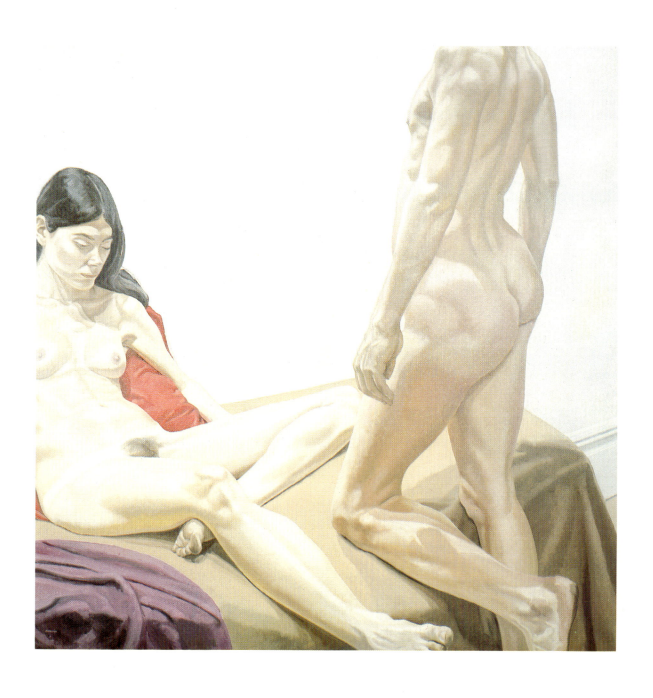

RICHARD ESTES
born 1936

Diner

1971
oil on canvas
40⅛ × 50 in (101.7 × 120.6 cm)
Hirshhorn Museum and
Sculpture Garden
Smithsonian Institution

Richard Estes paints the vernacular architecture of the urban scene with all its attendant accouterments. Nearly every sign of human presence is eliminated, distinguishing him from such previous painters of American city life as Sloan, Bellows, and Hopper. Working from color slides, Estes creates meticulous renderings of commercial cityscapes of steel and glass in which the emphasis on polished reflective surfaces results in complex and sophisticated formal patterns. He uses several views of a given scene, combines forms and colors, and makes numerous changes until he arrives at a final version. Unlike other Photo or Super Realists, who transpose their images directly from the photograph to the canvas, Estes uses neither a grid system nor a projector. Rather, he treats photographs only as preliminary studies, brings the painting to near completion in acrylics, and then uses oils to achieve a more painterly effect. As in *Diner*, Estes structures the composition as a detached scene of objects in light and forms in space, using reflections and a reduced scale to create complex readings of space, for the viewer sees forms outside the frame of vision, not only what is in front but also what is behind. Estes creates a world without air or movement, a moment caught under the microscope of time, transforming incontrovertible fact into questionable reality.

BORN 1936 in Kewanee, Illinois. Studied at School of the Art Institute of Chicago, 1952–56. Worked as illustrator and designer for publishing and advertising firms, 1956–66. Moved to New York, 1959. Lived in Spain, 1962. Began painting full time, 1966. First solo exhibition held 1968, Allan Stone Gallery, New York. Lives in New York and Maine.

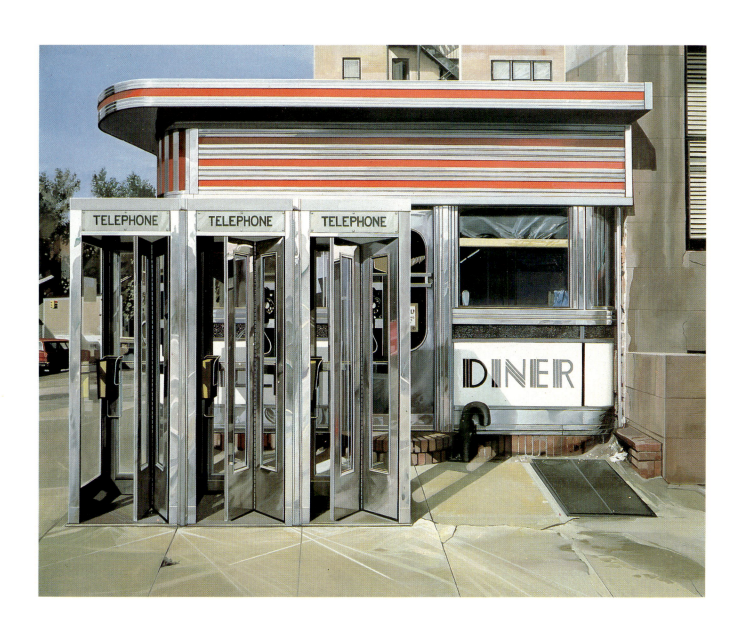

RICHARD DIEBENKORN
born 1922

Ocean Park #111

1978
oil on canvas
93⅛ × 93¼ in (336.4 × 336.7 cm)
Hirshhorn Museum and
Sculpture Garden
Smithsonian Institution

Originally trained to draw the figure, Diebenkorn initially joined the young California artists of the late 1950s who sought new solutions to the realistic tradition. He later developed a new style that reflected the work of the Abstract Expressionists. Following their notion of spatial rhythm stretched across a large canvas, he evokes the mood and timeless energy of an abstract landscape. *Ocean Park #111* is a late work in a series that dates back to the 1960s and is named after an amusement park near which he lived. Diebenkorn here is closer to the color structure of Mark Rothko than to the gestural Abstract Expressionists. He favors the subtle distinctions that Rothko developed by his limited use of color and restricted sense of form and shape. He is, however, more severe in his approach to abstraction. His use of color is cautious, even reticent, diminishing its sensual quality by a design of taut straight lines. Diebenkorn's stern and remote landscape avoids dramatic conflict or struggle; random sight is controlled by brittle discipline, line by simple severity.

BORN 1922 in Portland, Oregon. Studied at Stanford University, Palo Alto, California, 1940–43. Served in U.S. Marine Corps as artist, 1943–45. Studied at California School of Fine Arts, San Francisco, with David Park, Clyfford Still, 1946; University of Mexico, Albuquerque, M.A., 1952. Painted abstract landscapes, 1950s. Taught at California School of Fine Arts, 1947–50; University of Illinois, Champaign, 1955–57. First solo exhibition held 1948, California Palace of the Legion of Honor, San Francisco. Artist-in-residence, Stanford University, 1963–64; professor of art, University of California at Los Angeles, 1966–73. Lives in Santa Monica, California.

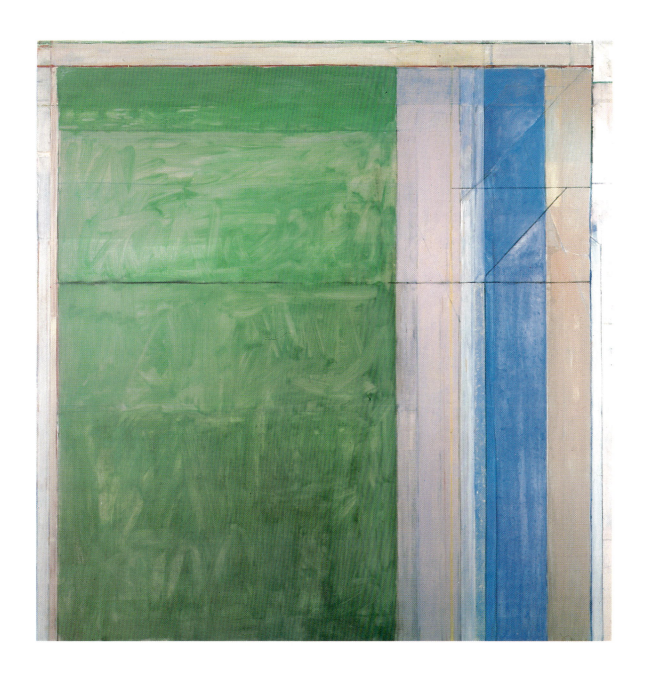

INDEX OF ARTISTS

Page numbers in *italic* refer to colorplates.